François Bovier & Adeena Mey
[eds.]

Cinema in the Expanded Field

JRP|RINGIER & LES PRESSES DU RÉEL

François Bovier & Adeena Mey
[eds.]

Cinema in the Expanded Field

Published with ECAL/University of
Art and Design Lausanne

Table of Contents

The Multiple Sites of Expanded Cinema
François Bovier and Adeena Mey

Translated by Miranda Stewart

This volume, published in parallel to *Exhibiting the Moving Image: History Revisited*,[1] extends our inquiry into the history, theory, and practice of exhibiting artists' cinema, video, and installation, by focusing on the domains of performance and the "expanded" arts. Both volumes, conceived as part of a research project at ECAL/University of Art and Design Lausanne, supported by the University of Applied Sciences and Arts of Western Switzerland, offer case studies of "exhibitions" understood as events which take on particular significance in light of the issues they raise and in terms of the formation and redefinition of larger "exhibitionary complexes."[2] The intention is to sketch alternative archaeologies of film exhibitions and expand their histories as indexed either to the black box or to the white cube. We aim to map situations of cross-pollinations and hybridization, between these two apparatuses, as well as those of mutual exclusion, and account for

the singularity—resulting from the relationship between the aesthetic domain, technical apparatuses, discourses, and audiences in their spatial settings—of each of the events studied here.

We are thus contesting the tendency of the recent field of "exhibition studies" to remain subordinated to the *telos* of art (or film) history, with the consequence that, while the *ideological* function of the "white cube" has to some extent become part of mainstream criticism, the study of exhibitions has remained largely confined to museums and galleries. This, in turn, raises the question of their transparency, which is precisely one of the issues addressed in the present volume.[3] Therefore, the essays collected here engage as much with the expansion of cinema and its corollary, the expansion of its sites and modes of projection, as with performance and live art. Indeed, as Andrew Uroskie put it in his study of expanded film practices, "the artists of expanded cinema understood that the very nature of a moving-image *medium* was irrevocably bound up with the specificity of its exhibitionary *situation*."[4]

Cinema in the Expanded Field

The practices of expanded cinema,[5] quintessentially an intermedia art, offer fertile ground for an exploration of the interaction between the apparatus of the "black box" and the "white cube." Some artists and filmmakers, working in the fields of performance, the "happening," and the expanded arts, have shifted the moving image in the direction of a participatory, total experience—even though, in this case, synthesis has been achieved through disruption, tension, and saturation, as opposed to the post-Romantic ideal of the total artwork.

Consequently, the dichotomy between "white cube" and "black box" can itself be contested in favor of a more complex and multiple topology, which includes sites of presentation of the moving image other than film theaters or art spaces: if the reconfiguration of the architecture of the spaces of projection and exhibition is taken into account from the perspectives of digital images and virtual technologies as Lev Manovich suggests,[6] the immutability of these apparatuses vanishes. The "cinema" dissolves and

reconfigures itself through digital distribution practices which go beyond the apparatus of the black box, as well as museum "exhibition" conventions, which each presuppose the relative stability of the work. However, this diffraction of modes of presentation and reception of moving images is not historically unprecedented, and occurs in particular in experimental cinema, video art, expanded cinema, installation art in museums and galleries, informal spaces, festivals, or in the public sphere—to name but a few examples that form the main focus of our two volumes.

Our engagement with the notion of the "expanded field" must also be briefly discussed. Originally coined by Rosalind Krauss to address some of the directions sculptural practice took in the post-medium era, Krauss' expanded field signaled a moment when sculpture was defined by a double absence: its not-being landscape and its not-being architecture. Nevertheless, the modalities of expansion Krauss sought to grasp developed in parallel, yet in an ambivalent position if not in opposition to the expansion of expanded cinema and of the expanded arts as discussed in this book.[7] The essays included in these pages do not hold together by way of our desire to apply and prolong Krauss' systematic analytical grid, indebted to structuralist thinking, but operate somewhere where the life and legacies of the concept enables new points of departures.

To borrow Spyros Papapetros' and Julian Rose's words, "Krauss' concept of the expanded field has become part of our art historical unconscious."[8] Yet, what we might claim to perform by having gathered these original essays together is a kind of mapping, where the many forms of expansions—of exhibition formats and of moving image practices—could not be entirely be recovered by either Krauss' or Youngblood's concept (or even that of Mekas, who significantly shifted his perspective from expanded arts to expanded cinema in the *Film Culture* issue he devoted to these practices[9]). It should also be stressed that we contest what we would like to call "filmocentrism" which is still prevalent in the studies of expanded cinema, even if efforts to locate "paracinematic" practices through the process of "re-mediating" cinema by "other means"[10] have recently been undertaken. To put it briefly, the dynamics of interme- dia are usually restricted if not repressed by disciplinary

frames, while these performative practices actually aim at dissolving all boundaries; this is already observable through the semantic fields used, which reveal the use of medium-specific logic in a post-medium era. "Happening" is used to designate live arts in gallery spaces; "performance art" mostly refers to a theater context; "expanded cinema" is often equated with multi-screen installations in cinema, museum, or gallery situations.

The Multiple Sites of Expanded Cinema

Expanded cinema is a hybrid and intermedia practice in its mode of existence and manifestation, but also as it unfolds in the venues where it takes place. Due to its performative nature, its contexts of presentation contribute to its reception and understanding. The essays gathered in this volume alternate between the interrogation of specific practices and the sites of exhibitions in the expanded field and the definition of larger theoretical frameworks.

Eric de Bruyn offers a critical reading of "live" practices which frequently use new media and the latest technologies, and deconstructs the intermedia utopia of expanded cinema and the "global village" that Gene Youngblood notoriously advanced in his pioneering work,[11] which remains genre-defining even today. "Expanded consciousness," which delineates the experience of expanded cinema, cannot be disassociated from the geo-political complex in which experiments with such utopia take place, namely a controlled society driven by government programs aiming to conquer all territory within their scope, including outer space. If we follow this line of thinking, the immersive forms of Stan VanDerBeek's *Movie-Drome* and the technological performances that took place under the aegis of the E.A.T. collective, are, in a sense, holographic images, spectral traces of events defined by their virtuality.

Juan Carlos Kase focuses on the role played by Robert Breer in a performance of *Originale* (1961) by Karlheinz Stockhausen, when it was restaged for the Second Annual New York Avant-Garde Festival organized by cellist and performer Charlotte Moorman. Robert Breer screened his film *Fist Fight* (1964) as part of this intermedia spectacle

where experimental music, concrete poetry, video, perfor-
mance, and dance were all interwoven. Robert Breer's film,
based on collage and images recycled from mass media
in a visual frenzy that borders on unreadability, was added
spontaneously as a performance to a happening character-
ized by its unpredictability and the radical juxtaposition of
its disparate elements. Juan Carlos Kase, by restoring the
live dimension to *Fist Fight*—usually studied as an autono-
mous film—closely follows the movement toward radically
redefining cinema when shown as a performance. The
moving image is just one element in a tangle of audiovisual
stimuli (which reached their culmination with the Action
against Imperialism Culture instigated by George Maciunas,
together with Henry Flynt and Tony Conrad among others,
condemning the supposedly reactionary character of
Stockhausen's concert).

Lucy Reynolds tackles the issue of the exhibition of
the moving image in a series of non-institutional venues in
indeterminate city spaces in 1960s London. She thus takes
an opposing view of the contemporary presentation of
expanded cinema in institutions, and offers a historical
perspective. In doing so, she calls on the notion of "terrain
vague," which she borrows from architectural theoretician
Ignasi de Solà-Morales.[12] Lucy Reynolds describes informal
spaces inhabited by groups of radicalized artists who are not
on the commercial gallery or museum culture circuit: the
Arts Lab, Gallery House, and, for a short time, the Better
Books bookshop, managed by concrete poet, Bob Cobbing.
All were places where various practices—mainly expanded
cinema and other innovative forms of performance art—
were being developed in a spontaneous and indeterminate
fashion, thereby subverting the division of arts into different
media. Starting with Annabel Nicholson's expanded cinema
works, Lucy Reynolds pieces together the fragmentary
history of the British experimental film scene, which
clustered round the London Filmmakers' Co-operative.
She argues, at the same time, that there is a clear link
between radical artistic practices and the anti-institutional
(or a-institutional) venues where these approaches flourish.

EXPRMNTL (1949–1974) is a festival that took place
in the seaside resort of Knokke-le-Zoute, and was the main
venue in Europe for international experimental cinema.

Xavier García Bardón looks at the fourth in this series of festivals. In 1967, the Knokke-le-Zoute festival saw an unprecedented explosion in the number of screenings of expanded cinema. The format of this festival—that of an event lasting for a finite period of time—was to be disrupted by interventions involving apparatuses and performers' bodies, and its main focus of attention was entirely displaced. It turned into a venue for European-style happenings, with the apparatus of the darkened room being strongly contested by politically committed spectators (such as Holger Meins and Harun Farocki).

Érik Bullot uses a methodology akin to that of "minor history"[13] and revisits the neglected work of Roland Sabatier, an artist belonging to the Lettrist movement that took off in France after the Second World War. Érik Bullot demonstrates how Roland Sabatier's strategies for performative certification of work through the creation of technical sheets have much in common with certain procedures adopted by Conceptual art, despite a lack of any interaction between Lettrism and this vast field of "dematerialized" practices. The paradoxical form of conceptual anti-cinema proposed by Sabatier sheds some light on the dual phenomena of contraction and expansion of cinema, which is manifested in this instance primarily through the book. This type of crossover, which is at the heart of visual poetry, is an area that remains to be fully explored[14].

Stéphanie Jeanjean focuses on the situation in France to offer a "minor history" of video art. She examines the "sociological," "ecological," and "socio-critical" art of Fred Forest, Hervé Fischer, and Jean-Paul Thenot. Stéphanie Jeanjean shows how these early pioneers of the Portapak, whose approach fell somewhere between the arts and the social sciences, have been excluded from the canonical exhibitions of video art and institutional collections which grew up around this "new" medium in France. Stéphanie Jeanjean draws on research carried out by the Research Service managed by concrete musician Pierre Schaeffer and the first international exhibitions of video art including *Art/Vidéo Confrontation 74* organized at the ARC2, along with developments in the art market and the effects of government cultural policy on these practices, to describe a neglected, not to say entirely forgotten, page in the history

of the moving image. By meticulously reconstructing the personal career paths of various artists, Stéphanie Jeanjean is able to analyze the ways in which sociological art and related cultural fields came to be connected.

In an interview with François Bovier, Don Foresta looks back at his professional career and the role he played in introducing video art to France. Don Foresta was appointed director of the American Cultural Center in Paris in 1971, acting as a bridge between Europe and the United States. His links with artists such as Nam June Paik and Woody and Steina Vasulka allowed him to show artists such as Stan VanDerBeek and collectives such as Radical Software and The Kitchen from New York, and to give video a presence at events such as *Art/Vidéo Confrontation 74* at ARC 2 —discussed by Stéphanie Jeanjean in this volume—and the Biennale de Paris. Don Foresta also discusses issues such as places and ways of showing video art, opportunities to set up a network for the production, distribution, and reception of works in the context of an emerging information society. Developments such as these question the need for a tradi-tional museum and, indeed, foreshadow the interactivity and multiple temporality of the present age.

In the wake of intensifying debates on the current state and future of the moving image—through an increas-ing amount of original historical case studies on one side and the analysis of "post-cinematic" forms in their alignment with digital culture on the other, both entering academic discourse—and its corollary, the repeated announcement of a "death" of cinema, this book (and its twin volume) aim to relativize both a romantic defense of celluloid and a technophile embrace of a more "democratic" circulation and consumption of moving images. For the essays gathered here may well suggest that "cinema" was never born, or at least always had several lives. Moreover, by championing a certain critical tradition in the arts and film, while all historical in scope, our hope is to attest to its relevance to foster the criticality of moving image work to be made in the future.

[1] François Bovier, Adeena Mey (eds.), *Exhibiting the Moving Image: History Revisited*, JRP|Ringier, Zurich 2015.

[2] See Tony Bennett, "The Exhibitionary Complex," *New Formations*, no. 4, Spring 1988, p. 73–102.

[3] For a more detailed discussion, see our introduction in *Exhibiting the Moving Image: History Revisited.*

[4] Andrew Uroskie, *Between the Black Box and the White Cube: Expanded Cinema and Postwar Art*, University of Chicago Press, Chicago/London 2014, p. 14.

[5] Gene Youngblood, *Expanded Cinema*, E. P. Dutton, New York 1970. For more recent investigations, see A. L. Rees, Duncan White, Steven Ball, David Curtis (eds.), *Expanded Cinema: Art, Performance, Film*, Tate Publishing, London 2011; Pavle Levi, *Cinema by Other Means*, Oxford University Press, Oxford/New York 2012.

[6] Lev Manovich, "The Poetics of Urban Media Surfaces," *First Monday*, no. 4, Special Issue ("Urban Screens: Discovering the Potential of Outdoor Screens for Urban Society"), 2006, http://firstmonday.org/article/view/1545/1460 (last accessed July 2015).

[7] The relationships between Krauss' expanded field ("Sculpture in the Expanded Field," *October*, vol. 8, Spring 1979, p. 30–44) and Youngblood's expanded cinema are discussed in Uroskie's *Between the Black Box and the White Cube*, p. 9–12. For the author, "The two texts, occurring at either end of the 1970s, occupied extreme points

on the rhetorical spectrum." An another seminal essay should be included in that discussion, i.e. Georg Baker's "Photography's Expanded Field" (*October*, no. 114, Fall 2005, p. 120–140). The legacies of Krauss' essay, extended and revised by her own affirmation of a "post-medium era," are discussed at length in Georges Baker, Branden W. Joseph, Miwon Kwon, moderated by Stan Allen, "The Expanded Field Now: A Roundtable Conversation," in Spyros Papapetros, Julian Rose (eds.), *Retracing the Expanded Field: Encounters Between Art and Architecture*, MIT Press, Cambridge, Massachusetts 2014, p. 91–127.

[8] Spyros Papapetros, Julian Rose, "Introduction," *Retracing the Expanded Field*, p. XV.

[9] Jonas Mekas (ed.), *Film Culture*, no. 43, Special Issue ("Expanded Arts"), Winter 1966.

[10] See Pavle Levi, *Cinema by Other Means.*

[11] Gene Youngblood, *Expanded Cinema.*

[12] See Ignasi de Solá-Morales, "Terrain vague," in Cynthia Davidson (ed.), *Anyplace*, Anyone Corporation/MIT Press, New York/Cambridge, Massachusetts 1995, p. 118–123.

[13] See Branden W. Joseph, *Beyond the Dream Syndicate: Tony Conrad and the Arts after Cage*, Zone Books, New York 2011.

[14] Nevertheless, on this point see Kaira M. Cabañas, *Off-Screen Cinema: Isidore Isou and the Lettrist Avant-Garde*, University of Chicago Press, Chicago 2015.

Empire's Hologram
Eric de Bruyn

Interior of *The Pepsi-Cola Pavilion*, Osaka, Japan, 1970

"You bend over the hologram like
God over his creature: only God
has this power of passing through
walls, through people, and finding
Himself immaterially in the beyond.
We dream of passing through
ourselves and of finding ourselves
in the beyond: the day when your
holographic double will be there
in space, eventually moving and
talking, you will have realized this
miracle. Of course, it will no longer
be a dream, so its charm will be lost."
—Jean Baudrillard, "Holograms"[1]

"I never had to follow a ghost
before."
—Ridley Scott, *Prometheus*[2]

1. Prefigurations

"There is no past," Gene Youngblood
states with a confidence that bor-
ders on the foolhardy in *Expanded
Cinema*, his famous paean to the
intermedia experiments of the neo-
avant-garde.[3] This assertion would
lead many cultural critics to despair

about the future of human culture, but not Youngblood. He declares the death of history in the middle of a discussion of the merits of Stanley Kubrick's magnum opus, *2001: A Space Odyssey* (1968), which Youngblood accepts, if not without some hesitation, as articulating a mythology of human progress that is proper to the emerging era of information technology or what the American critic prefers to call the Paleocybernetic age. One could say, therefore, that Youngblood appoints Stanley Kubrick as the Richard Wagner of intermedia art, although *Expanded Cinema* makes no actual reference to the German inventor of the total work of art. However, what this comparison might help to clarify at the outset of my argument is, first of all, how expanded cinema envisions an interaction between aesthetics and politics through the active rearrangement of the senses and, secondly, that the declaration of a rupture between past and present, which was so often used to announce the birth of a new avant-garde during the 20th century, did not preempt the creation of a new origin myth. In fact, it necessitated the invention of such a myth to "reboot," as it were, the connection between past and present.

In the following, I shall address in particular this question of the political aesthetics of expanded cinema and I shall do so, largely, in dialogue with Youngblood's text. However, it should be clear from the beginning that I do not take Youngblood's book as an authoritative account of a set of practices, which are now assembled under the historical label of "expanded cinema," although Youngblood's text is one of the earliest, and most informative to address the wide assortment of multimedia screenings, performances and installations that went by the name of expanded cinema since the mid-1960s. No doubt this phenomenon forms a historical construct which does not possess an intrinsic, formal logic, despite the multifarious attempts, such as Youngblood's, to define such a comprehensive logic in retrospect. There should be no need to point out that expanded cinema—as the very term implies—does not consist of a homogenous and unified set of practices although, as I will indicate, recent scholarship has established a few basic, if divergent *dispositifs* of expanded cinema (not all of which are recognized by Youngblood in his book). Furthermore, if Youngblood's text will have a prominent

presence in the following, I do not propose to undertake
what would be a rather superfluous gesture; namely, to
perform a critical deconstruction of his argument for its
own sake. What I propose to undertake is of a more specula-
tive nature, which requires that we productively work
through the "ideological materials" that are contained within
Youngblood's text, instead of simply dismissing its metaphor
of "expanded consciousness" as a false resolution of
underlying social conflicts. Such a mode of ideological
critique would serve no real purpose in the present.

What I find compelling about Youngblood's text is its
anticipatory value, the manner in which it indicates a process
of mediatization that has worked its way through into our
own present, although not in the manner that the author
predicted. This historical development I shall attempt
to grasp through the ambivalent figure of the holographic
image, which must be understood here in a more allegorical
than technical sense. It is a genealogy of the hologram, in
other words, that will concern me here, but not in the sense
of writing the history of a specific technological invention.
What I wish to sketch, in a preliminary manner, is the
genealogy of what we may call a *hologrammatization* of the
space of politics.[4]

Hence I shall focus on the one phantom that haunts
Youngblood's text throughout, if only putting in a full
appearance at the very end of the book. Yet, even there,
it shows up in a elusive manner, more dream than tangible
reality, as a kind of holographic spirit that announces to
Youngblood a vision of an utopian future. I propose that we
consider this holographic figure in two, complementary
ways: on the one hand, as representing a political allegory of
expanded cinema, and on the other hand as drawing a social
diagram, to borrow Gilles Deleuze's phrase, of the later
1960s. The hologram is more than a technological device
in Youngblood's book, it exemplifies a specific apparatus
of power. To understand what is at stake here, we need
to recall Deleuze's crucial addendum to Michel Foucault's
concept of a disciplinary society, in the "Postscript on
a Control Society."[5] Since the Second World War, Deleuze
contends, we have already been moving away from a disci-
plinary regime of power, which confined people within the
institutional sites of work, entertainment, and education.

New forces have come into play, he insisted, constructing an informational society of communication and control, which is perhaps more open in character, but not less subject to administration. Controlled societies are organized by means of a new bio-political technology of continuous monitoring and information feedback loops.[6] Cybernetic machines are the hallmark of this new society of control, yet as Deleuze points out, machines do not explain anything. Rather we must always "analyze the collective arrangements of which the machines are just one component."[7]

One such collective arrangement of information technology was fantasized during the 1960s under the name of the "Global Village," and Youngblood wished to gather the tribal audience around its electronic hearth. In his opinion the creative media of the future would be formed by video, television, and computers. A new form of "synaesthetic" and "cybernetic" cinema would soon render narrative cinema obsolete. And thus Youngblood came to portray expanded cinema in 1970 as embarking on an adventurous mission to discover and harness the "universals of communication," drawing a parallel to the "interstellar morality play" of Kubrick's *2001: A Space Odyssey*, in which the intrepid crew of the spaceship Discovery travels into outer space to investigate a mysterious signal emanating from the edge of the solar system. Two decades later, however, this journey into cyberspace would come to be viewed in a quite different light. As Deleuze remarked in 1991, any quest to establish a system of universal communication "ought to make us shudder."[8]

"Through the Hologram Window"

To imagine a world of universal communication is to imagine the world as a closed circuit in which all contingency—as an "external" disturbance of the homeostatic balance of the system—has been submitted to algorithmic control. In short, all "noise" will be banned from such a realm. In such a world, we might imagine that information as such, which Gregory Bateson once defined as a difference that makes a difference, would be reduced to a single "live" signal, emptied of signification, coursing through the pathways of the system. At this point we would enter

Jean Baudrillard's domain of hyperreality, or a world of
total simulation. Indeed Baudrillard maintains that it is the
accelerating degree of information circulating within the
media system that causes information to divest of its ability
to "make a difference": "the loss of meaning is directly
linked to the dissolving, dissuasive action of information,
the media, and the mass media."⁹ And we may imagine how
Deleuze begins to shudder at the thought of Baudrillard's
future society of universal communication, a hologenic
world that consists of the "materialized projection of all
available information on the subject," leaving nothing
behind to be desired. Even the hand that passes through
such a "materialized transparency" becomes unreal. Indeed,
not only is the hyperreal populated by holographic bodies,
it is nothing but a holographic projection.

There are then two fatal strategies, two transgressive
acts that must be avoided, according to Baudrillard, in one's
interaction with the realm of media technology. In the first
place, one must never try to traverse the transparent plane
of the *image*. One must never yield, that is, to the temptation
to pass over to the side of the real. For this would cause the
image to disappear, and with the vanishing of the image we
would lose our sense of self-identity as well. To save our-
selves, Baudrillard implies, the imaginary must be protected
at all costs. Should our fantasy of "seeing ourselves" in a
mirror or photograph somehow be brought to an end,
the world as a whole would dissolve into a shapeless fog.
Yet, Baudrillard contends, the opposite temptation is equally
deadly: we must also not try to pass over to the side of our
own double or holographic twin. To externalize, that is,
our ideal ego as a hologram. It may be hard, he writes, to
shake the fascination of "being able to circle around oneself,
finally and especially of traversing oneself, of passing
through one's own spectral body—and any holographed
object is initially the luminous ectoplasm of your own
body."¹⁰ Yet, should a laser beam, as it were, be capable of
excising a secret double from our unconscious, creating an
ideal prosthesis of ourselves, we would not be seen bending
over our own creations "like gods." These more-than-perfect
holographic others—existing "there in space, eventually
moving and talking"—would render our own bodies
immaterial in turn.

In short, Baudrillard employs the metaphor of
the hologram—he is not speaking of any actually existing
technology—to describe a process of *spectrogenesis*.[11]
In pursuit of the status of a god, the human subject
attempts to give autonomous life to the abstractions of his
own thought. A process that, of course, Karl Marx had
already shown to lie at the basis of capitalist society in
his discussion of the commodity fetish. Only now it is the
mind itself, not the body's physical labor that assumes a
spectral shape. I shall develop this notion of spectrogenesis,
but Youngblood was clearly not worried about the dangers
of "passing to the side of the hologram" in 1970. Further-
more, he welcomed the accelerated flow of information
and its effect of creating an "implosion of meaning."
This destruction of the social imaginary was emancipatory
in his eyes as it released us from the hold of the past:
"technologies such as television displace the individual from
participant to observer of the human pageant, and thus we
live effectively 'outside' of time; we externalize and objectify
what previously was subjectively integral to our own self-
image."[12] In other words, the mass media produce a state
of radical alienation in the spectator, but at the same stroke
he is liberated from the specious images that enslaved
former generations: "As we unlearn our past, we unlearn
our selves."[13]

By means of our mediatized detachment from history,
we are all being prepared, like astronauts, to step into
the beyond and to become a "child of the new age, a man
of cosmic consciousness." In order to illustrate this idea,
Youngblood refers to a scene in *2001: A Space Odyssey* in
which a crew member receives a birthday message from his
Earthbound parents. The moment is infused with sadness,
Youngblood observes, but not because he longs for a past.
The astronaut is both physically and mentally removed from
the social institution of the family. What significance could a
birthday have to someone who no longer shares his parent's
comprehension of the difference between life and death?
Are not his companions aboard the Discovery preserved in
a state of cryogenic suspension? To this "child of the new
age" who lives in a cybernetic symbiosis with the machine,
there exists only a continuous gradation between the
animate and the inanimate.

It is our current plight, therefore, to be filled with
"an inevitable sense of melancholy and nostalgia, not for
the past, but for our inability to become integral with
the present."[14] Furthermore, he continues, this is also not
a nostalgia for the future, as "there are no parameters by
which to know it."[15] Youngblood perceived his own genera-
tion, therefore, as living in the antechambers of time waiting
to be reborn, literally, in the artificial light of the electronic
media, similar to the fate of the astronaut in *2001: A Space
Odyssey*, who "finds himself in austere Regency chambers
with an aqueous video-like atmosphere, constructed by
whispering omniscient aliens." In this simulated environment
or video-incubator, the astronaut undergoes a "series of
self-confrontations," continuously processing himself as if
he has become trapped in an endless feedback loop.[16]
Until, that is, the astronaut is reincarnated as the Star Child,
"transcending logic far beyond human intelligence."[17] It is
clear what Kubrick's movie, this "interstellar morality play,"
has to offer Youngblood: he comprehends it as an allegory
of human redemption by means of technological develop-
ment.[18] Human consciousness is to ascend "beyond infinity"
through the administrations of an alien intelligence. Yet it
is easy to grasp that this "alien" mind is nothing else than
an objectification of human thought. In this continuous
hypostasis of mental images into some form of "alien
intelligence," Youngblood is, as it were, laying a holographic
trap for himself.

We might sense his holographic double already
standing in the wings, waiting to step out onto the central
stage. But there is a hitch. As Youngblood complains, *Space
Odyssey* suffers from an "unfortunate syndrome"; namely,
a disturbing fear of the dehumanizing effects of computer
technology. Once again, a shudder is felt. This time it is
caused by HAL, the panoptic computer of *Discovery*, who
monitors every thought and action of the starship crew.
To Youngblood, HAL represents the "highest achievement"
of artificial intelligence—a machine that not only thinks,
but can sense emotion—yet it goes berserk and murders all
but one astronaut. Nevertheless, Youngblood is willing to
overlook the "confused" thought of the director, preferring
to see HAL not as an evil machine, but as a metaphor of
the "end of logic" that releases the "cosmic mind" from its

earthly bounds. Alternatively, HAL might represent the necessary victim that needs to be sacrificed if Youngblood's myth of redemption is to be brought to its final conclusion. The ghostly HAL functions as the uncanny incarnation of abstract, algorithmic thought, a product of the human brain, which turns against its own creator. And just as television exorcises the ghosts of the past, humanity must now exorcise the ghost of the future as well. But in this case, exorcism means a flight forward or what Baudrillard described as a passage to the side of the hologram. This trajectory of sublimation runs from human intelligence to artificial intelligence to alien intelligence to cosmic intelligence.

Indeed we must "pass through" our holographic double, Youngblood implies. We must become more ghost-like, not less, in order to realize our full potential as god-like creatures. To quote "Saint Max," only "as a specter has [the human subject] been regarded as sanctified."[19] Which brings me to my next point: political theology masquerades as media theory in *Expanded Cinema*. As the author explains: "expanded cinema does not mean computer films, video phosphors, atomic light, or spherical projection." It is not a matter of technology as such; rather "like life it is a process of becoming, man's ongoing drive to manifest his conscious-ness outside of his mind, in front of his eyes."[20] *Expanded Cinema* pursues not so much an expansion as an externaliza-tion of consciousness. And once consciousness has assumed this autonomous, exterior status, it becomes not simply alien, but angelic: a "star child."

In constructing this myth, however, Youngblood is actually following the script of cybernetic theory. For the "star child" is what Gregory Bateson, for instance, would call the "larger Mind," which as the latter concedes might be called God by some people, but refers to the fact that the mental world is not limited by the envelop of our bodies. As a true cybernetician, Bateson equates consciousness with the processing of information and circuits of information that extend beyond the skin. The mind is not only immanent to the "whole communication system within the body—the autonomic, the habitual, and the vast range of unconscious process." Such a corporeal immanence of the mind, as Bateson notes, was already established by Freudian psychol-ogy. What is truly radical about the notion of the "larger

Mind" is that it no longer considers human consciousness as a mere epiphenomenon of a bodily substrate, but as seamlessly integrated within the "total interconnected social system and planetary ecology." This posthuman view of a non-anthropomorphic universe in which autonomous subjects can no longer claim to occupy center stage should teach us a certain humility, Bateson advises. We are but temporary patterns of data coalescing in a continuous flow of information. Yet, it should also be reason to rejoice as cybernetic theory proposes that we are part of something bigger than ourselves: "a part—if you will—of God."[21]

I shall come back to this question of political theology, shortly, as there is another issue that we need to settle first. For someone who claims that the parameters of the future cannot be known, Youngblood seems quite eager to fulfill the role of a prophet. As a matter of fact, he actively seeks out his own experience of epiphany. In the final chapter of *Expanded Cinema*, called "Holographic Cinema: A New World," the author constructs a memory of the precise moment in time when he came to stand face-to-face with infinity, sensing the eternity within all of time:

> In April, 1969, overlooking the Pacific from the crest of Malibu Canyon in Southern California, I became one of the few persons to view the world's first successful holographic motion picture. There at Hughes Research Laboratories one can look across the canyon to see a Catholic monastery … perched majestically atop its own mountain … the temples of science and religion separated by a canyon as old as time, each in its own way dedicated to the same quest for God … Through the hologram window we peer into a future world that defies the imagination, a world in which the real and the illusory are one, a world at once beautiful and terrifying.[22]

Looking back, we might wonder about Youngblood's excitement about the medium of holography, which still stood in its infancy in 1969.[23] Yet at the time, the new 3D image technology seemed to contain an endless promise for the future. Practical applications of holography in the field of science, mass culture, and artistic practice seemed to be

imminent.[24] Youngblood had no doubt: it was certain,
he asserted in *Expanded Cinema*, that holographic cinema
and television will be common features by the year 2000.[25]
Nevertheless, Youngblood did misread the parameters
of the future: holography would acquire its most widespread
application elsewhere, not in the domain of art and enter-
tainment, but primarily in the sphere of military surveillance
and control. Which comes as no big surprise, considering
the fact that the principle of holography was discovered as
an offshoot of military research in the use of radar and that
Youngblood himself, in his quest to learn more about the
medium, would visit several labs that were part of the
aerospace and defense contracting system.[26]

The military genealogy of holography will be of more
interest to me later and, therefore, I shall have little to
say about the short-lived history of the hologram as artistic
device.[27] I am even less inclined to engage in the rather
fruitless discussion of why the hologram was never fully
embraced by the art world.[28] In passing, it is interesting
to note that holography quickly escaped from the secretive
military lab in the later 1960s, spreading both to the com-
mercial world and the artistic community. Bruce Nauman
was one of the first artists to experiment with the new
medium, creating his *Making Faces* series in 1968. Soon
thereafter the first exhibitions with holograms were orga-
nized at Cranbrook Academy in Detroit (1969) and Finch
College in New York City (1970). In 1971, the School of
Holography was established in San Francisco (1971) and in
1976 the New York Museum of Holography was founded.[29]
However, with a few exceptions, such as the Simone Forti's
Striding Crawling, the medium, in contrast to other new
media technologies, such as video, did not fully mesh with
the dominant concerns of advanced artistic practice and
it remained largely confined to the cultural realm of optical
curiosa. Until lately, that is.[30]

What is holography? In brief, a hologram is a three-
dimensional representation of an object that is created when
a laser beam is split, with one part of the beam reflecting off
the object onto a photographic plate and the other part—
the reference beam—projected directly onto the plate.
The plate registers the interference pattern that is caused
by the light waves from the two beams. Subsequently, by

shining the reference beam back onto the hologram, a
virtual, 3D image of the object becomes visible to the naked
eye. In essence, a hologram is an informational storage
device, it encodes a "wave front construction" of the object.
The resulting images, certainly in the later 1960s, were far
from perfect, creating ghoulish effigies clad in shimmering,
rainbow-like effects. As one contemporary critic put it:

> Three-dimensional holographic images were disturb-
> ingly there but not there. They hovered like ectoplasm
> both before and behind the transparent or reflective
> plates to which clear celluloid sheets bearing laser-
> generated interference patterns were attached.[31]

This unsettling confusion by the hologram between
presence and absence, inside and outside, appears to have
triggered an historical memory of the 19th-century *séances*
and its conjuring of ghosts. It is, then, not so much the
actual technique of holography that is at play here, but its
imaginary potential that is both fascinating and "disturbing."
Even Youngblood admits that holography suffers from a
popular misconception, which maintains that it is possible
to interact with the holographic image—moving around
and through it. However, he immediately adds that this
misconception may become reality soon. When, succes-
sively, Baudrillard writes in 1981 about "the day when your
holographic double will be there in space" and the "dream
of passing through ourselves and of finding ourselves in
the beyond" has become reality, the confusion between the
hologram and virtual reality (or, alternatively, volumetric
display technologies) is complete. Of course, Baudrillard is
doing nothing less than filling in Youngblood's dreamy view
of the future that was revealed to the latter as he stood
on the bluffs overlooking the Pacific Ocean. But Baudrillard
does so with apocalyptic fervor, converting Youngblood's
vision of a posthuman future of immanent being into a
nightmarish scenario of total implosion. With Baudrillard's
concept of hyperreality, capitalist society is indeed con-
ceived as a vast hologram, which is inhabited by simulacra
of ourselves, pure informational bodies which leave no
remainder, no supplement that escapes representation.
Abstraction vanquishes the real, although in his essay on

the hologram the French theorist appears to hedge his bets.[32] Baudrillard displaces the actual *technological* implementation of this nightmarish dream to an indefinite future where it has become possible to send our holographic avatars to travel the world in our stead. The dialectic between the "non-living" and the "living" would then be complete, the battle decided in favor of the former, and with the establishment of a total regime of simulation, human desire would itself become an extinct species.

Two totalizing views of the future, one utopian, the other dystopian, but both are focused on the holographic image as an entity that occupies a threshold space, which is mesmerizing *and* terrifying due to the manner in which it allows the sensuous and the non-sensuous, the abstract and the concrete, to become intertwined. Let us explore this strangely twisted, topological realm a bit further.

"A Materialist Below and an Idealist Above"

Let me now return to the question of political theology as it is raised in *Expanded Cinema*. According to Youngblood, we are no longer able to identify ourselves in the images of the past that are transmitted into the present. And this radical uprooting of the contemporary subject, the author goes on to argue, may seem traumatic, but it is, nevertheless, a blessing in disguise. But to what calamity do we owe this death of history? How did the calendar become reset to year zero? Time was certainly not stopped by any human act of insurrection, unlike those 19th-century revolutionaries that allegedly fired on the clock towers of Paris during the first day of fighting.[33] Our detachment from the past, Youngblood maintains, is the inevitable result of our exposure to the "implosion of information" in the mass media. Television, as noted above, is blamed for displacing the individual to the sidelines of time. But what could this mean: to live "outside" of time? Is Youngblood to be considered guilty of an old perversion of the avant-garde project; namely, to glorify in the self-alienation of the human subject? Is Youngblood a futurist-in-disguise who is enthralled by the spectacle of technological domination? Has he not succumbed to that old ruse of history: to confuse a political aesthetic of emancipation with the politicization of aesthetics?

Allow me to suggest a more fruitful mode of analysis. Perhaps it is more apposite to define Youngblood as "a materialist below and an idealist above," to borrow Friedrich Engels' famous characterization of Ludwig Feuerbach.[34] At this point, we may recall how the latter undertook a critique of religion by accusing Christians of hypostasizing "their mental states into beings and qualities of things, their dominant emotions into powers dominating the world."[35] Religious thought, in other words, gave birth to a confusion between what is internal and what is external to consciousness. Mental abstractions were given a body as "self-subsisting beings," and unlike the sensuous object that exists apart from man, "the religious object exists within him—it is itself an inner, intimate object, indeed, the closest object, and hence an object which forsakes him as little as his self-consciousness or conscience." Like ghosts, these "self-subsisting beings" that are exposed on the outside of the subject consist of a *sensuous nonsensuous* nature: they are both spirit and body, living and nonliving entities. Feuerbach took it upon him to expel from human society these demons, which had sprung from the human mind, achieving an autonomous presence only to enslave humanity in turn. The complaint of Engels—as well as Karl Marx— was that Feuerbach's exorcism had not been radical enough; he had left the idea of divinity intact by reinscribing it within the human "essence." Man, in Feuerbach's estimation, was the equal of God.

Yet, the problem for Marx and Engels was not only that Feuerbach injected consciousness with a spectral notion of divinity. As the radical anarchist, Max Stirner, had already enjoined, Feuerbach's divine subject is derealized by his own ghosts: "the man identified here with the unique, having first given thoughts corporeality, i.e., having transformed them into specters now destroys this corporeality again, by taking them back into his own body, which he thus makes into a body of specters."[36] Like Baudrillard's hologram, which makes the hand that passes through it unreal, Feuerbach's living body becomes spectral by absorbing its own phantomatic projections within itself. And thus the human subject becomes the absolute ghost: "simulacrum of simulacra without end," as Derrida puts it.[37] Yet even Stirner, in rejecting Feuerbach's anthropological critique of

theology, was not sufficiently dialectical in his thinking. It is not possible, Marx maintained, to liberate humanity from the phantoms of their brains by a mere adjustment of consciousness. Alienation cannot be annulled by a sheer act of contemplation.[38]

The side of Youngblood that is a "materialist below" wishes to expel the ghosts of the past by means of media technology. Yet he transforms into the "idealist above" once he spectralizes the world in the name of science or, more specifically, cybernetic theory. Science has reached such a high degree of abstraction, Youngblood maintains, that it has left the realm of visible, tangible reality behind. As a result, there is no finite perspective, no "precise focusing" possible within the worldview of modern science. Instead, the human subject has become an immanent part of a larger, environmental system of information processing or, in Youngblood's terms, "we are confronted with dynamic interaction between several transfinite space systems." What science and technology create, in other words, is not so much a transcendental subject, but an *omnipresent* one. Youngblood would agree, for instance, with Marshall McLuhan's cybernetic vision of a man-machine symbiosis according to which our nervous system has become extended into a global closed circuit of communication. And he would be equally drawn to Bateson' statement that the individual mind is but a "subsystem" of a larger Mind, which is itself comparable to God. Thus, Youngblood proposes that while the Paleocybernetic Age witnesses the secularization of religion through electronics, it has also "come closer to whatever God may be than has the church in all its tormented history." What modern science has discovered, Youngblood concludes, is the existence of "an a priori metaphysical intelligence omni-operative in the universe."[39]

We have now come to the point that it is possible to comprehend this cybernetic god or "larger Mind" as nothing other than the "holographic projection" of those actual omni-operative minds, which Karl Marx defined as the general intellect in the *Grundrisse*.[40] In this text, which is a mainstay of (post-)*operaist* theory, Marx foresaw a future where abstract thought, rather than physical labor, would become the main driving force of capitalist production. Which is to say, to a certain extent Marx anticipated the

emergence of a "postindustrial" society that is organized
by immaterial, or informational modes of labor. The general
intellect refers to the *exterior*, collective, and social character
of intellectual activity, which, in the present, has become
integrated within the capitalist system of production; a
system that is more engaged in the invention of new life
styles, affective experiences, and financial derivatives than
the reproduction of the material commodities of industrial
society. According to post-operaist theory, therefore, the
valorization of the general intellect by capital has led to an
expropriation of our own mental faculties, bringing the
biopolitical control of society to a state of near completion.
I shall not be concerned here with the post-operaist
response to this dystopian scenario—i.e., that the general
intellect, as embodiment of the multitude, contains the
seeds of resistance within itself. Rather, I am interested
in how expanded cinema and, in particular, Youngblood's
holographic *dispositif* of a "cosmic consciousness," can be
accommodated within the Marxist concept of the general
intellect. In this manner, we may begin to comprehend how
expanded cinema was both "idealist above" and "materialist
below" or, in other words, how it could operate as both a
critique and a *prefiguration* of a control society that existed at
most on the horizon in 1970. Or, as Youngblood put it, the
holographic window of expanded cinema delivered a pre-
monition of a future that was both "beautiful and terrifying."[41]

Network Power

What are the facts that have been established thus far?
We know how expanded cinema celebrated the liberating
potential of the new technologies of communication;
technologies that oddly enough were themselves the product
of the military-industrial complex. Indeed expanded cinema
happily ransacked the military warehouses in search of
surplus equipment. But we also know that a particular
technology does not equal an apparatus or *dispositif* of power:
technology is not *inherently* emancipatory or repressive.
Expanded cinema opposed the new mechanisms of social
control and surveillance which were being implemented
on a world-wide basis, and therefore artists such as
Stan VanDerBeek set out to build, as it were, their own

multi-media "control rooms" to counter those of the media conglomerates, financial corporations, or the Pentagon. We must transform weaponry into livingry, as the awkward slogan of Buckminster Fuller put it, and expanded cinema took this demand seriously (even more so than Fuller did). But, unfortunately, in its attempt to articulate an alternative, more democratic model of media ecology, the practitioners of expanded cinema more often than not failed to acknowledge the concrete nature of the power relations it engaged in. In a perverse twist on Foucault's panoptic diagram, expanded cinema imagined the central control room to be empty, although clearly there was the need for someone or something to twist the dials and pull the switches; to keep, in short, the negentropic feedback loop between subjects and images running and alive.[42]

And so we arrive at a familiar question of political theory: Is it possible to conceive of a critical position outside the current system of social organization? Once such a strategy might have seemed to be possible. As Michael Hardt and Toni Negri assert in *Empire*, the emergence of a modern, governmental system of nation-states establishes a bounded space of sovereignty where power always resides at the limit.[43] Which is why, during modernity, political critique would fashion itself upon a dialectic of inside versus outside. The revolutionary dialectics of Marxism, for instance, was grounded on the concept of an inside that desires to connect with an outside through the abolition of the nation-state. Yet, if we are to take the premise of a control society seriously, it may be clear that the former dialectic of inside versus outside no longer applies. As Alexander Trocchi put it already in 1963, writing in the pages of the *Situationist International*: "We are concerned not with the *coup d'état* of Trotsky and Lenin, but with the *coup du monde*, a transition of necessity more complex, more diffuse than the other, and so more gradual, less spectacular."[44] What might constitute an "outside" to the global closed circuits of information? Youngblood himself seems confused by this question. On the one hand he appears to embrace the social model of a "closed world" of control and communication, which has its origins in a military politics of "containment" that was first developed during the Cold War.[45] On the other hand, Youngblood is in thrall of the

ideology of the new space age where we will be free to
wander as astronauts in the infinite expanse of a cosmic
consciousness: "we've left the boundaries of Earth and again
have entered an open empire in which all manner of
mysteries are possible. Beyond infinity lurk demons who
guard the secrets of the cosmos."[46] But what is it to be:
closed circuits or open empire?

Hardt and Negri propose that we grasp this paradox
in terms of a "network power."[47] What is network power?
In contrast to the transcendent character of sovereign power,
which determined the European system of nation-states,
network power operates in an immanent fashion, constitut-
ing and redistributing social relations from within the very
fabric of society as such. Hardt and Negri state that network
power is based on three principles: (1) the drawing of a
territory which allows the "productive synergies of the
multitude" to construct its own political institutions; (2)
the establishment of an internal limit to the conflictive and
plural nature of the multitude itself; and (3) the maintenance
of equilibrium between constituent and constituted forces
by opening up ever new lines of flight. It immediately follows
from these three principles that a republican confederation
of people will exist in a constant state of exodus, always
seeking to populate new territories. Yet ideally, if not always
in actuality, this expansion takes place by means of inclusion,
not repression of that which is foreign. This amounts to
saying that imperial (but not imperial-*ist*) power works in
a topological, rather than a geometric fashion: it concerns
a new folding of space. Of course, the Republic of the
United States, which Hardt and Negri credit with the
invention of network power, did not always adhere to its
original principles. Hardt and Negri point, for instance,
to the Vietnam War as a symptom of America's occasional
lapse into colonialist behavior. But, at the same time,
this regression was countered by the rise of the New Left,
which reaffirmed the principle of constituent power within
American society. There can be no doubt that the 1960s
were characterized by an unbinding of social energies, a
deterritorialization of the social spaces internal to American
society. In a similar fashion the American counter-culture,
to which expanded cinema was intimately linked, set a kind
of internal exodus in motion, which attempted to resettle

the countryside with its dismountable, geodesic domes—
Fuller's gift to the nomadic generation of the 1960s.
But in seeking a mode of self-governance, these communes
or "drop cities" did not simply try to carve out a natural
paradise, an Eden of sexual innocence, from the derelict
remains of industrial society. The pleasure domes of these
new communes were actively plugged into the new informa-
tion spaces. They functioned as a kind of biopolitical
laboratory of self-experimentation in which cybernetic as
well as psychotropic modes of feedback were explored
in order to open the stargates of expanded consciousness.[48]

We still need to determine, however, what bearing
network power has on expanded cinema's project. In recent
years we have established a profound understanding of
the way in which expanded cinema, in all its mutable forms
and shapes, is entangled with the agonistic sphere of the
political. How, that is, expanded cinema *articulates*, often
unwittingly, a set of variable and conflicted relations between
art, technology, and subjectivity. On the one hand, Branden
Joseph has offered the interpretation of the expanded
cinema event, as embodied by Andy Warhol's *Exploding Plastic
Inevitable* [1996–1967], which attenuates the disintegrative
effects of the multimedia performance: a series of strobo-
scopic blasts that allow no mercy in breaking down the
defenses of the self.[49] Or, as Jonas Mekas famously declared,
the sensory overload of EPI establishes "the last stand
of the Ego, before it either breaks down or goes to the other
side."[50] On the other hand, there is the psychedelic or
mystical variant of expanded cinema, which was perhaps
the more dominant form, and which aimed to push beyond
the barrier of the ego, beyond the "screeching, piercing
personality pain" (Mekas) in order to accomplish a retribal-
ization of society. This alternative, integrative paradigm of
expanded cinema is the one celebrated by Gene Youngblood
and exemplified in his book by such practices as Stan
VanDerBeek's *Movie-Drome* [1963–1965] and the road show
We Are All One, by the media art collective USCO.[51] In these
projects, the immersion of the viewer in the flow of images
and other sensory stimuli is meant to induce an erasure of
all distinctions between the self and its environment,
allowing one to become absorbed in an ecstatic "flow" of
sensations. Or, according to USCO, producing "a journey

of this being riding and fighting the waves from birth
through love's body, searching living currents, sampling
peaks of illumination, holding on and letting go of the
experience of time-space-death, finding potential rebirth
in the consciousness WE ARE ALL ONE."[52]

In other words, expanded cinema pursued a project
of social reprogramming in which the human subject was not
only trained to master the accelerated pulse of informational
processes, but to shed his or her former identity and fuse
within the new networked space of a global tribe. It was
VanDerBeek, in particular, who established the link between
expanded cinema and the latest frontiers of network power.
"It is imperative," he wrote in his manifesto "'Culture:
Intercom' and Expanded Cinema," "that we quickly find
some way for the level of world understanding to rise to a
new human scale. This scale is the world … Technical power
and cultural 'over-reach' are placing the fulcrum of man's
intelligence so far outside himself, so quickly, that he cannot
judge the results of his acts before he commits them … the
world hangs by a thread of verbs and nouns. It is imperative
that the world's artists invent a non-verbal international
language."[53] Hence his proposal to construct a global system
of Movie-Dromes connected by satellites that would establish
an "image flow and image density" (also to be called "visual
velocity") "both to deal with logical understanding and to
penetrate to unconscious levels, to reach for the emotional
denominator of all men, the nonverbal basis of human life,
thought, and understanding, and to inspire all men to
goodwill." The Movie-Drome was thus merged, as Beatriz
Colomina has argued in a now classic essay, with a series of
other contemporary "spaces" that were the product of the
new space age: the mission control and war control rooms to
which we may now also add, the data centers of the financial
industry and drone command sites.[54]

I am not the first to point out that expanded cinema
stood in a highly ambivalent relationship to a new *dispositif*
of techno-scientific visuality, one that is enabled by the dome
of communications satellites that began circling the Earth
after the Russian launch of the Sputnik to the startled eyes
of the West. In the 1960s network power had discovered
a new frontier, a new boundless space of expansion, which
seemed to open up new lines of flight even while closing

some old frontiers. Thus, Youngblood's notion of an "open empire." Yet we might also listen to Marshall McLuhan, for instance, as he welcomes the closure of Earth from its outside: "Since Sputnik and the satellites, the planet is enclosed in a man-made environment that ends 'Nature' and turns the globe into a repertory theater to be programmed."[55] Or, elsewhere, "For the first time the natural world was completely enclosed in a man-made container. At the moment that the Earth went inside this new artifact, Nature ended and Ecology was born. Ecological thinking became inevitable as soon as the planet moved up into the status of a work of art."[56] To transform the Earth into a work of art—i.e., an artificial, self-enclosed and controlled environ-ment—is to treat it as a computer simulation on a planetary scale. The world as holographic projection. *Es spukt in der ganzen Welt*—the world is itself an apparition—ever since Sputnik was sent aloft.[57]

We have seen how network power not only unleashes constituent forces; it also sets an internal limit to their expansion. This becomes apparent when we consider how the global technology of satellite surveillance serves, in the words of Eyal Weizman, a new politics of verticality, which literally upsets the former horizons of political thought and social control.[58] Here is how another critic rephrases Weizman's notion of a politics of verticality:

> Everywhere, the symbolics of the top (who is on top) is reiterated. Occupation of the skies therefore acquires a critical importance, since most of the policing is done from the air. Various other technolo-gies are mobilized to this effect: sensors aboard unmanned air vehicles (UAVs), aerial reconnaissance jets, early warning Hawkeye planes, assault helicop-ters, an Earth-observation satellite, techniques of "hologrammatization." Killing becomes precisely targeted.[59]

In the present text, I will not be able to develop this more lethal genealogy of the hologram, but what is important here is that it shows another aspect of the collective arrangements of which the hologram was part. On the one hand, we have Youngblood encased within the technological dome of

communication, yet imagining this closed space, like a planetarium, to be infinitely larger. On the other hand, we have the symbolics of "who is on top," which relates to the actual situation of military commanders looking down on a miniaturized battlefield, rendered within the sphere of a holographic display.

The Real Image

"The new consciousness does not want to dream its fantasies, it wants to *live* them."
—Gene Youngblood[60]

We have seen how Youngblood developed a political theology of the image in expanded cinema, thereby putting a fresh spin on Karl Marx's famous comments about the mystical character of the commodity fetish, "abounding in metaphysical subtleties and theological niceties."[61] As a matter of fact, the substitution in expanded cinema of the presentation of art *objects* by the processing and circulating of *images*, partakes of a further development in the dialectics of capitalist production, but I shall not dwell on this topic here.[62] In Youngblood's view, expanded cinema's purpose was to reveal a supersensory, even metaphysical reality wavelengths beyond ordinary human perception and the means toward attaining such a revelatory awareness would be provided by nothing else than the "instrumented and documented *intellect* that we call technology."[63]

This remarkable phrase can be found in the concluding section of Youngblood's *Expanded Cinema*, called "Technoanarchy: The Open Empire." Here the rhapsodic quality of Youngblood's prose is driven up a further notch as he unfolds his ecstatic vision of the future. Throughout the chapter, Youngblood recounts a tour he made of the research laboratories of the aerospace and computer industry, allowing himself to become enthralled by the phenomenon of holographic images. The conviction of the scientists, whom Youngblood reverently addresses by their professional titles, leaves no doubt in his mind: the reality of a truly participatory cinema is imminent. The medium may not be quite ready to fulfill its promise right here and now, but Youngblood remains full of anticipation nevertheless.

As he explains, a hologram is not made with lenses and therefore it creates a virtual image that appears to exist *out there*, on the other side of the film from the viewer. It is as if the viewer looks through a window. Yet it is possible, he exults, to develop an optical system of projection that will create a "real image" *on this side* of the film; that is to say, to produce a holographic image that assumes a three-dimensional, bodily form in actual space. In fact, a process for the creation of such real images already exists, he asserts, and has been practiced by magicians for centuries.

This conjuring trick, Youngblood explains, is known as "The Illusion of the Rose in the Vase" and all that is needed to produce such a real image in space is the combination of a lens, a concave mirror, and a pinhole light. What the viewer experiences when looking at the concave mirror is a floating image or phantomatic object that seems to exist in actual three-dimensional space as the focal point of reflected light rays lies *in front* of the mirror's surface, rather than behind it as in the case of a regular, flat mirror. Little did Youngblood know that Jacques Lacan had used the very same mirror trick of the inverted bouquet to expose the self-deception at work within the psychic processes of identification.[64] But more on this below. The hologram, Youngblood maintained, stood in service of truth not deception. Holographic technology that would soon produce real images that are incapable of telling a lie. Just ask the experts: as "Dr. Wuerker of TRW Systems group" asserts, when you watch a holographic movie "your own eyes are the lens, just as in reality ... [hence] holograms cannot be doctored ... you won't be able to pull the tricks that are in movies or on TV because holography is too dependent on actuality." Real images, indeed.

Throughout this text, Youngblood sounds very impatient, but it appears he had a valid reason to be so. The future seemed already in the make as his book went to press. On its last pages he describes the trial run of an inflatable, mirrorized dome that Experiments in Art and Technology (E.A.T.) was developing for the Pepsi-Cola Pavilion at the Expo'70 in Osaka.[65] "An astonishing phenomenon occurs," Youngblood writes, "inside this boundless space that is but one of many revelations to come in the Cybernetic age: one is able to view actual holographic

images of oneself floating in three-dimensional space in real time as one moves about the environment." What does this epiphany of the real image signify to Youngblood? That technology as such has become a means of self-realization: "only through technology is the individual free enough to know himself and thus to know his own reality." For him technology becomes a means toward self-realization (i.e. the real image) because the apparatus as such (the catoptrical device) is able, or so it seems, to create alternative worlds. The technological medium functions both as an *environment* that sustains a way of life and an *instrument* that differentiates a form of life. In other words, Youngblood conceives of technology as a *dispositif* of subjectivation that not only modulates us, but somehow we are able to modulate in turn.[66] This celebration of information society as a kind of auto-poietic machine might remind us, once more, of Deleuze's physical revulsion at the notion of universal communication. Yet let us look a bit closer at the nature of this looped pathway, which E.A.T.'s pavilion, according to Youngblood, helps to engrave upon the circuit board of society. For what is presented here in the shape of an inflated, mirrorized dome, developed from the "synergetic technologies of computer science and polyvinyl chloride (PVC) plastics," is nothing less than the social diagram of its own historical moment.

The Pepsi Pavilion was not revolutionary in all its aspects. Referring back to the earlier link that he made between expanded cinema and the space program and their joint exploration of "the larger spectra of experience," Youngblood notes that NASA had already experimented with the construction of mirrorized, Mylar spheres in developing the Pageos and Echo satellites. Yet, after establishing this pedigree of the Pepsi Pavilion within the military and communications industry, he believes it is necessary to point out the obvious: "one could not enter them" (i.e. the satellites). Indeed, the Pepsi Pavilion conflates the outer "dome" of information technology with the interior space of a networked subjectivity: environment and instrument become fused within the "synergetic efforts of all men applying all disciplines."

It requires no stretch of our imagination to move from Youngblood's concept of the "synergetic Pageos,"

cooperative forces of mental labor at work in E.A.T.' s project to Karl Marx's notion of the general intellect. Although in taking this step, we will obtain a quite different perspective on Youngblood's position. As noted above, the general intellect refers to the exterior, social character of intellectual activity, which is the principle source of economic productivity in post-Fordism. What is important to emphasize is that this notion of the general intellect is related to the phenomenon of "real abstraction" whereby an idea becomes a thing, as, for instance, money. And, I should add, a real abstraction is not just an inert thing, but also a thing that seems to be magically endowed with agency, with the power to act independently of human beings. Which, of course, is exactly how Marx described the commodity fetish. But how does the general intellect manifest itself in contemporary society? It does so not merely in the objectified form of fixed capital—say, factory machines—but in the communicative performances of living subjects who are involved in the productive cycles of immaterial labor. It follows that we must consider information technology as both the product of the public intellect and the very medium in which its distributed intelligence operates. For Youngblood, as we have seen, technology has indeed acquired some of this independent power, it has become spirit, in the same way that industrial relations of production had provided the commodity with a spectral presence of its own.

So how might the Pepsi Pavilion be connected to this notion of the general intellect? In the first place, the Pepsi company was one of the first corporations to implement an advertising campaign which leveraged a life style—the famous "Pepsi Generation"—rather than selling a product in the classical sense. The Pepsi Generation commercials were innovative in that they did not attempt, as previous advertisements did, to distinguish the product by means of its price or taste. This explains, in part, why the advertising executives of PepsiCo were willing to take a chance with the pavilion, handing the project over to a group of artists and composers, among which were Robert Breer, Robert Whitman and David Tudor, who, at the time, were completely unknown to the company men. What these individuals had in common, however, was an interest in the staging

of lively, performative events, and the corporate strategy
of PepsiCo, as we will see, had become directed at the
exploitation of "experiences" in order to sell their actual
product.[67] More importantly, however, the design process
and programming of the Pepsi Pavilion provides a good
example of the collaborative, social nature of the general
intellect's mode of production.[68] Not only were various
artists and musicians involved in the design of the pavilion,
but also an extensive team of engineers, scientists, and
architects. The design process was open-ended, with no
preconceived goal. Indeed the planning stage was organized
according to the protocols of the so-called Delphi method,
a system of forecasting based on a collaborative process
of decision-making that was developed by Olaf Helmer at
the RAND corporation.[69]

 Apparently the system did not operate all too
smoothly in the case of E.A.T.'s project. Only after several
inconclusive meetings of the initial planning group was
it possible to settle on a shared concept: the Pepsi Pavilion
was to operate as a kind of multi-sensory, feedback appara-
tus or a "living responsive environment" to borrow a phrase
of the engineer Billy Klüver who was a cofounder of E.A.T.[70]
In other words, the dome was conceived as a social labora-
tory of *affect*—"an experiment in individual experience"—
submitting a steady stream of visitors to an endless modula-
tion of audio-visual stimuli.[71] E.A.T.'s plan was to invite a
succession of Japanese and American artists, choreographers
and composers to operate as joint "programmers" of the
space during a residency period of a few weeks.[72] They were
expected to work in a collaborative fashion in order to
develop a different program of events and performances
every week. The programmers had the ability to manipulate
a multi-channel light and sound system by means of a
control console, placed within the dome, which was con-
nected to a "Master programmer"—an 82-channel punch
paper tape machine in a separate room that was not
accessible to the visitors.

 Unfortunately, there is a lack of substantial informa-
tion on what actually transpired in the dome. After a month,
the contract with E.A.T. was cancelled by the executives of
PepsiCo who had become alarmed by the rising costs of the
project, and, it seems, the provocative nature of some of

the events taking place in the dome.[73] What we do know is that the interior of the dome was equipped with specific features and apparatus which was meant to excite those partial drives of the body that were symbolized by Lacan's "bouquet of *real* flowers" [my emphasis] within his diagram of primary identification.[74] For instance, the center of the floor was built of different materials such as rubber, wood, lead, and stone. The visitors were supplied with a hand-held device that emitted distinctive sounds coordinated to the floor material. For example, above a grassy segment, the visitor heard birds, cicadas, or a lion roaring, above a tile section horses' hooves and shattering glass, and above asphalt, trucks, motorcycles, a traffic jam, and squealing brakes. Also a multi-speaker sound system, using a switching network, was able to create spatialized sound environments. David Tudor, who helped develop the sound system, created oscillating patterns that moved between the speakers, using environmental and microscopic sounds such as fog horns, a beetle walking, ultrasonic bat sounds, earth vibrations, heart beats, and nerve impulses. Thus the body became subjected to a micro-modulation of affective experience. But stimulated in what direction? And what would be the equivalent of Lacan's moment of secondary identification within the environment of the dome?

In his seminar, Lacan figured this secondary process of identification by visualizing a spectator that stood with his/her back to the convex mirror and looked at the reflection of the real image in a plane mirror (i.e. looked at a *virtual* rather than a *real* image). The result of Lacan's optical experiments is to illustrate, as one commentator puts it, "how the ego functions at various levels simultaneously— as container and thing contained, as subject and object, as a mechanism of spatial location and as a displaced and displacing actor trapped in its own identificatory mirages."[75] Secondary identification within the Lacanian scheme of things signifies the originary alienation of the subject that becomes expressed in social relationships of desire, aggression, and competition. But in the case of the E.A.T. pavilion, it is the total interior of the dome, and its cybernetic circuits of regulation, that operate as a means of containment; that is to say, the dome not only replicates the spherical mirror in Lacan's diagram of identification,

but it also functioned, in a more complex and contradictory fashion, as the enveloping vase within Lacan's demonstration. Although one might imagine the dome to be boundless in scale, as an ecstatic Klüver noted, it also had the function to enclose, in more sense than one, the dispersive energies it released.

If the dome's shell functioned as Lacan's concave mirror, it did so on a vastly grander scale, completely enveloping a group of spectators and multiplying their real images several times over. The real images produced by the reflective surface of the dome are inverted, seeming to hang upside down within the interior of the pavilion. The dome produces image worlds to the first, second, and third order and in principle these image worlds may extend indefinitely, but they become increasingly difficult to identify by a spectator standing in the space. More importantly, each spectator sees the real image of another person in a slightly different position due to the effects of spherical aberration. Spectators can walk around the suspended real image of another individual, which appears to materialize in thin air, but they cannot share the same view of the bodily mirage. In fact, as one of the scientists involved in the dome project observed: "if many people on the Pavilion floor point to the same man's image, they will find they are pointing in different directions. This fact, when appreciated by the observer, lends an air of uniqueness and individuality to his images. No two people can have exactly the same image world."[76] Furthermore, due to the sloping floor of the dome, visitors obscured each other's view of what was happening on the floor level. They only had direct access to the reflections hovering above their heads.[77] And, finally, it was possible to exclude the point of view of other spectators altogether by standing in the exact center of the dome: "no matter where you look into the Mirror [sic], you see only yourself ... You see all your own images and, in fact, no one else can see them but you. Your image world is filled solely with yourself."[78] In other words, the specular properties of the dome replicated Lacan's thesis of secondary identification, according to which "you never look at me from the place which I see you," but it also enabled a subject position of primary identification in which I can identify with the externalized image of my own body—as in the famous

"mirror stage"—without being conscious of the location of this "real image" of myself within a visual field that is dominated by the gaze of a transcendent Other.

In this sense, the dome does not conform to Baudrillard's totalizing notion of a hologrammatic space that, as it were, fully occludes the dimension of the real in the Lacanian diagram of identification, but it also does not fully coincide with Youngblood's vision of a "heaven on earth" that, as he writes at the very end of his final chapter on "Technoanarchy: The Open Empire," is on the verge of being realized by the "art and technology of expanded cinema."[79] The split within the visual field according to which, as noted above, "no two people can have exactly the same image world," appears to preempt the singular event, which Youngblood desired and Baudrillard dreaded, according to which the real bodies and real images that comingled in the enclosed, simulated world of the dome became the avatars of that "concrete-abstract" entity of self-regulating thought, which Bateson called the "larger Mind." Considering E.A.T.'s aesthetic politics of cooperation it is perhaps surprising that this fundamental inability of the spectators to share an identical view of the image world within the dome was celebrated by in their publication. As if all suspicion had to be removed that the pavilion functioned as a cybernetic machine of social programming, it was the "uniqueness" and "individuality" of the viewer's experience within the dome that was stressed by most authors.

At the basis of E.A.T.'s project, therefore, a basic contradiction existed between a liberal conception of the human subject as autonomous agent, whose individual freedom must be protected against exterior forces of domination, and a cybernetic conception of the human subject who is only "individuated" as an immanent part of the informational loops of the social system. On the one hand the pavilion was conceived as a complex cybernetic machine which allowed the "programming" of multiple, audio-visual feedback loops between the visitor and the environment, whereas on the other hand any totalizing effect of this program was meant to be counterbalanced by the free movement of the audience through the space. There is, then, a conflict between the emancipatory politics of the pavilion and its cybernetic technology of control.[80]

Yet, there is a further differentiation we need to make.
In so far as the pavilion was conceived as an "open-ended"
experiment with new forms of sociability in a cybernetic age,
it operated predominantly on an affective, rather than
cognitive level.

To illustrate this idea, we may contrast the manner in
which the Pepsi Pavilion (under the directorship of E.A.T.)
served to create a corporeal mode of shared, intensive
experience to the well-known example of the IBM *Think*
Pavilion at the New York World's Fair of 1964–1965, which
was designed by Charles and Ray Eames.[81] The objective of
the multimedia program of *Think* was not only to entertain
the vacationing visitor to the fair, but also to train the future
citizens of an information society, to teach them how to
navigate the torrents of data flooding their way. To think, in
this context, meant to perform a split-second, cognitive act
of pattern recognition that transpired on an almost intuitive
level, below the threshold of self-reflective consciousness.
If the *corporate* medium of expanded cinema contained a
message, therefore, it was that the human brain had to
develop its own bio-rhythmic subroutines in order to keep
up with the violent speed of the computer's algorithmic
processing of digital data. Therefore, in the case of *Think*,
the informatization of society is predominantly linked to
the cognitive and linguistic faculties of the human subject,
testing their adaptability to the new forms of communicative
labor. Indeed, during the *Think* presentation, a live com-
mentator was present to help guide the bewildered specta-
tors through the fast-paced screening.

The program of the E.A.T. Pavilion, on the other
hand, was meant to resist any instructional (and, therefore,
discursive) content. It was intended to "tend toward the
real," as their call for proposals read, and the inclusion of
sociopolitical commentary or pedagogic performances were
strongly discouraged.[82] As Klüver put it, introducing the
theme of individualism that others would employ as well:
"The Pavilion would not tell a story or guide the visitor
through a didactic, authoritarian experience. The visitor
would be encouraged as an individual to explore the envi-
ronment and compose his own experience. As a work of
art, the Pavilion and its operation would be an open-ended
situation, an experiment in the scientific sense of the word."[83]

The viewer was not to be instructed in the manner of *Think*, so much is clear, but what was so new about this open-ended situation that Klüver announces? What is the nonfinite character of the Pepsi Pavilion? Klüver explains his intentions by making a striking observation that distinguishes the Pepsi Pavilion from its 19th century precursors. Whereas previous universal exhibitions functioned as a showcase for the industrialization of society, the Pepsi Pavilion consolidates "a change away from concern for the object—its engineering, operation, and function, and toward aesthetics—human motivation, and involvement, pleasure, interest, excitement."[84] In other words, Klüver-the-engineer appears to be bidding farewell to the industrial fairgrounds of the past, ushering in a new era in which a postindustrial economy is no longer dominated by the manufacture of durable goods, but is directed at the valorization and governance of the inter-subjective faculties of "involvement" and "interest" and the presubjective sensations of "pleasure" and "excitement."[85]

Entrusting these thoughts to paper in August 1970, Klüver could not be aware of their full bearing on the future. However, it is not difficult to comprehend from our present viewpoint how Klüver's statement already points to the emergence of a new stage of capitalist production; that is, to a biopolitical regime of immaterial labor that succeeds, if not completely supplants, a disciplinary regime of industrial production. At this point, life itself enters into the capitalist cycles of reproduction and it becomes all the more remarkable that Klüver even noted with satisfaction that social scientists had expressed an interest in studying the reactions of the visitors to this constantly changing environment, and he marveled at how "the Pavilion became theater conceived of as a total instrument, using every available technology in which the accumulated experience of all the programmers expanded and enriched the possibilities of the space."[86] But before we collapse the complex moment of 1970 all too quickly within a linear narrative of the transition from a Fordist to a post-Fordist society, it is essential to return to my previous comment about the two different modes of immaterial labor: a cognitive or informatized aspect versus a corporeal or affective aspect.[87] With regard to the latter aspect, the historical rise of an information society

reveals itself to have followed a process of complex struggle and resistance. During the 1960s, for instance, the neo-avant-garde, as embodied in the performative activities of Fluxus, Happenings, the Situationist International, Hi Red Center, or, in our present case, expanded cinema, practiced an aesthetic of indeterminacy and immanence in order to defend the potentiality of a "ludic" mode of life, which might counteract the excesses of instrumental reason by catering to the affective needs of the body. The neo-avant-garde understood, if not always with equal clarity, that an aesthetic politics of affect (rather than an ideological politics of representation) could lead to the formation of alternative, collective subjectivities that are no longer submitted to the dominant forces of administration and standardization. And to this end, as we have seen, some neo-avant-garde groups would engage the new possibilities of sensorial micro-modulation that cybernetic technology provided. Yet, as several critics have argued, affective experience would not be immune to the capitalist processes of valorization in the long run.[88] Indeed, such was the ultimate fate of the pavilion in Osaka, after the contract of E.A.T. was cancelled. Subsequently, the pavilion was converted into the pleasure dome of a joyful, if vapid "Pepsi Generation."

In the end, it remains an open question to what extent the cybernetic apparatus of the Pavilion furthered the emancipatory agenda of the neo-avant-garde or fore-shadowed the biopolitical regime of immaterial labor. The Pavilion kept its underlying contradictions in suspension. Within its seemingly infinite interior, all spatiotemporal coordinates of habitual behavior were meant to fall away. Nevertheless, the programmers were requested to make sure that the visitors would not outstay their individual 15-minute time-slot: "To aid the programmers, a graph in the control room will plot the number of people in the Pavilion at any given time. A given section of the programming may be shortened or lengthened by manual controls. This will add flexibility in affecting the length of stay of the visitors."[89] PepsiCo had to make sure the Pavilion would not open a permanent black hole within the curvature of informational space, which would release time from all means of measurement.

Yet despite the inconclusiveness of E.A.T.'s experiment in the production of affective experience, the main idea that I wish to get across is the following: the real images projected in the Pepsi Pavilion figure as a ghostly manifestation of the "general intellect." The inverted crowd of spectral bodies hovering at the top of the mirrored dome exist as more than mere phantoms. What the Osaka Pavilion proposed was a hologrammatization of life, an *externalization* of techno-scientific consciousness within the *interior* of the dome. Yet Youngblood could only interpret this biopolitical process of control within a mystic framework. For him, technology formed the *noosphere* or "film of organized intelligence that encircles the planet, superposed on the living layer of the biosphere and the lifeless layer of inorganic material, the lithosphere."[90] And he continues to note that the combined minds of all the inhabitants of the globe, which are distributed by a growing intermedia network, "nourish" this spiritual *noosphere* of collective, technological consciousness.

Surplus of the Inside

"Performers will move through the Pavilion as aliens in a human environment or as humans in an alien environment."
—Alvin Lucier[91]

We have seen how the Pepsi Pavilion has assumed the character of a "real allegory" in Youngblood's thought, combining in a paradoxical fashion the notion of a "global closed circuit" and an "open empire." The mirrorized dome is a bounded space, but due to the multiplication of reflections in its exterior it seems, like a planetarium, to expand infinitely outward. In a psychological sense, the inside of the dome seems to surpass its actual perimeter in scale. We face, therefore, yet another topological puzzle in which the relation of inside and outside becomes confused, similar to the manner in which the holographic trope of Youngblood has operated all along.

Yet is this psychological reversal in scale between inside and outside not always the case when we enter an architectural space, if not in such an intense manner as the Pepsi Pavilion made possible? The interior of a building will

always seems to us more expansive than seems possible from the outside. There is always a "surplus of the inside," as Slavoj Zizek has pointed out. Why this phenomenon occurs, he attempts to illustrate by means of the plot of a sci-fi novel by Robert Heinlein and it is only fitting that I end this essay with a counter-myth to Youngblood's own allegorical take on *2001: A Space Odyssey*.

The basic premise of Heinlein's tale is the notion of the multiverse: our world is but one of numerous, parallel worlds that are created by a set of transcendent beings as works of art. On occasion these originators of all worlds, or "universal artists," will dispatch one of their own kind to visit a particular world and, acting as an art critic, to evaluate its state of aesthetic perfection. In this case, a fault has been found in the design of the world that demands repair. The divine art critic informs two protagonists of the story to step into their car and drive home, but under no circumstance to open their window. When they witness an accident, however, they are compelled to roll down their side window and are horrified to see absolutely nothing. That is to say, "nothing but a gray and formless mist, pulsing slowly as if with inchoate life."[92]

The moral of this story is apparent to Zizek: what else can this horrifying, throbbing miasma signify than the Lacanian real, "the pulsing of the presymbolic substance in its abhorrent vitality?"[93] What Heinlein has done, in fact, is to intensify our basic phenomenological experience of being inside a car, which produces a discord or disproportion between interior and exterior. Once we are withdrawn within the car, external objects appear to undergo a mutation. They become fundamentally "unreal" and assume the insubstantial character of cinematic images that are projected onto the window shield. As a result the world outside the car has become "fictional," and it is this very projection of an outside reality that the final scene in Heinlein's story rudely disturbs, emptying out the imaginary screen of fantasy with a roiling, gray fog. As Zizek argues, in a phenomenological (and psychological) sense there is always a *surplus* of the inside in relation to the outside. By secluding ourselves within an interior space, it will always seem to be larger, more vivid than thought possible from the outside. This surplus of the interior is a structural effect of the boundary

itself. Once the barrier comes down, however, the inside—
or fictional world—will become engulfed by the formless
flux of the real. According to psychoanalytic theory, of
course, we continuously dream that we are behind the wheel
of a car. In other words, we move through this world as if
seated within the bubble of an automobile. Hence, when
we think we are awake we are living an illusion: "This social
reality is then nothing but a fragile, symbolic cobweb that
can at any moment be torn aside by an intrusion of the
real."[94] In other words, the psychoanalytic worldview is not
unlike the fictional world of the television sci-fi series *Under
the Dome*: we are all trapped within a translucent hemisphere
which appears to have a will of its own, even if the desires
of this dome, the demands it places on us, must remain
opaque and mysterious.[95]

Curiously, the exterior of the Pepsi dome was
shrouded in a white cloud of vapor. The Japanese artist,
Fujiko Nakaya, had been employed to transform the geodesic
dome into a "fog sculpture"; that is, to create a "fog to walk
in, to feel and smell, and disappear in."[96] This is formless
mist, which, on occasion would drift into other areas,
causing neighboring pavilions to complain. On the inside,
everything was transparent. The inverted, holographic
projections of the viewers floating within a silvery expanse,
surrounded by the whispering of alien voices, produced
by a computerized sound system. Within the hemisphere,
if the visitors listened attentively enough, they might have
recognized the murmur of Bateson's "larger Mind," or
what I have called the general intellect, as if they inhabited
the cranial dome of the control society as it slowly came
to life, creating specters out of us all.

48 – 49

[1] Jean Baudrillard, "Holograms," *Simulacra and Simulation*, University of Michigan Press, Michigan 1994 [first edition: *Simulacres et simulation*, 1981], p. 105.

[2] Comment by Charlie Holloway, one of the two archaeologists aboard the *Prometheus*, after being instructed by a hologram of his employer to inform the crew about their mission.

[3] Gene Youngblood, *Expanded Cinema*, E.P. Dutton, New York 1970, p. 146.

[4] I am thinking here, among others, of the work of Eyal Weizman whose crucial study, *Hollow Land: Israel's Architecture of Occupation* contains a pun on the "hologram" in its title and also such recent projects as *Forensis* at the Haus der Kulturen der Welt in Berlin, which explored the role of three-dimensional imaging technologies in order to challenge "the prevalent status of forensics in articulating contemporary notions of public truth." Eyal Weizman, "Introduction," *Forensis: The Architecture of Public Truth*, Sternberg Press, Berlin 2014, p. 9.

[5] Gilles Deleuze, "Postscript on Control Societies," *Negotiations*, Columbia University Press, New York 1995 [first edition: *Pourparlers*, 1990], p. 177–182.

[6] For more on the topic of feedback loops and their deployment within the visual arts during the 1960s and 70s see, among others, David Joselit, *Feedback: Television against Democracy*, MIT Press, Cambridge, Massachusetts 2010; William Kaizen, "Steps to an Ecology of Communication: *Radical Software*, Dan Graham, and the Legacy of Gregory Bateson," *Art Journal 67*, no. 3, 2008, p. 86–106; Branden W. Joseph, *Beyond the Dream Syndicate: Tony Conrad and the Arts After Cage*, Zone Books, New York 2008; and my "Topological Pathways of Post-Minimalism," *Grey Room*, no. 25, Fall 2006, p. 33–63.

[7] Gilles Deleuze, "Control and Becoming," *Negotiations*, p. 175.

[8] Deleuze, "Control and Becoming," p. 175.

[9] Jean Baudrillard, "The Implosion of Meaning in the Media," *Simulacra and Simulation*, p. 79.

[10] Baudrillard, "Holograms," p. 106. See also my comments under note 60 below.

[11] The term "spectrogenesis" derives from Jacques Derrida, *Specters of Marx*, Routledge, London 1994.

[12] Youngblood, *Expanded Cinema*, p. 145. The influence of Marshall McLuhan's thought on Youngblood is obvious in passages such as these, even though the former argued that television was a "participatory" medium. However, both maintained that the "instantaneity" and "simultaneity" of media technology would prove sufficient to overcome the restrictions that held previous generations captive to an ideological regime of representation. According to this position, in other words, media technology "automatized" ideology critique.

[13] Youngblood, *Expanded Cinema*, p. 145, 146.

[14] Ibid., p. 143.

[15] Ibid., p. 146.

[16] On the concept of self-processing in video art, see my "Topological Pathways of Post-Minimalism."

[17] Youngblood, *Expanded Cinema*, p. 141.

[18] Drawing upon a well-known, contemporary review of Kubrick's movie by Annette Michelson that appeared in *Artforum*, Kenneth White provides an alternate reception history of *2001: A Space Odyssey*, which is linked to the work of the "structural" filmmaker Michael Snow. However, White situates his argument in relation to the same social diagram of control that is examined in these pages. See Kenneth White, "Strangeloves: *From/De La Région Centrale*, Air Defense Radar Station Moisie, and Media Cultures of the Cold War," *Grey Room*, no. 58 (forthcoming).

[19] Saint Max is the name given by Karl Marx to Max Stirner in *The German Ideology*. Stirner's quote can be found in the "Apparition" section of Chapter Three of the *German Ideology*.

[20] Youngblood, *Expanded Cinema*, p. 41. There is no need to interrogate what such an eclectic thinker as Youngblood exactly means here by "consciousness," but most likely he would embrace a "posthuman view" that, according to N. Katherine Hayles, "privileges informational pattern over material instantiation, so that embodiment in a biological substrate is seen as an accident of history rather than an inevitability of life," and considers consciousness not as the Cartesian seat of identity, but "as an epiphenomenon, as an evolutionary upstart trying to claim that it is the whole show when in actuality it is only a minor sideshow." See N. Katherine Hayles, *How We Became Posthuman: Virtual Bodies in Cybernetics, Literature, and Informatics*, University of Chicago Press, Chicago 1999, p. 2–3.

[21] Bateson, "Form, Substance, and Difference," *Steps to an Ecology of Mind*, University of Chicago Press, Chicago 2000, p. 468.

[22] Youngblood, *Expanded Cinema*, p. 399.

[23] Dennis Gabor is credited with the discovery of the hologram process in 1947. But it would last until the early 1960s before the process became fully feasible. Two researchers, Emmette Leith and Juris Upatnieks, who worked at the classified military site of Willow Run Laboratories in Michigan, created the first successful, laser-generated hologram of a three-dimensional object in 1963.

[24] The first laser-generated hologram dates from 1963; the product of a laboratory engaged in military research at Willow Run in Michigan.

[25] It is important to emphasize that Youngblood is referring to an, as yet nonexistent, mode of holographic projection, which provides an illusion of a three-dimensional reality without the need of any viewing device. He is, quite specifically, not interested in the phenomenon of stereoscopic cinema or the kind of virtual reality displays, which have more recently become a source of fascination within mass culture. Furthermore, the recent surge of "holographic" events that have been reported in the media, ranging from K-Pop concerts to public speeches by the Turkish President Erdogan, are not the product of *actual* holograms but are optical tricks, such as Pepper's Ghost, which were already part of 19th-century stage craft.

[26] Youngblood visited, for instance, the Hughes Research Laboratories (now HRL Laboratories), where the first operating model of a laser was demonstrated in 1960. Laser light made it possible to construct the first hologram, even though the principle of holography had been known since 1947. Youngblood also talked to researchers at the TRW Systems Group, which built many spacecraft, such as the Pioneer 1 lunar orbiter, that was launched by NASA in 1958.

[27] Sean F. Johnston has published several essays on the technical, military, and cultural history of the hologram. See, among others, "A Cultural History of the Hologram," *Leonardo*, vol. 41, no. 3, 2008, p. 223–229, and "Der parallaktische Blick: Der militärische Ursprung der Holographie," in Stefan Rieger and Jens Schröter (eds.), *Das Holografische Wissen*, Diaphane, Dortmund 2009, p. 33–57.

[28] On this topic, see Jens Schröter, *3D: History, Theory and Aesthetics of the Transplane Image*, Bloomsbury, London 2014.

[29] The Museum of Holography closed in 1992 and its collection is now owned by the MIT museum.

[30] In 2012, the New Museum in New York returned to the history of the "artist" hologram in *Pictures from the Moon: Artists' Holograms 1969–2008*. Interestingly, the contemporary artist Eduardo Kac, who is one of the more vocal supporters of the medium, does not appear to have been included. Alternatively, one might trace a properly "postmodern" genealogy of the hologram to Jean-François Lyotard's exhibition *Les Immatériaux* (1985) at the Centre Pompidou in Paris. This exhibition included a holographic section (entitled *Profondeur simulée*), which was curated by the French structural filmmakers and disciples of Lyotard, Claudine Eyzikman, and Guy Fihman. (I thank the editors of this volume for the reference). However, I am interested in a very different genealogy of the hologram as political technology, which was first brought to my attention by the lecture-performance of Hito Steyerl, "The Body of the Image," which took place at the Berlin Documentary Forum 2, Haus der Kulturen der Welt, on June 2, 2012. For an initial response to this performance, see my "Ghost Stories," *Artforum*, vol. 51, no. 1, September 2012, p. 532–533.

[31] Edward Lucie-Smith as quoted by Johnston, "A Cultural History of the Hologram," p. 225.

[32] If realized in practice, according to Baudrillard, the hologrammatization of the world would collapse the Lacanian triad of the real, symbolic, and imaginary, extinguishing all differentiating forces of desire in the process. According to this scenario, which appears to be modeled on the death drive, the perfect hologram synthesizes a virtual subject in which the distinction between ego-ideal (the Other) and the ideal ego (the imaginary self) is cancelled—"a materialized projection of all available information on the subject"—but in crossing this threshold, where phantasm and reality merge, there is literally no one left to desire anything.

[33] The story is recounted by Walter Benjamin in his "Theses on the Philosophy of History [1940]." See W. Benjamin, *Illuminations*, Shocken Books, New York 1969, p. 262.

[34] Friedrich Engels, "Ludwig Feuerbach and the End of Classical German Philosophy [1888]," in Karl Marx and Frederick Engels, *Collected Works*, vol. 26, International Publishers, New York 1991, p. 382.

[35] The following paragraph draws on Ludwig Feuerbach, "Essence of Religion in General [1845]," in Marx and Engels, *The Essence of Christianity* [1841] as consulted at: https://www.marxists.org/reference/archive/feuerbach/works/essence/eco1_2.htm (last accessed July 2015).

[36] Max Stirner as quoted by Derrida, *Specters of Marx*, p. 159–160.

[37] Derrida, *Specters of Marx*, p. 159.

[38] As Paul Thomas observes: "A reality like the state cannot be abrogated merely by revealing at the level of consciousness its unsound position—although Stirner ... thought that it could," whereas Marx indicated "that alien politics can be abolished only by actively transforming the real world." Paul Thomas, *Karl Marx and the Anarchists*, Routledge & Keagan, London 1980, p. 162.

[39] Youngblood, *Expanded Cinema*, p. 138. Youngblood borrowed this phrase from Buckminster Fuller.

[40] See the so-called "Fragment on Machines" in the *Grundrisse* [1858] and, in particular, the commentary on this passage in Antonio Negri, *Marx Beyond Marx: Lessons on the Grundrisse*, Autonomedia, New York 1991, p. 139–147.

[41] Youngblood, *Expanded Cinema*, p. 399.

[42] It should be noted, in this context, that there is a profound tendency in expanded cinema to materialize images; that is, to provide images with a corporeal presence. One only needs to think here of the projection of filmic images onto the bodies of live performers in,

for instance, Robert Whitman's *Prune Flat* (1965) and Malcolm LeGrice's *Horror Film 1* (1971), or the use of substances such as smoke, inflatable tubing, foam, paint, jelly, powder, and water sprays as projection surfaces in the *Corpocinema* (1967) of the Event Structure Research Group. On the latter, see http://imaginarymuseum.org/imp_archive/AAA/index.html#09 (last accessed July 2015).

[43] Michael Hardt and Toni Negri, *Empire*, Harvard University Press, Cambridge, Massachusetts 2000.

[44] Alexander Trocchi, "Technique du coup du monde," *Internationale Situationniste*, 8 January 1963, p. 48–56.

[45] See Paul N. Edwards, *The Closed World: Computers and the Politics of Discourse in Cold War America*, MIT Press, Cambridge, Massachusetts 1996. See also the various essays collected in *The Whole Earth: California and the Disappearance of the Outside*, Sternberg Press, Berlin 2013.

[46] Youngblood, *Expanded Cinema*, p. 146.

[47] Hardt and Negri, "Network Power: US Sovereignty and the New Empire," *Empire*, p. 160–182.

[48] See Felicity Scott, "Acid Visions," *Architecture or Techno-Utopia: Politics after Modernism*, MIT Press, Cambridge, Massachusetts 2007, p. 185–206.

[49] Branden W. Joseph, "'My Mind Split Open': Andy Warhol's Exploding Plastic Inevitable," *Grey Room*, no. 8, Summer 2002, p. 80–107.

[50] Jonas Mekas, "May 26, 1966," *Movie Journal: The Rise of a New American Cinema, 1959–1971*, Collier, New York 1972, p. 242.

[51] One might propose, therefore, that one social diagram of expanded cinema operates according to a process of positive feedback, working against the establishment of any state of equilibrium within the media system, whereas the other installs a mode of negative feedback in order to establish a dynamic form of self-regulation within collective group of participants. This is not to conflate, of course, the more specific, material differences between the *Movie-Drome* or *We Are All One*. Similarly, I do not want to suggest that one cannot differentiate other political strategies within the expanded cinema movement. Nor do I wish to imply, as Youngblood might seem to, that the geographical purview of expanded cinema is limited to the United States. A full account of the movement (in so far as one can speak of a "movement") would not only have to engage the context of the London Film Co-op and other groups within Europe, such as the Dutch Event Structure Research Group, but also comparable practices of expanded cinema in Argentina or Brazil. However, this would lead beyond the framework of my present argument. For more comprehensive attempts to historicize the field of expanded cinema, see Matthias Michalka (ed.), *X-Screen: Film Installation and Actions in the 1960s and 1970s*, exh. cat., Walther Koenig Verlag, Cologne 2003; A. L. Rees, Duncan White, et al. (eds.), *Expanded Cinema: Art, Performance, Film*, Tate, London 2011; and Andrew Uroskie, *Between the Black Box and the White Cube: Expanded Cinema and Postwar Art*, Chicago University Press, Chicago 2014.

[52] Scott, "Acid Visions," p. 189. It is noteworthy, in light of my comments on the relation of the practice of expanded cinema to the emergence of a control society that former members of USCO would join up with a group of behavioral scientists at Harvard University to form the Intermedia Systems Corporation in order to develop intermedia strategies in the area of education and business.

[53] Stan VanDerBeek, "Culture: Intercom and Expanded Cinema," *Film Culture*, no. 40, Spring 1966, p. 15–16.

[54] Beatriz Colomina, "Enclosed by Images: The Eameses' Multimedia Architecture," *Grey Room*, no. 2, Winter 2001, p. 6–29.

[55] Marshall McLuhan, *From Cliché to Archetype*, Viking, New York 1970, p. 9.

[56] Marshall McLuhan, "At the Moment of Sputnik the Planet became a Global Theater in which there are no Spectators but only Actors," *Journal of Communication*, vol. 24, no. 1, 1974, p. 49.

[57] See Derrida, *Specters of Marx*, p. 170.

[58] Eyal Weizman, "The Politics of Verticality" [2002], consulted at https://www.opendemocracy.net/ecology-politicsverticality/article_801.jsp (last accessed July 2015).

[59] Achille Mbembe, "Necropolitics," *Public Culture*, vol.15, no. 1, Winter 2003, p. 29.

[60] Youngblood, *Expanded Cinema*, p. 348.

[61] Karl Marx, "The Fetishism of the Commodity and its Secret," in *Capital*, Volume 1, Vintage, New York 1977, p. 163.

[62] In "Transformations of the Image in Postmodernity," Fredric Jameson establishes three stages in the history of visuality under capitalism. The final, third stage is announced by "a euphoria of high technology proper, a celebratory affirmation of some post-McLuhanite vision of culture transmogrified by computers and cyberspace." Fredric Jameson, *The Cultural Turn: Selected Writings on the Postmodern, 1983–1998*, Verso, London 1998, p. 110. We can easily map expanded cinema onto this historical moment of techno-euphoria; however, Jameson points out that "the reflexivity implied by the mixed-media or techno-logical works of art is of very brief duration indeed. For … the very sphere of culture itself has expanded, becoming coterminous with market society in such a way that the cultural is no longer limited to its earlier, traditional, or experimental forms, but is consumed throughout daily life itself, in shopping, in professional activities, in the various often televisual forms of leisure … social space is now completely saturated with the culture of the image." (p. 111) The expanding field of the capitalist image becomes apparent in the successive World Fairs of the 1960s—New York (1964), Montreal (1967), and Osaka (1970)—where multi-media displays become more-and-more dominant in the national and corporate pavilions, presenting visitors an audio-visual "experience," rather than exhibiting commercial and technological objects.

[63] Youngblood, *Expanded Cinema*,p. 418.

[64] In his *Freud's Papers on Technique, 1953–1954*, Lacan theo-rizes that the primary level of identification, the ego ideal, is situated at the level of the "real image," i.e. the vase that contains, or binds together, the bouquet of flowers (which represent the heteroclite drives of the body). It is important in this Lacanian scheme of identification that the real image can only be clearly seen if the viewer is positioned in a specific relation to the concave mirror. By introducing a second, planar mirror into the diagram, Lacan then makes the orientation of the spectator within the field of vision dependent on a "virtual" subject—"the other which we are"—who exists outside of us. This virtual subject, or transcendent other, determines, as it were, the incidence of the mirror, thereby determining how well the ego is able to see its own "reflection" and acting as the guardian of the symbolic field of connections between human beings. What Jean Baudrillard seems to suggest in his text on holograms is that the symbolic mediation between the ego ideal and the "virtual subject" is by-passed: the subject externalizes itself in the form of an ideal, hologrammatic ego, thereby annulling the fascinatory operations of the imaginary. To transform oneself into a hologram, or real image, leaves nothing to be desired.

[65] Experiments in Art and Technology was founded in 1966 by engineers Billy Klüver and Fred Waldhauer and artists Robert Rauschenberg and Robert Whitman. For more information on this organization, see http://www.fondation-langlois.org/html/e/page.php?NumPage=306 (last accessed July 2015). I shall not address the historical circumstances of the World's Fair of Osaka at length here. The literature on Expo'70 is rapidly expanding, but for more information on the political and cultural conflicts surrounding this event, see, among others, Yuriko Furuhata, "Multimedia Environments and Security Operations: Expo'70 as a Laboratory of Governance," *Grey Room*, no. 54, Winter 2014, p. 56–79; and Angus Lockyer, "The Logic of Spectacle, c. 1970," *Art History*, vol. 30, no. 4, September 2007, p. 571–589. The *Review of Japanese Culture and Society*, no. 23, December 2011, is dedicated in its entirety to "Expo'70 and Japanese Art: Dissonant Voices."

[66] The aesthetics of environmentalism were strong in the post-Cagean context of the American neo-avant-garde as well as contemporary Japanese art. Indeed there were many connections between the two fields of practice and they were meant to come together in the artistic programming of the Pepsi Pavilion; however,the project was discontinued before it could be fully executed. On the environmental aesthetics of Japanese art, see Midori Yoshimoto, "From Space to Environment: The Origins of Kankyō and the Emergence of Intermedia Art in Japan," *Art Journal*, vol. 67, no. 3, Fall 2008, p. 24–45.

[67] Nevertheless, the collaboration between Pepsi and E.A.T. would not last very long. Within a month of the opening of Expo'70, Pepsi canceled the contract and E.A.T. had to end its scheduled performances. On the aborted program of the Pepsi Pavilion, consult Billy Klüver et al., *Pavilion: Experiments in Art and Technology*, Dutton, New York 1972, and Fred Turner, "The Corporation and the Counter-culture: Revisiting the Pepsi Pavilion and the Politics of Cold War Multimedia," *The Velvet Light Trap*, no. 73, Spring 2014, p. 66–78.

[68] The idea to construct a hemispherical mirror came from Robert Whitman. He had been investigating the phenom-enon of real images by implementing concave mirrors in other installations of the period. Branden Joseph takes up a comparable theme of the spectral in relation to Robert Whitman's work in "Plastic Empathy: The Ghost of Robert Whitman," *Grey Room*, no. 25, Fall 2006, p. 65–91.

[69] The Delphi method relied on a procedure of consensus-building within an elite panel of technocratic "experts" and this method helped found the new prognostic "science" of futurology, which emerged at the same time that the Fordist organization of society was passing into history. Daniel Bell, the ideologue of post-ideology, was one of the spokesmen for this new discipline that was intended to assist governmental, military and corporate institutions in their long-term planning needs.

[70] Billy Klüver, "The Pavilion," in *Pavilion*, p. x.

[71] Ibid., p. xiv–x.

[72] As Billy Klüver explains, "a changing group of four artists (composers, dancers, painters, or scientists) were to reside at the Pavilion at all times." Klüver, "The Pavilion," p. xii–xiii.

[73] Nakaya Fujiko, who created a fog sculpture for the exterior of the pavilion, has claimed that the PepsiCo representatives were particularly shocked by the Butoh performance of Tatsumi Hijikata. For more on the performances in the pavilion, both executed and planned, see Hiroko Ikegami, "'World without Boundaries'? E.A.T. and the Pepsi Pavilion at Expo'70, Osaka," *Review*

of Japanese Culture and Society, no. 23, December 2011, p. 182. Klüver provides very brief descriptions of a few realized programs by, among others, Tatsumi Hijikata, Rikuro Miyai, Pauline Oliveros, and David Tudor, and a number of proposals for live programming are assembled in the back of Klüver et al, *Pavilion*.

[74] Jacques Lacan, *The Seminar of Jacques Lacan*, book 1: *Freud's Papers on Technique, 1953–54*, ed. Jacques-Alain Miller, Cambridge University Press, Cambridge 1988, p. 79.

[75] Barbara Freedman, *Staging the Gaze: Postmodernism, Psychoanalysis, and Shakespearean Comedy*, Cornell University Press, Ithaca, New York 1991, p. 34.

[76] Elsa Garmire, "Overview," in Klüver et al, *Pavilion*, p. 199.

[77] Garmire notes, however, that if the space were filled with the suspended particles of smoke it would be possible for all spectators to share the same image. In that case, the dome would convert into the kind of volumetric display that Baudrillard describes (and was first fictionalized in 1974 as a Holodeck in the Star Trek television series).

[78] Garmire, "Overview," p. 204.

[79] The very last sentence of Youngblood's book proclaims that expanded cinema will establish heaven on earth.

[80] Fred Turner has also drawn attention to how the pavilion was liberatory in its aesthetics, but controlling in its politics: "To free its visitors, the EAT designers built a world over which they could exert constant control. At the same moment at which American soldiers were using electronic sensors and computers to monitor traffic on the Ho Chi Minh Trail, the artists and engineers of EAT were deploying communication and computation technologies to monitor and manage the behavior of audiences at the Pepsi Pavilion ... When they entered the underground cavern called the Clam Room (for its clam-shell shape), a 42-channel punch paper tape machine—a form of computer—coordinated the patterns of the laser light show that surrounded them. When they stepped up into the main, mirrored dome, visitors encountered an array of sound types—from immersive, nondirectional tones to noises moving from point to point. These too were controlled by a computing technology—in this case, Hollerith cards. Finally, a single, 82-channel punch paper tape machine called the Master Programmer governed an array of other systems within the pavilion, from the tape loops in the moving capsules outside to the handset light signals." Turner, "The Corporation and the Counterculture," p. 73–74.

[81] See Colomina, "Enclosed by Images."

[82] Anonymous, "Live Programming for the Pepsi Pavilion: Request for Proposals, October 15, 1969," in Klüver et al, *Pavilion*, p. 280.

[83] Klüver, "The Pavilion," in Pavilion, p. ix.

[84] Ibid., p. xiii. It is helpful to situate this comment in relation to the general context of the Osaka Expo which presented a model for an "information city" of the future. The main architect of the Expo, Kenzo Tange, explained that, "hardware exhibits such as a rock from the Moon, or rockets, are unimportant, for the spectators already know them. What is important is creating a space for information, making people participate and exchange opinions." Tange as quoted by Haryu Ichiro, "Expo'70 as the Ruins of Culture" [1970], *Review of Japanese Culture and Society*, no. 23, December 2011, p. 54. Ichiro's text develops an important contemporary critique of Expo'70, arguing in relation to the traditional, religious concept of mononoke—the spirit of things—that "information functions as today's mononoke, and charms people offering a new form of fetish. The grounds of Expo'70 repeat ad nauseam a blueprint of this mononoke's domination of humanity." (p. 55).

[85] In this respect, the Pepsi Pavilion fitted within the larger context of Expo'70, which presented a model of the "information city" of the future by experimenting, for instance, with automated systems of crowd control. Expo '70 marks the culmination in a shift of the world exhibitions from the presentation of industrial products to the staging of informational technology. Since the previous world fairs of New York (1964–1965) and Montreal (1967) the focus of the fairs had come to reside on multi-media projections and the production of intangible "experiences," rather than the exhibition of physical commodities. Kenzo Tange, the master architect of Expo'70, stated that the purpose of the fair was to "display an environment connected with software, rather than display purely physical hardware." He wished, therefore, to produce a "space without fixed form" that would be like "something resembling clouds." To this end he produced the so-called Space Frame, a triangulated space frame structure, as the anchor point of the so-called Symbol Zone, which was to house the central festivities of the fair. Upon the request of Tange, Isozaki Arata took on the assignment to develop the technical design of the Festival Plaza, an open stage placed under the Space Frame. Isozaki had been closely involved with the avant-garde group Environment Society (Kankyo no kai), which shared the post-Cagean aesthetics of Kaprow's Happenings and Fluxus events. The Festival Plaza was meant to provide a platform for such a democratic approach to culture. As Tange put it: "We wanted the Plaza to be a space of spontaneity, not one where the sponsors alone would have complete control, but a place where the audience too can participate and help create a feeling of swelling movement" ["Some Thoughts about Expo'70: Dialogue between Kenzo Tange and Noboru Kawazoe," in *The Japan Architect* 45, nor 5/6 (May–June 1970), p. 31.] Despite the rhetoric of spontaneity and festivity employed by the Expo organizers, the Festival Plaza would be perceived in a more nefarious light by its critics. In Hyunjung Cho's description "the Festival Plaza was less a conventional building than an immaterial ambiance in which visitors could be immersed in a vast field of perceptual space of light, color, sound, and dynamic movement." Two giant robots, equipped with sensory systems connected to a main control computer, formed the main attraction of the Festival Plaza as they rolled across the stage blowing steam. In relation to the cybernetic urban model of the Festival Plaza, "it could be argued," Cho writes, that the "Festival Plaza func- tioned as a vast control system." ~~Indeed, Isozaki himself~~ would later distance himself from the project, famously claiming that "I felt as though I had participated in executing a war." Despite the massive participation of avant-garde artists in the programming of the various pavilions, Expo'70 was highly criticized within artist circles as furthering a state-endorsed agenda of totalized, social control by means of cybernetic systems. Unless noted otherwise, all quotes are from Hyunjung Cho, "Expo'70: The Model City of an Information Society," *Review of Japanese Culture and Society*, no. 23, December 2011, p. 57–71.

[86] Klüver, "The Pavilion," in *Pavilion*, p. xiv.

[87] On the notion of immaterial labor and its dual, cognitive and affective aspects, see Michael Hardt, "Affective Labor," *Boundary 2*, vol. 26, no. 2, Summer 1999, p. 89–100.

[88] The classic text is Luc Boltanski and Eve Chiapello, *The New Spirit of Capitalism*, Verso, London 2005.

[89] Anonymous, "Live Programming for the Pepsi Pavilion," p. 274

[90] Youngblood, p. 57. The *noosphere* is an idea that was first introduced, of course, by Teilhard de Chardin.

[91] Alvin Lucier, "Program Proposal for Pepsi-Cola Pavilion," in *Pavilion,* p. 299–300

[92] Heinlein as quoted by Slavoj Zizek in *Looking Awry: An Introduction to Popular Culture through Jacques Lacan*, MIT Press, Cambridge, Massachusetts 1991, p. 14.

[93] Zizek, *Looking Awry*, p. 14–15

[94] Ibid., p. 17.

[95] In the television series, which is based on a Stephen King novel, the inhabitants trapped by the dome immediately begin to map the inexplicable phenomenon, building a crude model of their new surroundings. However, as the story progresses, the actual scale of the dome becomes more and more unclear, which is not only due to the fact that dome shows a capacity to contract and expand.

[96] Fujiko Nakaya, "Making of 'Fog' or Low-Hanging Stratus Cloud," p. 207.

Fist Fight (1964) and *Originale* (1961):
Intermedial Tendencies of
Avant-Garde Art in the 1960s
Juan Carlos Kase

Robert Breer, *Fist Fight*, 1964

"What has changed cinema to expanded cinema has been nothing less than the development of whole new conditions and sensibilities spreading across all the arts … Likewise, artists have come to want to work in more than one medium, not just in painting, not just in sculpture. Artists want to work in many media, and to combine many media in one work."
—Sheldon Renan, 1966[1]

In the late 1950s to 1960s, many critics noted a marked shift in the methods and scale of fine art. As Allan Kaprow wrote in his famous essay, "The Legacy of Jackson Pollock," artists were expanding the frames of their work, moving off the canvas into the spaces that surrounded it, marrying painterly instincts with performance, and applying the temporal possibilities of theater, music, and film to the social spaces of fine art.[2] This well-known and well-documented shift in the art world was simultaneous

with similar shifts in experimental cinema. Throughout the 1960s, a trend developed toward the expansion of the materials of cinema, including multiple projection, live performance (music, dance, spoken language), video technologies, television sets, expanded and reformed frames of projection, and increasingly immersive atmospheres. For Renan, this move marked a new chapter in the evolution of experimental cinema that he describes as a shift from the third avant-garde into the fourth avant-garde.[3] It is with this move into expanded forms of film exhibition that my historical discussion here begins.

Some of the most celebrated performance and Happenings events of the 1960s and 70s—most of which have been canonized by the art establishment—incorporated a diverse variety of media that often included film projection (or other filmic elements), including works by Robert Rauschenberg, Claes Oldenburg, Robert Whitman, and Andy Warhol. In addition to the artists who came to mixed-media performance from painting, there was also a significant group of artists trained in experimental music who took part in this intermedial development, including Nam June Paik, Yoko Ono, and Tony Conrad.[4] In the groundbreaking, first book-length survey of American experimental film, critic Sheldon Renan describes the move into expanded forms of cinema as being integrally tied to a significant shift in tone and sensibility across all of the arts.[5] One can see in this cultural moment a heightened synthesis of the materials and representational strategies of myriad art forms including painting, performance, music, and film.

Within film studies, this intermediary episode of expanded cinema, paracinema, and multimedia performance poses significant difficulty to historical assimilation, because it lacks textual accessibility: much of this work can only be known through anecdotal description due to its ephemerality and singularity as live, one-time performance.[6] When cinema was made newly and overwhelmingly performative, as it was in the context of 1960s intermedial experimentation, it lost its claim to textual longevity and instead attained a position of contingency and presence in keeping with other varieties of performance in the era at hand. As a result, much of the live interaction that took place between film and other media in the early-to-mid 1960s has been lost from the

historical record. In the essay that follows, I will suggest that
Originale, a landmark intermedial performance event by
Karlheinz Stockhausen, marks a symbolic transition toward
an increased continuity between cinema and the other arts.

Between Plasticity and Performance: *Originale* (1961)
and *Fist Fight* (1964)

Debuted in the fall of 1964, in the context of Stockhausen's
all-star intermedial avant-garde theater performance,
Robert Breer's film, *Fist Fight* plays a significant symbolic
role in the historical interaction of film and the other arts.
Breer's film draws attention to the anxious and unsure limits
between different artistic traditions while it also presents its
own particularly provocative strategies for assaulting viewers
and unsettling more common artistic strategies within
avant-garde cinema. Breer's film is a wildly heterogeneous
assemblage work loaded with aleatory associations that are
articulated through the forceful use of jackhammer montage.
Both within the textual limits of the film and the extra
textual space of its exhibition, *Fist Fight* forces its viewers
into uncomfortable spaces of confrontation.

In its inclusion within Stockhausen's intermedial
experiment, *Fist Fight* functioned as one component of a
multi-faceted event that summarized—in an approximate
sense—a number of contemporary trends in avant-garde
culture. Breer's performative presentation of the film within
a theatrical work also suggests that the film experiments
of the mid-1960s should be considered in relation, more
generally, to the interactive climate of the avant-garde arts
of the period.

Stockhausen's *Originale* was a semi-theatrical art
spectacle featuring an all-star cast of the New York avant-
garde community.[7] Stockhausen had debuted *Originale* three
years earlier in Cologne in the fall of 1961. Restaged in the
summer of 1964 for the *Second Annual New York Avant-Garde
Festival* (under the leadership of Charlotte Moorman),
the revival combined the talents of a wide range of artists
involved in diverse practices, including experimental music,
concrete poetry, performance, dance, and experimental
film. In *Originale*'s New York revival, artist, performer, and
theorist of happenings, Allan Kaprow served as its director.

Avant-garde composer James Tenney and jazz critic and musician Don Heckman performed on piano and saxophone respectively. Cellist-performance artist Moorman took part in the event (in addition to organizing the festival itself), played her instrument, sometimes while lying on her back. Poets Allen Ginsberg and Jackson Mac Low performed alongside Fluxus artist Dick Higgins and avant-garde classical composer Alvin Lucier. Performance artist, composer, filmmaker, and videographer Nam June Paik enacted a vast array of semi-comic spontaneous gestural actions with his body. And artist filmmaker Robert Breer played the role of "filmmaker" (as notated in the score), shooting live closed-circuit video of the performance and, most significantly for the concerns of the present study, projecting his film *Fist Fight* within the live multimedia event.

As a filmmaker, Robert Breer experimented with a variety of representational modes, though he is primarily known as an animator. His films feature conventionally animated hand-drawn segments (*A Man and His Dog Out for Air*, 1957), while others combine this approach with live action (*Fuji*, 1974), and some occasionally include documentary elements (*Pat's Birthday*, 1962). Throughout his filmography, Breer continuously experimented with heterogeneous methods of production, but in almost all cases, has regularly depended on the particular artistic resources made available by the film-specific technologies of animation. Some of his earliest work featured an unusual, idiosyncratic approach to film composition—a kind of hybrid animation—often composed in the profilmic space of the animation stand upon which he assembled a diversity of materials, including hand-drawn, two-dimensional figures, as well as found objects, collectively sequenced and organized through the use of single-frame photography. This is the compositional strategy that he employed in the production of *Fist Fight*. With this method Breer devised a novel form of visual construction that is in some ways closer to assemblage than it is to drawing. This mode of Breer's filmmaking is both meticulous and spontaneous in its combinations of single-frame composition (which is painstaking and labor-intensive), and collage-based compositional logic (which is aleatory and frenetic). In such works, Breer conceived of a kind of assemblage filmmaking in which the animation stand frames

each discrete visual collage, such that each composition can
occupy a single frame, producing a continuous rushing flow
of mixed-media tableaus.[8] *Fist Fight* is one of Breer's most
exemplary works of this assemblage-animation approach.
In addition to demonstrating some of his signature strategies
and techniques—which blend the rapid, confrontational
style of his montagist filmmaking with a truly modern
assemblage sensibility—the work is also intertwined in the
socio-historical context of intermedial experimentation of
Stockhausen's semi-theatrical, multimedia event. The film
thus has a double-status as it functions textually as a
self-contained experiment in rapid-fire animated montage,
and historically as a meeting point of different performative
energies within the space of the New York avant-garde
of the mid-1960s.

Fist Fight begins with a short prologue featuring images of
the artists who contributed to the performance of *Originale*,
including its composer, Stockhausen, its director, Kaprow,
as well as Paik, Moorman, and Tenney. Like all of the images
in the film, the still photographic portraits pass quickly, and
probably would not be recognizable upon a single viewing.
At times, the photographs are upside down, as with the
film's opening shot, an extremely brief, flipped image of
Stockhausen. Occasionally, there is also camera movement
across them, which creates the illusion of motion despite
the fact that the basic materials of this section are still
photographs. In addition to the images of recognizable and
well-known artists that begin the film, this prologue section
also includes baby pictures of them, which were provided to
Breer specifically for inclusion in *Fist Fight*. Sections of black
leader punctuate the playfully juxtaposed images of the
artists as both adults and infants. The soundtrack features
a choppy blend of fragments of the performance of *Originale*
(separated by abrupt fades) that includes musical segments
from Stockhausen's composition, *Kontakte*, as well as
audience chatter and other ambient elements from the
work's performance at Judson Hall in 1964. When the film
was shown as part of *Originale*, it had no soundtrack; Breer
added this documentary component later for the film's more
conventional theatrical screenings. In his conversion of
the film from a silent into a sound work, he added indexical

elements of the performance and thus linked its textual space directly to the historical conditions of its performance in *Originale*. Therefore, the revised sound film, as it exists today, references and documents aspects of its original, unique exhibition conditions. It thus contains within it dual historical temporalities.

Following this prologue, the film's tempo of montage quickens. Its images fly by at breakneck speed, such that even after numerous viewings, it is extremely difficult to assess and identify the film's imagery in any remotely comprehensive way. *Fist Fight* presents a wildly heterogeneous blend of extremely diverse materials, including Breer's family photographs, images of playing cards, magazine photographs of celebrities, bits of advertising iconography, Breer's own drawings, brief blasts of hand-drawn animation, children's sketches, scraps of torn paper, decollage, photographs of the artist's gallery shows, and even, most curiously, live action footage of a mouse falling through the air.

In relation to the rest of Breer's filmography, *Fist Fight* is perhaps the most complete statement of his collage aesthetic. The film juxtaposes innumerable images recycled from mass media (the faces of The Beatles), comic books (including *Popeye*), commercial advertisements, as well as original visual material including Breer's drawings (some of which have been recycled from his other films, including images from *A Man and his Dog out for Air*), and scrapbook elements and objects taken from the artist's life. In this regard the film is an unlikely and idiosyncratic blend of original artwork, op art quotation, abstract geometric collage and scrapbook autobiography. And because of its prologue, its soundtrack, and its exhibition history, the film is directly linked to its extratextual conditions in ways that inscribe themselves in the film itself. Through its dizzyingly fast paced single-frame montage, *Fist Fight* combines disparate material elements into a visual frenzy so rapid that it undermines any impression of sequential progress or temporal development. The film's bristling, staccato rhythm patterns its images in such a way as to suggest a total collagic object that, rather than having a developmental structure, explodes continuously in a frenzied perceptual experience of immediacy that overloads the viewer's capacity for visual comprehension.

In describing his films, Breer challenges conventional understandings of both illusionist and theatrical space:

> Hooray for a formless film, a non-literary, non-musical, picture film that doesn't tell a story, become an abstract dance, or deliver a message. A film with no escape from the pictures. A film where words are pictures or sounds and skip around the way thoughts do. An experience itself like eating, looking, running, like an object, a tree, buildings, drips, and crashes. A film that instead of making sense is sense.[9]

In conventional live action cinema, the projection apparatus collaborates with the idiosyncratic biology of the human eye in order to create the illusion of continuous movement; when experiencing live action filmmaking, the viewer sees one second of natural mechanical action when in actuality, what actually exists on the film strip are 24 discreet still images. When projected, the images in *Fist Fight* shift with an extreme speed that often defies legibility due to its intentional disregard for the illusion of continuity that underpins most animation. It is difficult for the viewer to register and comprehend these images, because the film features extended sequences in which every single frame is different and visually discrete: one frame might feature a playing card, the next a family photograph, and the next a drawing of a geometric shape. When projected, these three discrete images occupy only one eighth of a second in total, and thus are virtually illegible to most viewers. Here, Breer's frame-by-frame composition openly defies the continuity to which most animation aspires. It utilizes a radically disjunctive editing style that, instead of creating the illusion of continuity, gives rise to an incredibly frenetic barrage of mostly still and singular visual compositions.

Throughout his filmmaking career, Breer took an interest in demystifying the slight-of-hand technique upon which filmic illusionism depends. In a 1962 interview, he said the following on this topic:

> I got disoriented by the theatrical situation of film, by the fact that you have to turn out the lights and there is a fixed audience, and when you turn out the lights

you turn on the projection light and you project the piece of magic on the wall. I felt that this very dramatic, theatrical situation in some ways, just by the environment of the movie house, robbed some of the mystery of film from itself.[10]

In his efforts to challenge both the illusionism of the moving image as well as the conventional theatrical spectacle of its exhibition, Breer experimented with variations on the filmic apparatus by creating loops for gallery screening, showing his films in atypical venues (as in the happenings context of *Originale*), and creating moving image devices that eschew projection entirely (including mutoscopes and early proto-cinematic devices that, in their relative simplicity, clearly display the apparatus of their visual deception).

Fist Fight incorporates related strategies of demystification in its idiosyncratic methods of composition and assemblage. It is a work that, because of its severe single-frame, visually variegated composition, calls attention to the constructedness of filmic illusionism by jerking aggressively and rapidly between radically different representational spaces. To most viewers this variety of film, because of its feverish, staccato visual pace, would likely be considered unintelligible, if not unwatchable. Against the conventional pleasures of narrative and visual continuity, Breer devised a cinema of extreme restlessness, montage-based disruption, and unrelenting assault. Breer's work in cinema, like that of many postwar experimental filmmakers, willfully tests the medium's representational limits, yet it also balances and integrates the opposing energies of materiality and illusionism. His work openly incorporates seemingly paradoxical aspects of the film apparatus as it simultaneously utilizes its unique capacity to conjure the illusion of movement while affirming its materiality.

Fist Fight's confrontational mode of address, when combined with its astounding diversity of visual objects, obliterates the possibility of any structural coherence like that which is usually privileged by more conventional modes of drama or visual art. Through the dialectical juxtaposition of seemingly contradictory representational strategies, Breer stages an altercation in *Fist Fight* between the contradictory artistic methods of illusionism and self-reflexivity. In his

juxtaposition of the most extreme kind of filmic materiality (single-frame composition) with the most openly illusion- istic film technique (animation), Breer directly confronts two opposing models of experimental cinema, one of which is generally associated with the plasticity of an expressionistic approach, and the other, an illusionistic sensibility linked to more plainly dramatic forms. In this sense, Breer's work stages a breakdown in film material, by openly reminding the viewer, with the jolt of every single discrete frame, that he or she is watching a series of visual objects that have simply been linked through the plastic resources of film editing.

In an essay on filmic illusionism, published in 1972, Annette Michelson identifies what she believes to be the philosophical force of this modernist gesture:

> Central to that sense of renewal in American cinema of independent persuasion was the formal evidence of the manner in which it was nourished and sus- tained, as in the work of Robert Breer, by a tradition extending from the Bauhaus and Dadaism and, as in the work of Stan Brakhage, by Abstract Expression- ism. The guarantee of success seemed, from film to film, to lie in both artists' attempt to rethink the nature of cinematic illusionism, and in doing so to propose new structural modes.[11]

Michelson goes on to argue, in a way that was congruent with the English structuralist filmmakers and theorists of the early-to-mid 1970s, that there was something fundamen- tally political about this desire to expose the material condi- tions that underpin the production of filmic illusionism.[12] Derived in a very general sense from Marxist thought, this variety of argument concerning reflexivity was extremely popular in the 1960s—reflecting, in particular, the influence of Bertolt Brecht's theories of distanciation—and in fact corresponded with Clement Greenberg's claims about medium specificity and the significance of artistic materials as determining influences upon artistic practice. However, Breer challenges the reductiveness of this interpretative model through his use of animation and its open and playful complicity with the most artificial of illusions that cinema

can create. In this respect, *Fist Fight* might best be under-
stood as a filmic realization of the perfect tension between
materiality and illusionism that is always inherent in the
film apparatus itself.

Breer's Expanded Cinema and its Place in History

Because of the film's unusual exhibition history, *Fist Fight*
occupies a two-tiered position, functioning both as a frozen
film artifact and a malleable, contingent performance.[13]
The film's genesis is partially tied to the New York debut of
Karlheinz Stockhausen's multi-media happening. However,
Breer was well underway with the making of *Fist Fight* before
he was asked to incorporate his work into the 1964 perfor-
mance of *Originale*. Breer and his work found their way into
this landmark theatrical presentation through the social
networks of the city's avant-garde. As a painter and sculptor
Breer was represented by the Galeria Bonino, the gallery of
Stockhausen's romantic partner, artist Mary Bauermeister.[14]
(Further evidence of the significant impact of the social
network of the avant-garde is the fact that Galeria Bonino
also represented Nam June Paik.) It was through the inter-
personal web of the art world that Breer met the composer,
and as a result, was asked to contribute a filmic element
for the New York presentation of his work. Stockhausen's
unusual expectations for Breer's contribution are clearly
inscribed in the existing score for *Originale*. It indicates that
a six-minute film be projected in the 79th minute of the live
event. However, it stipulates that the film to be included
in the work would be "made during rehearsals and includes
all of cast. (Not in theater. Not in costume. Portraits for the
most part.)"[15] Contrary to the score's directions, Breer's
film did not actually include any documentary footage of
the rehearsals. However, Breer did make an effort to respond
to this aspect of the score's documentary requirements by
adding the prologue described above. Breer, like the other
contributors to the project, was given significant artistic
leeway.

Stockhausen's piece was not a musical work of the
type usually associated with the composer. Instead, *Originale*
is a hybrid performance event that contains an incredibly
diverse array of other media within it; it has been described

as "a set of dramatic actions conceived in musical terms."[16] Biographer Robin Maconie explains, "In part the exercise is designed to acquaint the composer with the techniques of a related art in which such collaboration is taken for granted, namely theater, and in part to accustom his musicians to the new style of collaboration." The project blends "simple role-playing" with "spontaneous invention on stage."[17] The work's chaotic blend of performative actions was in some ways carefully controlled by specific, arbitrary temporal limits intended to corral the kinetic diversity of visual and sonic actions into contained, modular performance units.

A description follows:

> It consists of 18 scenes in the form of instructions for the dramatis personae carefully placed in timeboxes. Each character's actions, in other words, must take a specified number of seconds or minutes. These scenes are grouped into seven "structures," which may be performed successively as "normal," or simultaneously (up to three at once), or both.[18]

Each of these dramatic scenes featured an artist who would perform as him or herself, in the style and approach associated with his or her medium and artistic identity: a poet recites poetry, a musician plays his instrument, a painter paints on an easel, a camera man films the performance, etc. In this regard, the piece was meant to feature "originals," rather than actors, people recognized for their own unique art-making approaches.

Three years earlier Paik had performed in the German debut of *Originale*. By special request of the composer, Paik returned for the 1964 restaging of the work, playing "action music" with his body, a piano, and various props, which often included unpredictable gestures, such as drinking water from a shoe.[19] Paik's performances were significantly more outlandish than those of the other artists in *Originale*, such that he figures in practically every published review or description of the event. One evening, as a result of his particularly chaotic actions, some audience members handcuffed Paik to the scaffolding on stage, a fact that attests to the wild, interactive social context of this event. In addition to Paik's eccentric gestural contributions,

Originale also featured a number of other unusual performance components. Kaprow's young son played with blocks onstage; scantily clad women tried on clothes; a number of animals milled about (including two German Shepherds, a chimpanzee, and a cage of chickens); Ginsberg read sexually explicit poetry; performers dropped eggs and threw apples; and there were extended monologues from ancient Greek literature and Shakespeare to round out the disjunctive and iconoclastic tone of the event. The sonic and structural basis for the work was a prerecorded electronic piece of music titled *Kontakte*. Then, at the end of the work, in a final gesture of performative provocation, all of the performers turned toward the audience and photographed them with still cameras and flash bulbs.[20]

As one might imagine from the description above, many critics found the work profoundly strange and dysfunctional. *The New York Times'* music critic Harold C. Schonberg reviewed Kaprow's performance of Stockhausen's *Originale*, writing sarcastically, "The evening was a triumph of organization," and then continues to suggest how entirely absurd it was in its riotous diversity of materials and actions:

> Lest you think that the whole is not greater than the parts, consider how the following materials were so cannily used: live musicians (saxophone and percussion, the latter ending up undressed save for red leotard), a walkie-talkie, a film sequence, a piano decorated with flowers and stuff in its innards, a clothes rack, pillows, hi-fi equipment, a newspaper boy, kids erecting constructions from wooden blocks, a big clock, newspaper bits, a scaffolding, the audience itself, apples thrown around, a monologue in Greek, one from Shakespeare, insane laughter.[21]

Near the end of *Originale* Robert Breer projected *Fist Fight* on a small screen within the center of the large scaffolding that delineated the dramatic setting of the work. The temporal structure of *Originale* dictated that each performer's contribution occupy only a finite, predetermined length of time; for this reason the staging area for the work featured a number of clocks distributed throughout it. These conditions applied to Breer's film as well. The filmmaker describes

the unusual performative projection of his film within
Originale as follows:

> At a certain point I walked over to the scaffolding
> where a projector was sitting and turned on the
> projector. There was a movie screen on the stage.
> And the stage was overridden by all the activities
> taking place. The film just started up at a certain time.
> We had an enormous clock, like the clock in Grand
> Central Station, in the middle of the acting space
> that everyone had to refer to on the second, for the
> cue to start. So the film['s projection] had to start up,
> continue to x amount of time and then end, about
> halfway through the film. So, the film never got shown
> in its entirety, which pleased me because I had made
> it too long (with the idea of Cage's, to really obliterate
> the audience!) … As the film started up, lights
> died down on cue and it became the center of focus.
> Actors had all just expired and were lying on the
> floor. As the film went on for a certain amount of
> time, I walked up to the screen and I made myself
> a hoop of paper on a metal frame, like a butterfly net,
> big enough to cover the whole screen, and I took that
> and I walked back to the projector with it. And as
> I remember I had someone following focus. So I took
> the image, I took the screen and moved it up to the
> projector and the image got smaller and smaller.
> And went right back into the projector. It was very
> nice. And I had to step over the actors to do it.[22]

As he explains in this quotation, Breer manipulated the
physical conditions of his film's projection within the
theatrical space of *Originale*. Its scale was entirely dependent
on his physical, bodily presence in the space of the film's
projection. In addition, in other parts of the work Breer
walked around the stage shooting video of the other artists,
while the images were transmitted to a number of closed-
circuit video monitors throughout the space. In Stockhausen's
theatrical (or semi-theatrical) context, Breer's presentation
of *Fist Fight* was flexible, performative, and spontaneous. The
projection of his film was subject to the real-time, in-person
modifications of its creator, and functioned, like the other

elements of the performance, as a variable and contingent component of the work's realization within the social space and time of its public presentation. In this sense, Breer's pliable, moving, performative projection represented an intervention into film exhibition that should, in fundamental ways, affect how we understand and interpret the work as a historical construction.

Within the context of an interactive, multi-artist work of avant-garde theater, Breer's *Fist Fight* provides a provocative case study for the historical analysis of experimental cinema that foregrounds the difference between film (the material substrate of the medium) and cinema (the historical, industrial, economic, and social conditions by which it comes to be experienced in a specific space and time). Most specifically, what this encounter between Breer's film and Stockhausen's multi-faceted theatrical event demonstrates is a telling and perhaps forgotten example of an experimental art hybrid that was not uncommon in the 1960s and 70s. In this era, other American artist-filmmakers explored related intermedial/filmic territory to that of Breer. Tony Conrad, Andy Warhol, Stan VanDerBeek, and Carolee Schneemann, among others, reconceptualized the spaces of film projection as interactive, performative arenas by including uncommon resources, such as improvised soundtracks and live dance or multiple projectors, film loops, and modified exhibition spaces. These developments aimed to expand cinema beyond the controlled parameters of industrially determined and mechanically organized time and space. Since these interventions were ephemeral and contingent in terms of their spatiotemporal realizations they are difficult to recuperate, analyze, or comprehensively understand.

How, ultimately, should the historical understanding of *Fist Fight* be affected by its inclusion within Stockhausen's seminal intermedial experiment? In a very real sense, works like this are cultural objects inscribed in the texture of performance history. Therefore, when situated within the cultural context of avant-garde art, they pose major challenges to the contained textual limitations of conventional film analysis (including those varieties that are particularly dependent on the model of literary criticism).[23] The complex

historical identity of Breer's work perfectly demonstrates such a situation in which the extratextual conditions of its production and exhibition mandate a reconsideration of its function both within the artist's practice and the cultural landscape of avant-garde art that surrounds it and infuses it with its particular socio-aesthetic sensibilities.

Art events like *Originale* were one-time occurrences that cannot ever be replicated in any truly comprehensive way. Yet, if these mixed-media works of expanded cinema were a significant part of the postwar environment of the arts in America, then it must be admitted that they form a chapter that, like performance art, can only be accessed via anecdotal description and scant visual documentation— a situation that is significantly dissimilar from that of most movies, which are generally understood as uniform and repeatable. As a result, this variety of performative mixed-media work remains a difficult object for historical recuperation. Art historian Andrew Uroskie has addressed this problem and its disciplinary implications: "The discursive and institutional promiscuity of moving-image art—its failure to establish itself solely within the discourses of either film studies or art history—has occasioned a critical blindness that cannot be remedied through the simple reintroduction of a few neglected artists or works." [24] As Uroskie suggests, it is essential that these in-between spaces of cultural production, the interstitial zone of works like *Originale*, be reconstituted within some kind of appropriate hybrid historical context, which recognizes the diversity of its materials and the promiscuity of its aesthetic sensibility.

Originale represents a microcosm of the vibrant mid-1960s avant-garde scene in which a diverse array of artists interacted with each other, collaborating within a shared practice that challenged the disciplinary dividing lines between media.[25] Within the context of *Originale*, experimental film played a significant role, not as a minority filmmaking tradition that was a peripheral alternative to Hollywood cinema, but as an integral part of the fabric of postwar avant-garde art practice. In retrospect, *Originale* functions almost as a manifesto (in praxis) of intermedial art and a summary of avant-garde trends that foregrounded indeterminacy, arbitrary framing structures, and spontaneous

performance. It also forces us to reconsider the significance of experimental film for American art history during a moment in which the interaction between art forms was raised to a fever pitch by artist-theorists such as John Cage and Allan Kaprow, who presented radically new notions of interactive, intermedial, authorially flexible art.

It seems fitting that Breer took part in an environment of such radical medial diversity. The unpredictable and confrontational exhibition atmosphere of *Originale* was entirely appropriate for *Fist Fight*, an experiment in cinema that posed an open assault on the conventional techniques and conceptual methods of animated films. As a multi-faceted, multimedia artist, Breer worked in a number of forms, including painting, sculpture, motorized technologies, and proto-cinematic devices. With *Fist Fight*, he transposed his interdisciplinary interest in radical juxtaposition into the visual texture of the film itself, as shown in its overwhelming diversity of materials and methods. Visually Breer translates the heterogeneity of his multimedia practice into a radically diverse compositional logic in film, and as such foregrounds some of the most potent, unresolved aesthetic and social tensions of artistic exhibition in the era of the mid-1960s. Ultimately, any consideration of *Fist Fight*, in relation to Stockhausen's intermedial event, necessitates some reconditioning of the tools of film analysis, due to their historical derivation from the study of literature, which is based on concrete, linguistic assumptions about textual stability.

Fist Fight foregrounds a number of significant representational and socio-psychic tensions that underpinned the wider range of avant-garde arts in the period, drawing attention to the fault lines between the art world and an amateur filmmaking community, between artistic strategies that emphasize an expressive, visual plasticity and those that foreground blunt presence, between an understanding of film as an object or artifact and the sense that the medium had performative and communicative possibilities that were substantially more contingent and unpredictable than the contained textual space of conventional film analysis would allow. This aggressive and unstable work embodies a historically embedded variety of anxious and anxiogenic encounter between different cultural and representational registers. Even its title conveys these confrontational

energies. *Fist Fight* comprehensively challenges conventional notions of film pleasure and textual construction, while simultaneously threatening the disciplinary boundaries that surround it. Though it was an exemplary work in this regard, it was not alone in its capacity to enervate viewers and disrupt the traditional conditions of motion picture spectatorship. The international avant-garde's long standing affection for provocation was revitalized by the American experimental film and art communities that surrounded and interpenetrated the socio-aesthetic spaces of Breer's *Fist Fight* and the works that took part in its cultural trajectory.

[1] Sheldon Renan, *An Introduction to the American Underground Film*, E.P. Dutton & Co., New York 1967, p. 228.

[2] Allan Kaprow, "The Legacy of Jackson Pollock," in Jeff Kelley (ed.), *Essays on the Blurring of Art and Life*, University of California Press, Berkeley 2003, p. 1–9.

[3] Renan explains this transition to a new chapter in experimental cinema as marking a significant break from the conventional modes of film production and exhibition that dominated earlier works of the avant-garde that were "produced primarily in the way that all films have been produced (in the way that even the films of Lumière and Méliès were produced)." Instead this idea of cinema began to feel outmoded and filmmakers "have attacked it, have fragmented it, and have destroyed the old idea—that the motion picture is a static work, that it is the same every time it is shown [...] Liberated from the concept of standardization, the personal art film in America has pushed on into a fourth avant-garde." (Renan, p. 227–228.)

[4] See Liz Kotz, "Disciplining Expanded Cinema," in Mathias Michalka (ed.), *X-Screen: Film Installations and Actions in the 1960s and 1970s*, Museum Moderner Kunst Stiftung Ludwig Wien/Walther König, Vienna/Cologne 2004, p. 44–57.

[5] See Michael Kirby, "The Art of Time: Aesthetics of the Avant-Garde," *The Art of Time: Essays on the Avant-Garde*, E.P. Dutton & Co., New York 1969. Richard Kostelanetz, *The Theatre of Mixed Means: An Introduction to Happenings, Kinetic Environments, and Other Mixed-Means Performances*, Dial, New York 1968.

[6] The term "paracinema" has been attributed to either Ed Emshwiller or Jonas Mekas. There was an argument on the genesis of this topic at the Society of Cinema and Media Studies conference in 2007 in Chicago, during the panel titled "Cinema by Other Means."

[7] Another major event that would also be worthy of related consideration is *The Expanded Cinema Festival*, held in November 1965 at the Filmmakers' Cinematheque in New York. (However, any significant analysis of this show would greatly exceed the bounds of the present study; it is mentioned here as another example of a noteworthy possibility for future consideration.) Roughly contemporaneous with the New York debut of *Originale*, this event was organized by Jonas Mekas and Fluxus artist George Maciunas. Three significant mixed media pieces were debuted, each utilizing film or film projectors. These formally hybrid events included Robert Whitman's *Prune. Flat.*, Claes Oldenburg's *Moviehouse*, and Robert Rauschenberg's *Map Room II*. Whitman's as well as Rauschenberg's pieces included projected images that interacted with live performers, and Oldenburg's piece utilized a projector without film as well as costume fragments shaped like film cameras. The festival also included work by USCO, La Monte Young, Carolee Schneemann, Terry Riley, Andy Warhol, and Jack Smith.

[8] An animation stand is a mechanical device that includes a flat horizontal, compositional plane (in which the filmmaker places animation cells), as well as lights focused upon this space, and a stand to hold the camera tightly in place. It is a device that can guarantee precision while the filmmaker carefully takes single exposures and makes slight incremental moves between frames, such that motion will be simulated when the film is projected.

[9] Robert Breer, untitled, *Film Culture*, no. 26, Fall 1962, p. 57.

[10] Breer in "An Interview with Robert Breer, Conducted by Charles Levine at Breer's Home, Palisades, N.Y.,

Approximate Date, July 1970," *Film Culture*, no. 56–57, Spring 1973, p. 58–59 .

[11] Annette Michelson, "Screen/Surface: The Politics of Illusionism," *Artforum*, vol. 9, no.1, September 1972, p. 62.

[12] For accounts of the politics of English Structural/ Materialist cinema, see A. L. Rees, *A History of Experimental Film and Video*, 2nd ed., British Film Institute, London 2011; Malcolm Le Grice, *Experimental Film in the Digital Age*, British Film Institute, London 2008; Peter Gidal, *Materialist Film*, Routledge, London/New York 1989; Steven Dwoskin, *Film Is: The International Free Cinema*, Overlook Press, Woodstock, New York 1975.

[13] Again, for this rhetorical formulation see Paul Arthur, "Structural Film: Revisions, New Versions, and the Artifact," *Millenium Film Journal*, no. 2, Spring-Summer 1978, p. 5–13.

[14] This discussion of *Fist Fight*'s genesis is derived from the author's conversation with Breer, Spring 2008, Los Angeles.

[15] Getty Research Institute, Special Collections, Allan Kaprow Papers.

[16] Robin Maconie, *Other Planets: The Music of Karlheinz Stockhausen*, Scarecrow Press, Lanham, Maryland 2005, p. 218.

[17] Ibid., p. 218–219.

[18] Jonathan Harvey, *The Music of Stockhausen: An Introduction*, University of California Press, Berkeley, California 1975.

[19] This phrase "action music" is written on the English score to describe Paik's contributions, as translated by Mary Bauermeister (Getty Museum Special Collections, Allan Kaprow Papers). It was through this performance that Moorman met Paik, forming a bond that would produce some of the most absurdist and controversial avant-garde collaborations of the decade.

[20] Information taken from Kaprow's original score (Getty Museum Special Collections, Allan Kaprow Papers) and Harold C. Schonberg, "Music: Stockhausen's Originale Given at Judson," *The New York Times*, September 9, 1964, p. 46.

[21] Harold C. Schonberg, "Music: Stockhausen's Originale Given at Judson," *The New York Times*, September 9, 1964, p. 46.

[22] Lois Mendelson, *Robert Breer: A Study of his Work in the Context of the Modernist Tradition*, PhD Dissertation, New York University 1978, p. 194.

[23] Art historian Liz Kotz argues that cinema "becomes immeasurably more difficult to theorize when it incorporates live performance elements and strategies drawn from experimental theater ... Yet, however undertheorized, this multidisciplinary profusion was central to many 1960s avant-gardes. This is particularly the case in the United States." (Kotz, "Disciplining Expanded Cinema," p. 45.)

[24] Andrew Uroskie, "Siting Cinema," in Tanya Leighton (ed.), *Art and the Moving Image: A Critical Reader*, Tate Publishing, London 2008, p. 397.

[25] This performance catalyzed another art event, in the form of a protest from a different faction of the New York avant-garde of the period. Involved in this protest were George Maciunas, Tony Conrad, and Henry Flynt. See Branden W. Joseph, *Beyond the Dream Syndicate: Tony Conrad and the Arts After Cage*, Zone Books, New York 2008, p. 153–212. (As Joseph's narrative implies, *Originale* may be better known for the protests that it spawned than for is own aesthetic attributes.)

"Non-institution": Finding Expanded Cinema in the Terrains Vagues of 1960s London
Lucy Reynolds

Annabel Nicolson at Gallery House [March 1973]

"The relationship between the absence of use, of activity, and the sense of freedom, of expectancy, is fundamental to understanding the evocative potential of the city's *terrains vagues*. Void, absence, yet also promise, the space of the possible, of expectation."
—Ignasi de Solà-Morales, "Terrain Vagues"[1]

"A lab is a non-institution. We all know what a hospital, theater, police station, and other institutions have in the way of boundaries, but a lab's boundaries should be limitless."
—Jim Haynes[2]

Terrain Vague

The desire of scholars and curators to assimilate the past in order to orientate and understand current practices and modes of reception in artists' moving image echoes Stuart Comer's argument that, "It becomes increasingly urgent to

identify, exhibit, and understand this hybrid history so we can establish our critical bearings within our rapidly evolving media culture."[3] Exhibitions such as the Whitney Museum's ambitious 2001 exploration of "projected light" works from the 1960s and 1970s, *Into the Light*, and the thorough exposition of postwar expanded cinema seen at the *X Screen* exhibition at MUMOK, Vienna, are both exemplary of rehabilitative projects which have brought the contributions of an earlier generation of artist filmmakers such as Anthony McCall back into the spotlight, and have emphasized the diverse and proliferate use of film and video projection in the spaces of the gallery in the postwar period.

However, despite the best intentions of curators and scholars, a close look at the addresses of where many of these key works were first performed and exhibited underlines the extent to which they are being read, and experienced, out of context. Anthony McCall's celebrated and much restaged *Line Describing a Cone*, for example, was first projected at Artists Space in downtown New York in 1974, an artist-led initiative established to give assistance and visibility to emerging artists existing outside the art market, and which has been the locus for many experimental practices since. Artists Space is indicative of an emergent culture of art spaces during the 1960s and 1970s, often short lived and makeshift, whose modes of operation and ethos defined themselves against those of more major institutions.

This was not simply because the ambiguous hybrids of film, performance, and installation they supported were difficult to situate within, and were marginal to, existing cultural criteria, but because the alternative networks of artists and modes of practices for which these spaces and events were points of convergence, rooted in the anti-establishment politics of the period, chose to identify themselves as marginal to the main institutional and industrial structures of film and art. Furthermore, these spatial conditions of marginality could also be seen to impact on the art itself. As Dougal Sheridan contends, in his study of the repurposing of marginal or disused sites in the urban environment, "the understanding of indeterminate territories as spaces outside hegemony," suggests that these spaces may have a "formative effect" on the nature of subcultural expression, both affirming and reinforcing their marginality.[4]

Sheridan's exploration of indeterminate spaces is indebted to the architect Ignasi de Solà-Morales' formulation of the term *terrain vague,* which has become a fruitful paradigm for theorists, from across a range of disciplines, to understand the resonance of city spaces that exist outside the civic and commercial functions of urban life. It has also proved a resonant notion, as this essay will contend, for exploring the development of an alternative practice of the moving image in postwar London. Can a dialogue be identified between the speculative and experimental forms of 1960s and 1970s expanded cinema, and the makeshift and interstitial *terrain* in which they were devised and presented?

According to Patrick Barron: *"Terrain vague,* indeed, contains within it a multitude of possible connotations, and is thus well suited to serve as a collective term of various subtypes of leftover land within the edges of the pale— boundaries that, as they proliferate, are also increasingly difficult if not impossible to delineate."[5] In this way, *terrain vague* has provided a helpful schema from which to identify the ambiguous spaces which have been generated in the wake of industrialized urbanity: those areas of "antiquated infrastructure and former industrial sites,"[6] which have also been named "loose space"[7] or "indeterminate spaces,"[8] and which have more recently been the sites of transgressive architectural and ecological interventions.[9]

However, as Sheridan's comments intimate, Solà-Morales' term goes further to address the attraction of these spaces to groups for whom the city's *terrain vague* reflects their own experience of disenfranchisement and marginality to the functions of the city. Referring to Julia Kristeva's concept of "strangers to ourselves," Solà-Morales identifies in the unresolved nature of *terrain vague* a strangeness, or otherness, that reflects the alienating effect of urbanity on the individual, drawing to it those who identify themselves as disaffected by the city's unrelenting intensities: "Film-makers, sculptors of instantaneous performances, and photographers seek refuge in the margins of the city precisely when the city offers them an abusive identity, a crushing homogeneity, a freedom under control. The enthusiasm for these vacant spaces—expectant, imprecise, fluctuating— transposed to the urban key, reflects our strangeness in front of the world, in front of our city, before ourselves."[10]

Pinpointing the compelling strangeness of these interstitial sites, Solà-Morales thus portrays *terrain vague* as a space of identification and reflection for the disenfranchised city dweller who looks for "forces instead of forms, for the incorporated instead of the distant, for the haptic instead of the optic, the rhizomatic instead of the figurative."[11] But while Solà-Morales delineates the draw of *terrain vague* as a reflection of the conflicted condition of the "divided individual,"[12] he does not expand on *terrain vague*'s potency as a space of creative appropriation on the part of the artist, when what was once industrial becomes artisanal, as factories are transformed fleetingly into studios, galleries, and theaters.

For Solà-Morales' term not only opens up questions about current conditions and possibilities for urban dwelling, but could also act as a useful tool for reflecting on histories of creative occupation, and how these interstitial, indeterminate places shaped in turn the art practices developed within them, as the indeterminacy of the *terrain vague* is reflected in the hybrid, event-based nature of the work itself. Such, I would argue, is the case with the development of practices of expanded cinema in postwar Britain, Europe, and North America.

Therefore, in order to gain a more profound reading of its histories, we need to situate artists' moving image within these originating spaces of *terrain vague*. For this will enable us to comprehend, not only the first reception and configuration of key works, but to understand the contexts that influenced their conception. As the Artists Space exemplifies, the *terrains vagues* of London and New York afforded new opportunities for making and showing art to audiences beyond the reaches of more official cultural institutions, and it is vital that current restagings and reformulations of artists' moving image in the museum are understood as retrospective *mediations* for an institutional context which bear little relation to the situations in which these works were first exhibited, performed, and encountered. McCall's *Line Describing a Cone* illustrates only too well the problems of this institutional translation, now transformed by digital technology into a very different reading of cinematic duration, in the hushed spaces of major museums, and where its original performance at Artists Space,

displayed, perhaps, in blurry grain in the catalogue or adjacent wall panel, has become merely a seductive proposition of its earlier radicality.

I would like to consider two examples of where the *terrain vague* has played a significant role in fostering new sites for spectatorship and shaping expanded film practices, yet are little acknowledged in the chronologies and curatorial recoveries of British artists' filmmaking: the Arts Lab, situated in the countercultural milieu of late 1960s London, and Gallery House, one of the first London art spaces in the early 1970s to recognize and encourage the growing interest among artists in the film—and nascent video—mediums. I will also refer briefly to 26 Kingly Street, another countercultural space of early significance for the blurring of cultural boundaries, and will acknowledge the importance of the basement of the Better Books bookshop in Drury Lane as the first space to bring together, through the galvanizing energies of its manager, the concrete poet Bob Cobbing, art practices which exceeded the acceptable boundaries of art practice, such as film, performance, and sculptural installation.

Kingly Street: Urban Indeterminacies

The cultural and social conditions of postwar London played a central role in shaping the unique film forms that emerged in London during the late 1960s and early 1970s. And the state of the city itself was to produce the conditions for a cultural underground to flourish. The wide availability of empty buildings in mid-1960s London was a result of postwar delays in housing redevelopment by local boroughs, following the abandonment of much private housing by residents during the war, many of whom did not return to central London in its aftermath. As Anna Bowman notes, London's postwar *terrains vagues* "emerged as a consequence of delays to large scale local authority municipalization and renewal plans, which were disrupted by budget cuts in the 1970s."[13] Robert Hewison also observes the "strange principle," following an initial building boom between 1958–1964, where "it was often more profitable to keep a building empty than let it,"[14] when the developers who had profited during the boom through the availability of cheap land

from local authority compulsory purchase, speculated on rising prices for London land. Coupled with a drop in population, as Londoners chose not to move back after the ravages of the blitz, London itself might be seen as *terrain vague*, a space of indeterminacy, in hiatus between the promise of a bright and affluent future, soon to be curtailed by the oil crisis of the 1970s, and the halted building plans and bomb damage of war. On his arrival in London from New York as a Fulbright scholar in 1964, the artist filmmaker Steven Dwoskin recalled the city as "very dead, very strange ... I was looking for what was going on, but so much was in secluded spaces and there wasn't a kind of network at that time."[15]

However, the buildings lying empty across the capital, which contributed to Dwoskin's experience of blankness and lack at the beginning of the decade, could also be seen as spaces of opportunity, offering in their very makeshift and ad hoc nature Solà-Morales' "space of the possible" for the burgeoning counter-culture to create an alternative network. The need by landlords both commercial and public to fill empty spaces on a temporary basis— whether before demolition, or for tax incentives—appealed to marginal organizations and individuals, concerned either with cultural or activist causes. As Bowman observes, "The organizations were opportunistic, and most developed without any long-term plans but plenty of idealism, and hoped to shape temporarily licensed resources into something more lasting."[16]

In the brief period in which they flourished, both the Arts Lab and Gallery House indeed mark a distinct shift from the mono-cultural configurations of earlier institutions to inscribe instead a counter-cultural indeterminacy into their spatial and curatorial configurations. The challenging of boundaries which they encouraged in their mixed programs of art, film, music, and theater, were symptomatic of the wider challenge to the hierarchies of culture that began in the 1960s, crystallized by Lawrence Alloway writing in 1959, as "the long front of culture." In an echo of Walter Benjamin's prescient essay,[17] and anticipating the debates of postmodernism, Alloway perceived in the burgeoning "mass production techniques" to which art was now subject, the dismantling of traditional hierarchies of elite versus

mass culture; declaring that: "[T]o approach this exploding field with Renaissance-based ideas of the uniqueness of art is crippling. Acceptance of the mass media entails a shift in our notion of what culture is."[18] Alloway's essay refers to the emergent Pop art movement in Britain, with its celebratory engagement with the print media, cinema and television of American consumer culture, yet his remarks look ahead to film and video, not solely as a point of reference within the canvases of Peter Blake or Richard Hamilton, but as a feasible medium for artists.[19]

The dissolution of hierarchies Alloway articulates also reflected the wider societal changes precipitated by economic boom and expanded education in 1960s Britain, which challenged prevailing cultural standards, described by Stuart Laing as "a hierarchical education system (with universities, public schools, and grammar schools at the pinnacle), key quasi-state institutions (including the BBC and the still new Arts Council), and a network of commercial institutions, including 'quality' newspapers, journals, magazines, publishing houses, and theaters."[20] A key figure instrumental in pioneering hybrid practices of sound, film, and sculptural form at 26 Kingly Street, the Arts Lab, and Gallery House, Malcolm le Grice recalls how the 1960s in Britain represented a break with structures of power once dominated by tradition and class, which he termed "old-fashioned, real class conservatism."[21] The pluralistic cultural landscape that emerged fused political sympathy with the student uprisings of 1968, and anti-Vietnam protest with an expression of popular culture. As Le Grice asserts, "The 1960s, its lifestyle, pop, The Beatles, changing fashions, and so on went along with a real desire amongst radical intellectuals to break that class structure … For example, rock music at that time also seemed to share a radical philosophy, a radical political position."[22]

Le Grice's observation that a form of music associated with entertainment such as rock music could take on the dimension of the political corresponds to the questioning of cultural hierarchies characteristic of the period. Thus the 1960s in Britain, buoyed by affluence and the expansion programs of Harold Wilson's Labour government, engendered potent and unprecedented reciprocities between politics, culture (in both its elitist and commercial forms),

and the individual. This meeting of ethics and aesthetics found foremost expression in the values of the counter-culture or Underground movement which burgeoned fleet-ingly in London during the mid 1960s; and who, as Hewison asserts, " ... recognized that cultural categories are also social definitions. Thus its arguments would necessarily be at the same time political and aesthetic."[23]

Indeed, the Underground movement could be characterized as a society running in parallel—but, as its very name suggests, at a subterranean level—to its "straight" counterpart; with its own established economies, societal rules, and moral codes, which, informed by the politics of Marx and Herbert Marcuse, and infused with the philoso-phies of Eastern mysticism, called for a turn away from mainstream norms, to promote what Jeff Nuttall described as a politically inflected "deliberate sell it yourself amateur-ism," whose subcultural markers included the liberalization of drugs, sexuality, and distinctive language and cultural activities.[24] As one-off events in peripheral, temporary spaces, the expanded film forms and collisions of sound, art, and performance that emerged in London from this countercultural context could thus be seen as meeting points of mutual recognition, as an arts culture rethought itself in the era of the cold war and the protests against the bomb.

As part of this pluralistic activity, the unprecedented spatial and conceptual juxtaposition of film with other arts mediums in these spaces of *terrain vague* was to impact on the film practices that emerged from the nascent London Filmmakers Co-operative (LFMC) housed there. For while the underground's explosion of diverse activities may seem at variance with the rigorous antinarrative focus that would later characterize the films to emerge from the LFMC in the early 1970s, it is significant that the LFMC's formative years were spent at the hub of countercultural activities, first at Better Books and then the Arts Lab. In a 1975 interview with Deke Dusinberre, Bob Cobbing remembered the diverse convergence of activities in the basement of Better Books as "very definitely the meeting point for artists of all kinds in London at that time. We might have poetry reading another night and people showing film ... And we had exhibitions there and so people were constantly in for these activities

and meeting each other and it was a very good period for sparking off ideas."[25]

The atmosphere of experimentation and cross-fertilization that Cobbing describes, is also confirmed in Stuart Laing's study of 1960s cultural practice, and his observation that live event became the "paradigmatic form of the counterculture" where "the cultural process ('performance,' 'happening') rather than the fixed product was a central feature of much would-be revolutionary culture of the decade."[26] The focus on the ephemeral which Laing notes may have had its roots in the early predominance of event-based culture such as the poetry readings and musical performances at Better Books,[27] but it also returns us to Solà-Morales' marginalized citizen, and the self-determined turn from traditional art institutions, and conscious resistance to the production of cultural capital required by art's commercial and state-funded sectors that Hewison describes.

A pertinent example of this fertile moment of convergence is apparent in the conception and reception of Le Grice's first expanded work in 1966, *Castle 1*, which was presented "[A]round late 1966 or early 1967,"[28] in a small gallery at 26 Kingly Street in London's Soho, in conjunction with some performances and a film projection piece by the artist Jeffrey Shaw, an artist who had previously shown proto-expanded film installations in the basement of the Better Books bookshop. The event was initiated not through Le Grice's involvement with the nascent London Filmmakers' Co-operative, but with London's experimental music community in his role as a jazz guitarist who often played with Keith Rowe and his improvisational music group, AMM, exploring the improvisational techniques and instrumentation of experimental music forms, such as those being advocated by John Cage, Fluxus, and contemporaries such as Cornelius Cardew, who also played with AMM.

Castle 1's structure could thus be seen as a convergence of influences from contemporary experimental music, the visual arts, and Le Grice's anti-establishment affiliations, rooted here in his readings of Marxist theater, particularly Brechtian methods of alienation and distanciation. The film's use of repeating black and white imagery, which Le Grice describes as "largely drawn from the TV documentary of an

unspectacular kind, but which thematically are concerned with the 'surface' of the industrial institution and political world"[29] also shows his admiration for the screen print collage techniques of Rauschenberg. At the same time, his formal interventions of repetition, re-filming, and reversing the image, employ strategies derived from jazz improvisation and experimental sound art to scramble the messages of consumer comfort that the film was originally designed to convey. The interposition of an intermittently flashing lightbulb hanging in front of the film screen and operated in an improvisational fashion by Le Grice goes further to disrupt the transmission and decipherment of the images, while the sound track disconnected, looped, and repeated out of sync the original music and commentaries from their accompanying image.

Le Grice's first film experiment could be seen to contain the seeds of his future approach to expanded cinema, its loose improvised structure of looping sound, performance, and projection providing a framework in which influences from music, politics, and art could converge. Run by the artists Keith and Hazel Albarn, the mixed media "happenings" and "environments" at their short-lived Artists Own Gallery at 26 Kingly Street between 1966 and 1967 could be read as symptomatic of the diverse nature of the art activities undertaken by galleries of the counter-culture period, as they moved away from more traditional art mediums to explore a multidisciplinary approach.

Non-institutions: The Arts Lab

For if 26 Kingly Street provided an ad hoc space open to the expression of countercultural convergence, Jim Haynes' Arts Lab could be seen as the most consciously and ambitiously wrought spatial articulation of this oppositional subculture in London, reflecting *terrain vague* as a psychological as well as a spatial condition, where, as he described to *Town* magazine in 1966, a year before it opened, the Arts Labs " ... will be completely flexible so that a room which is a cinema one moment will be used for poetry reading the next."[30]

An American ex-airforceman who had stayed on in Scotland after the war, Haynes was a charismatic counter-

cultural figure, already well known for earlier projects such as the Traverse Theatre and the Paperback Bookshop in Edinburgh, before coming to London. Like the Arts Lab, the Traverse and the Paperback Bookshop had both challenged the elitist institutional conditions for culture that Laing outlines, emphasizing culture as a generative, discursive, and event-based phenomenon, which emphasized audience integration rather than the display of artifact or artwork.[31] Extending the pluralist and participatory model he had developed in Edinburgh in a more ambitious direction, Haynes' intent was to employ the example of the laboratory as his blueprint. The lab paradigm evoked the experimental, speculative approach of the scientific test-bed that Haynes intended for his arts space.[32] At the same time, with its reference to chemistry and science, his alternative model might also be seen as an oppositional gesture to the prevailing structures and official validations of British culture, apparent in his stress on the Arts Lab as a "non-institution" where "boundaries should be limitless."[33] Indeed, few examples of this discursive model of cultural integration existed in postwar London prior to the Arts Lab. The Institute of Contemporary Arts combined a bar and gallery that hosted readings and discussions; however as Hewison notes, the atmosphere at the ICA was "inward-looking, cosy and staid," while the size of London caused its literary and artistic network to be "informal and dispersed."[34]

In this sense the Arts Lab could be seen as an attempt in architectural form to break down the class-inflected distinctions between the visual arts, performance, and the written word still dominant in postwar Britain and to assert, what the historian Robert Hewison describes as, "a system (or rather anti-system) of aesthetics," which "wished to destroy artistic categories altogether."[35] Launched in 1967, it housed a gallery, cinema, theater, and café, and became a point of convergence for a diversity of multidisciplinary activities. As the theater critic Ronald Bryden remembered: "It refused to define itself because any definition would have implied limitation … You could drift in at almost any hour of the day or night, eat a huge beef sandwich or a bowl of soup, watch the *People Show* or an Andy Warhol movie, buy a copy of the *International Times* or *Oz*, sign a petition about Biafra, find out where the next demo would start, sit on

the floor under the branches of a lurid pop-sculpture, and meditate on the Vedanta."[36]

This short-lived and vibrant oppositional culture recalibrates Solà-Morales' portrayal of the alienated city dweller's "strangeness in front of the world" as group dynamic, for whom *terrain vague* might offer, not so much succor from strangeness, but spaces flexible enough to reflect these dissolutions of boundaries, and create new spaces for a hybrid art practices: recalibrating mediums such as film as an experiential rather than a figurative form within the broader expression of countercultural sensibility. Against the backdrop of "the extraordinary rich series of events" at Better Books instigated by Cobbing from 1965, David Curtis recalls the film screenings initiated there by the fledging Co-op, from the early avant-garde of Dada and Surrealism, to more contemporary American work by Kenneth Anger, as "a curiously secondhand experience, encumbered by the need to black out the shop, the projector's noise and stray light, and the lack of the presence of an author."[37] Curtis' comments indicate how at odds the fixed conditions required for screening film were with the live, event-based culture that Laing perceives as so paradigmatic of the period. However, Curtis concedes that while incompatible with the spontaneous feel of the Underground approach, film "gains a sense of belonging to a wider cultural movement."[38] As he stresses, " ... the question of context has some relevance here. At Robert Street the Arts Lab philosophy of 'mix all the arts!' meant that film was produced in an environment that might contain performances by Brisley, Schneemann, any of the current fringe theater groups, Jim Ballard's *Crashed Cars* exhibition and so on, 'hot' imagery abounded."[39]

As Curtis' points suggest, *proximity* is key here: not only in the disciplinary juxtapositions he lists, but also in the adjacent spatial configurations of cinema and gallery, which presented opportunities for inter-influences between different media and formal approaches. Le Grice's first opportunity to fuse film with performance and sculpture in *Castle 1* had been afforded by the convergence of the visual arts with experimental music encouraged in the Albarn's short-lived space. At Haynes' laboratory model, and at the Arts Lab, with its emphasis on performance, improvisation,

and live event as the countercultural agency through which
boundaries between the art forms might be dissolved, film
was opened up to a new potential, not only to bring theater
off the screen into the viewing space through performance,
but also to assert a new awareness of the space around the
screen as an integral part of the film experience; this might
extend from the supine seating in the basement space of the
Arts Lab cinema, where mattresses replaced chairs, to the
adjacent spaces of gallery and theater. At the Robert Street
Arts Lab, established in 1968 by some of the original artists
involved at Drury Lane without Haynes' involvement, such
as underground figure John Hoppy Hopkins and Curtis
himself, the derelict state of the building, which required
substantial renovation, enabled them to rethink the spatial
conventions associated to more traditional cultural institu-
tions. Thus, the projection box was situated between the
gallery space and the cinema auditorium, and although the
uses of these spaces remained distinct, projections could
be directed in both directions, into the gallery and into the
cinema. Ian Breakwell, for example, took advantage of this
in *Unword*, his early combination of projection and perfor-
mance in the gallery in 1968. Whereas, for Annabel Nicolson,
a painter then starting to experiment with film, the concep-
tual approach being used by young artists such as Tim
Head and Roderick Coyne in the gallery, "felt quite radical."
The sequential installation which they created, where each
artist responded to the configuration created the week
before, allowed, according to Nicolson, "for movement out
of a static situation of the gallery,"[40] relating to her own
tentative explorations with film, and suggesting new
reciprocities between film and sculpture.

Furthermore, the unconventional layout of these
alternative spaces reconfigured the relationship between
viewer and film image to introduce a reinvigorated form
of spectatorial proximity, which extended countercultural
ideas of the politically activated body of the individual to
encompass the notion of an activated form of perception.
By rejecting conventional seating in favor of tiers of foam
mattresses, the basement cinema at the Drury Lane Arts
Lab could be read as a challenge to the institutional spaces
of cinema and theater, redefining the perceptual relation-
ship between viewer and image within the liberalizing

context of the Underground[41] by blurring the distance
between body and screen, as the cushioned, horizontal
surfaces of the viewing space evoked, as Maxa Zoller has
suggested, a "cinema bed."[42] While Zoller concedes that this
perceptual shift may have been an incidental result of the
cramped intimate conditions of the Arts Lab, "probably
merely a practical solution to the lack of chairs," she rightly
asserts that this new proximity between viewer and screen
"carried political meaning ... which challenged the spatial
and social codes of the traditional cinema screening."[43]
At the Robert Street Arts Lab, spatial juxtaposition also
elided film and visual art for visitors, who had to walk
through the gallery to reach the cinema.

The new forms of spectatorship that flourished in
this brief period may also account for the emphasis placed
on the viewing experience by artist filmmakers such as
Malcolm Le Grice, Annabel Nicolson, Gill Eatherley, and
William Raban. Thus, while Le Grice has sought to distance
his film performances from the "light shows of the 1960s,"[44]
I would argue that his articulation in his 1972 article "Real
TIME/SPACE," of the potential for cinema as an event-
based one rooted in the present moment, where "Real
TIME/SPACE" is *"now* and *here*,"[45] reflects the contingent
immediacy and proximity experienced at countercultural
spaces such as the UFO club and the Arts Lab. At the UFO,
for example, the emphasis was on ambient environment
rather than attention to on-screen content, as Mark Boyle's
light shows projected swirling patterns of colored lights over
the dancers and performers.[46] Similar to the convergence
of moving image and popular music already seen across the
Atlantic in Warhol's Exploding Plastic Inevitable perfor-
mances with the Velvet Underground, the experience of film
no longer remained within the frame of the cinema screen,
but was now distributed across the viewing space, accentu-
ated by the material presence of projection and performer,
and the agency of the freely moving audience. It could be
argued that film's new element of contingency, subject to
the temporal conditions of the space, audience interaction
and the performing body, can be traced in Le Grice own
1970 shadow piece *Horror Film 1*. Moving back through the
audience while two pulsating screens of colored light cast
the artist's shadow in different hues upon the wall, Le Grice's

performative dialogue with his own shadow, like a kind of
dance, evokes the ambience and multi-sensory spectacle
of the period's club culture.

Convergences and Dematerializations: Gallery House

The question of a more participatory experience for the
audience was also at stake in the gallery. The historian Mark
Donnelly refers to "the increasingly prevalent trend toward
an elision of the artistic work and the process of spectator-
ship, with the intention being that spectators would experi-
ence art as a total environment."[47] As 26 Kingly Street
has shown, the galleries most sympathetic to cross-media
practices were those independent initiatives that existed
outside the funding structures of the major public art
institutes and which had emerged as a result of the multidis-
ciplinary convergences of the mid 1960s. It could be argued
that, by the early 1970s, when Sigi Krauss and his codirector
Rosetta Brooks first formulated their plans for Gallery
House, they were more concerned with the convergences
occurring across practices within the visual arts rather than
across art forms, as traditional categories of painting and
sculpture were challenged by emerging conceptual and
"dematerialized" art practices. This new tendency toward,
as Brooks puts it, "a redefinition of the concept of art, of
art's function and its social purpose … "[48] was reflected in
the ambitious three-part *Survey of the Avant-Garde in* Britain
mounted in 1972, which attempted to bring together "the
most important tendencies that make up the art activity of
younger artists in Britain," showing artists working across
time-based media, installation, and performance, like Stuart
Brisley and Stephen Willats.

The roll-call of artists in the *Survey* included many
who had been associated to the Arts Lab, such as David
Medalla, John Latham, and Brisley himself, suggesting that
the "anti-commodity," anti-institutional position of the
1960s noted by Hewison still held currency at the beginning
of the next decade, and that the strategy for rethinking art
practice and art purpose through a practice of subcultural
indeterminacy, by the destruction of traditional art catego-
ries, retained its urgency.

Thus, the increasing prevalence of film and video as a method of challenging existing artistic divisions was strongly reflected at Gallery House, with the last part of their *Survey* devoted to artists working across the medium. Continuous screenings in the galleries and one off screening events attempted to address the diversity of film and video activity then occurring in Britain and internationally: from artists for whom film served a conceptual or documentary function, such as Brisley, to the materialist explorations of practi-tioners associated to the Co-op, such as Le Grice, who presented a film action. The *Survey* attempted to represent a breadth of different international contexts, from the underground context of the infamous *Destruction in Art Symposium*, such as Vienna Actionists Günter Brus and Hermann Nitsch, to film works much more steeped in the discourse of art, such as those by Carolee Schneemann, Anthony McCall, and two films by American minimalist Robert Morris.

However, the critic Richard Cork's disparaging review of the survey, which argued that "as an art form" the moving image "is still in its infancy; and any artist who wishes to encroach on its preserves should be confronted with the label 'handle with care'"[49] reveals the extent to which the British art establishment of the time was still suspicious of film and video in the gallery. Furthermore, LFMC screening programs from the early 1970s show that opportunities to screen artists' film and video in larger institutional spaces such as the Tate usually occurred as adjuncts to main exhibition spaces, often taking place in the context of the education department.[50] As the Arts Council's short lived New Activities committee has already shown, film continued to be understood only in the context of a pedagogic role for the major art institutions, as a form of explanation or context rather than a work in itself.

Gallery House thus offered a unique space of visibility and experimentation for film and video artists existing outside the validation of British public arts institutions as well as the art market. Le Grice stresses that it offered "really the first of the public showings where we experi-mented with installation and performance."[51] Certainly spaces like Gallery House offered the artists associated to the London Filmmaker's Co-operative a rare chance to

screen their films to an audience outside their own tight knit group, and to use the open gallery spaces like a studio where new ideas could be tested out, taking advantage of practical support from each other as necessary, and presenting their films as works in progress with which the visitor could engage, echoing of Haynes' laboratory dynamic of an integrated practice and spectatorship.

The opportunity arose over an intense weekend in March 1973, when Le Grice was given free reign to organize a weekend of "film action" events, and invited his LFMC colleagues Annabel Nicolson, David Crosswaite, Gill Eatherley, and William Raban to join him. For William Raban it was "an unconscious precursor" to Filmaktion, a week of expanded film events at the Walker Art Gallery in Liverpool later that year, and was crucial to the development of his expanded practice. In a later press release for Filmaktion he refers to "the recent 'film action and installation show' at Gallery House" as "the first positive step toward discovering a new direction for presenting expanded films."[52] Certainly the Gallery House events provided momentum for an intense period of expanded cinema activity across the year, which also included events at the ICA as part of the International Festival of Independent Avant-Garde Film as well as Filmaktion in Liverpool.

To their advantage, and that of other artists who created experimental works at Gallery House, was the significant expanse and flexible nature of the spaces, which offered up to 14 rooms over four floors, which could be converted to a range of different situations. Freed from the temporal and spatial constraints of a conventional auditorium-based event, they developed installations in response to the space and the mobile audience, who were encouraged to engage directly with the work and the artist, and become more directly involved in the processes of performance and projection occurring around them. For Gallery House, as well as the New Arts Lab, freedom from rent restrictions enabled them to support experimental practices without the need for commercial sustainability. Before taking on the space at 50 Princes Gate, Krauss, for example, insisted to the director of the Goethe that he be allowed a "free hand," and was not required to charge admission, close the gallery, or censor the artists.

However, it should also be stressed that neither Gallery House nor the Arts Lab received public arts funding to support their running costs, relying instead on the goodwill of individuals working without payment, private benefactors, and sporadic income from ticket sales in the case of the Arts Lab. This lack of public support indicated the Arts Council's slowness during the 1960s to recognize the new hybridity of arts culture, and to reflect its practices in their funding allocation. As Hewison observes, "The Arts Council found it difficult to come to terms with the new forms of art that were being submitted for subsidy, for they did not conform to the old academic discipline of form and practice."[53] Some acknowledgment came in 1968 with the establishment of the New Activities Committee, but its recommendations for a substantial amount to be awarded to artists working outside officially sanctioned art media, through a New Activities and Multi-media panel, was met with obstruction and disapproval by the Arts Council chairman Lord Goodman, and the small amount allocated did not consequently find its way to any of the organizations in question here, despite repeated applications from Haynes, and later David Curtis. As a result, this severely stretched the resources of many individuals involved, suggesting also that long-term sustainability might come at a cost. A 1970 letter from David Curtis to the Arts Council prior to the Arts Lab's closure, unsuccessfully seeking financial support for the cinema, talks about how, without funding, it would be "fruitless to attempt to continue to work on this scale."[54]

However, it could also be argued that this lack of security conferred a certain intensity and common purpose upon the activities of both organizations, which positioned itself in opposition to the cultural remits of government and market alike, and aligned itself to countercultural concerns. Gallery House also gave them access to a new type of spectator, one more attuned to, and expectant of, the mobile and contemplative mode of engagement associated to the art object. As Gill Eatherley remembers: "[A] lot of the pieces we did were actually worked out in the space ... I think that generated a lot of energy and audience interest ... instead of being hidden away in the projection box, you were down there with anyone who came into the gallery and you could talk to them."[55] The suggestive film installation

Sicher Heits, which Eatherley devised and presented in one of the rooms, represents one of the earliest examples of British film installation. Part of a series of film works called *militaresque*,[56] her sober installation combined an experimental electronic soundtrack with slides and film projections of a found film fragment of a missile ready for launch.

Annabel Nicolson's film performance at Gallery House, referred to only as a "spatial projection event," evokes Haynes' laboratory model in its improvised and speculative register. Nicolson remembers: " … looking at the tall windows in the little room I was using and holding up strips of film near the window and moving the shutters to alter the angle of light coming in, so the images were projected onto the wall by natural light … When people came in it was very difficult because I'd been building up a dialogue with the space and the materials, torn fragments of film, pulling them through the slide projector, holding those lenses in my hand, moving things, just in focus."[57] Despite her concern about the intrusion of visitors, the imbrication of artist, space, and her materials captivated some, such that one visitor, David Miller, felt moved to write eloquently to the artist, going so far as to compare "the economy, the slowness, the modest proportions and range, and the quietude" of her work to the music of Morton Feldman.[58]

Opening out her questioning exploration of the properties of film to the gaze of the spectator, Nicolson's low-key confluence of different temporal and spatial elements—from artist presence to the flicker of filmic light play and the daylight streaming from the windows—might indeed be seen as a form of orchestration, which like Feldman or John Cage, used environmental contingency as a determining part of its score, where the visitor was invited to engage not as a bystander, but as another element of Nicolson's creative dialogue. As she later articulated " … it's creating a situation which people can come into and certain resonances can be felt, rather than stating them or projecting them outward. It's very much about inviting people in."[59]

In the loose improvisational orchestration of Nicolson's film performance, accentuating the passage of time and the contingent movement of visitors, light, sound through her temporary make-shift studio, we might thus identify an

exemplar of *terrain vague* articulated as a creative practice. Within the indeterminate environs of Gallery House, once a private townhouse, now briefly customised as a (counter) cultural space, the potency that Solà-Morales perceives in the lack or 'absence' of *terrain vague*, becomes in Nicolson's work, 'the space of the possible.'

And yet, it could be argued that the beguiling qualities that Miller experienced in her film performance were only possible because a trace of the building's temporary and unresolved condition is inscribed within it. For it was not only the boundaries between art forms which were challenged and dismantled within the open ended briefs and open spaces of the Arts Lab or Gallery House. The boundaries between the spaces of production and presentation were also tested as the distinctions melted away between the private and public spheres designated for film and art practice of studio and gallery, darkroom and auditorium. This spatial dissolution closed the gap between the space of making and reception, creating an emphasis on film as experiential and participatory to the extent that the spaces, and roles, of maker and viewer become inextricably, symbiotically fused. Here I feel the efficacy of Haynes' laboratory model is proved, as the improvisations and experiments normally kept private within the walls of the studio assume the dimension of public performance as they are opened up and played out to the spectator. As Nicolson's film performance at Gallery House shows, time is reconfigured to the dynamic of studio processes: with a durational and developmental momentum open to incident rather than preplanning.

Therefore, it is imperative that these spaces of interdeterminacy are considered in the current scholarship of artists moving image, because a study of these indeterminate spaces, neither cinema or art museum, will enable us to resist the misrepresentations which current institutional rehabilitations unwittingly create. The Arts Lab, and Gallery House, as part of London's countercultural dynamic, supported and encouraged the breaking down of boundaries between art forms, enabling early developments of the hybrid practices of film, performance, and installation. And in the dialectic created between their informal structures and the speculative and experimental practices that they

supported and encouraged, moving image and its modes of spectatorship were liberated from the spatial and institutional constraints of both the cinema auditorium and the art museum. Now such a feature of artists' moving image culture, the indeterminacy and promise of a *terrain vague* is inscribed in the loose and improvisational formulations of these pioneering film actions.

[1] Ignasi de Solà-Morales, "Terrain Vagues," in Cynthia C. Davidson (ed.), *Anyplace*, MIT Press, Cambridge, Massachusetts 1995, p. 119–120.

[2] Jim Haynes, quoted in Robert Hewison, *Too Much: Art and Society in the Sixties: 1960–1975*, Methuen, London 1986, p. 124.

[3] Stuart Comer, "Introduction," *Film and Video Art*, Tate Publishing, London 2009, p. 2.

[4] Dougal Sheridan, "The Space of Subculture in the City: Getting Specific about Berlin's Indeterminate Territories," *Field Journal*, vol. 1, 2007, p. 112.

[5] Patrick Barron, "Introduction: At the Edge of the Pale," in Manuela Mariani, Patrick Barron (eds.), *Terrain Vague: Interstices at the Edge of the Pale*, Routledge, New York 2014, p. 6.

[6] Ibid., p. 7.

[7] See Karen A Franck, Quentin Stevens (eds.), *Loose Space: Possibility and Diversity in Urban Life*, Routledge, New York 2007.

[8] J. Groth, E. Corijn, "Reclaiming Urbanity: Indeterminate Spaces, Informal Actors, and Urban Agenda Setting," *Urban Studies*, vol. 42, no. 3, 2005, p. 503–526.

[9] For example, the work of the architectural activist group Stalker, with projects such as *Transborderline*. See Peter T Lang, "Stalker on Location," p. 193–209; Gil M. Doron, "Dead Zones, Outdoor Rooms and the Architecture of Transgression," p. 210–230, both in Karen A Franck, Quentin Stevens (eds.), *Loose Space*.

[10] Ignasi de Solà-Morales, "Terrain Vagues," in Davidson (ed.), *Anyplace*, p. 122.

[11] Ibid., p. 123.

[12] Ibid., p. 122.

[13] Anna Bowman, *Interim Spaces: Reshaping London – the Role of Short Life Property 1970–2000*, Doctoral Thesis, University of Bristol, 2003, p. 83.

[14] Robert Hewison, *Too Much*, p. 58.

[15] Steven Dwoskin, interview with *Illuminations* (unpublished), circa 2002, p. 2. Source: Steven Dwoskin file, British Artists' Film and Video Study Collection, University of the Arts London.

[16] Anna Bowman, *Interim Spaces*, p. 83.

[17] I refer to his 1936 essay, "The Work of Art in the Age of Mechanical Reproduction."

[18] Lawrence Alloway, "Long Front of Culture," *Cambridge Opinion*, 1959, cited in Robert Hewison, *Too Much*, Methuen, London 1986, p. 46.

[19] A more involved discussion of the emergence of Pop art in British culture can be found in Robert Hewison, *Too Much*, p. 41–55.

[20] Stuart Laing, "The Politics of Culture: Institutional Change," in Bart Moore-Gilbert, John Seed (eds.), *Cultural Revolution? The Challenge of the Arts in the 1960s*, Routledge, London/New York 1992, p. 72.

[21] Maxa Zoller, "Interview with Malcolm le Grice,'" in Mathias Michalka (ed.), *X Screen: Film Installations and Actions in the 1960s and 1970s*, MUMOK, Vienna 2000, p. 140.

[22] Ibid.

[23] Robert Hewison, *Too Much*, p. 86.

[24] Jeff Nuttall, *Bomb Culture*, Delacorte Press, New York 1968, p. 182. Nuttall's book gives a detailed account and insight into the rise of the underground and the counterculture in Britain.

[25] Extract from interview with Bob Cobbing by Deke Dusinberre (1975), Maxa Zoller, "1.The Pre-History of the London Co-op: From HAT Film Club to Cinema 65," Aural History, online exhibition for British Artists Film and Video Study Collection, University of the Arts London, www.studycollection.co.uk/auralhistory/part1.htm (last accessed July 2015).

[26] Stuart Laing, "The Politics of Culture: Institutional Change," in Bart Moore-Gilbert, John Seed (eds.), *Cultural Revolution?*, p. 90.

[27] For a more detailed description of Better Books activities, see Hewison, *Too Much*, p. 110–111.

[28] "There was a gallery called 23 Kingly Street behind Carnaby Street which must have been around late 1966 or early 1967 and was doing some things with AMM and Keith Row. I did some performances. And also a guy called Jeffrey Shaw. He made a tube of plastic and filled it with smoke and projected into the smoke. The film itself was like abstract single frame drawings, so the film had very little to do with the projection. I also showed *Castle 1* with AMM and Keith Rowe at Goldsmiths at a multi media happening thing." Le Grice interviewed by Deke Dusinberre (April 22,1975), Maxa Zoller, Unpublished Doctoral thesis, Birkbeck College, 2008, p. 95.

[29] Malcolm Le Grice, LFMC catalogue, 1970.

[30] Richard Gilbert, *Town Magazine*, March 1966.

[31] A more in depth discussion of Haynes' earlier projects is outside the scope of this essay, but can be found in his autobiography, Jim Haynes, *Thanks for Coming!* Faber and Faber, London 1984.

[32] It should be stressed that Haynes' position reflects a tendency among artists and countercultural figures of the period to challenge the prevailing cultural boundaries between art and science, as Billy Klüver's Experiments in Art and Technology (E.A.T.) attempted in America. For a thorough account of the relationship between arts and technology in the 1960s, see Pamela M. Lee, *Chronophobia: On Time in the Art of the 1960s*, MIT Press, Cambridge, Massachusetts 2004.

[33] Robert Hewison, *Too Much*, p. 124.

[34] Ibid.

[35] Ibid.

[36] Jonathan Green, *All Dressed Up: The Sixties and the Counter Culture*, Pimlico, 1998, p. 172. Green gives a more detailed general account of the successes and failures of the Arts Lab than is possible in the scope of this essay. See Green, p. 169–172.

[37] David Curtis, "English Avant-Garde Film: An Early Chronology," *Studio International*, November/December 1975,

revised 1978, republished in Michael O'Pray (ed.), *The British Avant-Garde Film: 1926–1996*, University of Luton, Luton 1996, p. 102.

[38] Ibid.

[39] David Curtis, "English Avant-Garde Film: An Early Chronology," p. 116.

[40] Annabel Nicolson in correspondence with the author, May 2009.

[41] This intent is apparent in the advertising literature for the Arts Lab: "If you like films; poetry, environments, paintings, sculpture, music 'old and new,' food, plays, happenings, People Show, warm flesh, soft floors, happiness; better things through chemistry, or what was once called art then you should probably join the arts lab at once." Barry Miles, *In the Sixties*, Random House, London 2003, p. 210.

[42] Maxa Zoller, Unpublished Doctoral thesis, p. 96.

[43] Ibid.

[44] Malcolm Le Grice, "ICA Expanded Cinema Festival," *Studio International*, no. 978, November/December 1975, p. 226.

[45] Malcolm Le Grice, "Real TIME/SPACE," *Art and Artists*, vol. 7, no. 9, December 1972, p. 39.

[46] Such as the LFMC's inaugural screening event for the launch of the Underground's presses most celebrated organ of dissent, *The International Times* (IT) at the Roundhouse in October 1966, where Kenneth Anger's *Inauguration of the Pleasure Dome*, and Anthony Balch and William Burroughs' *Towers Open Fire* were screened alongside psychedelic rock bands such as Pink Floyd and Soft Machine; in an atmosphere where "2,5000 people [were] dancing in that strange, giant barn. Darkness, only flashing lights. People in masks, girls half-naked ... Pot smoke.' (IT report, quoted in Robert Hewison, *Too Much*, p. 121).

[47] Mark Donnelly, *Sixties Britain: Culture, Society and Politics*, Routledge, New York 2005, p. 103.

[48] Gallery House publicity material, 1972, p. 1. Source: British Film and Video Artists' Study Collection, University of the Arts London.

[49] Richard Cork, Review of *Survey*, 1972.

[50] This was the case, for example, for "Film Structure— Three Evenings" at the Tate in June 1973. The program leaflet, giving details of film evenings organized by Gidal and Le Grice, is headed "Activities Arranged by the Education Department." Source: British Artists' Film and Video Study Collection, University of the Arts London.

[51] Maxa Zoller, "Interview with Malcolm Le Grice," p. 146.

[52] Taken from a press release by Willam Raban for Filmaktion, June 1973. Source: British Artists' Film and Video Study Collection, University of the Arts London.

[53] Robert Hewison, *Too Much*, p. 198.

[54] Source: Arts Lab file, British Artists' Film and Video Study Collection, University of the Arts London.

[55] Annabel Nicolson, "Annabel Nicolson at the Co-op," *Light Years: 20 Years of the London Filmmakers Co-op*, Festival catalogue, London 1986.

[56] The other film works in this series were the three screen film performances *Hand Grenade* (1972) and *Shot Spread* (1973).

[57] Annabel Nicolson, "Annabel Nicolson at the Co-op."

[58] David Miller, "Paragraphs on some films by Annabel Nicolson Seen in March 1973." Source: Annabel Nicolson file, British Artists' Film and Video Study Collection, University of the Arts London.

[59] Mary Prestidge, "Interview with Annabel Nicolson" (transcript), *Seeing for Ourselves*, Channel 4, 1983. Source: the artist.

On Performative Cinema.
On the Films of Roland Sabatier
and Lettrist Anti-Cinema
Érik Bullot

Translated by Miranda Stewart

Roland Sabatier, *Le film (n')est (plus) (qu')un souvenir*, 1975

Cinema today serves many new purposes. It is exhibited in galleries and museums, activated in the shape of installations, disseminated on the screens of mobile phones or computers. So what has become of the medium we know as cinema? Is it now a relic of the past, a museum piece, indissolubly bound to its traditional mode of delivery, or has it been able to break free without totally denying its past and negotiate the terms of its metamorphosis through its various avatars? The recent renewal of critical and historiographical interest in expanded cinema is clearly a direct result of this new state of affairs.[1] Just how far can cinema expand and change? Where does the breaking point lie? Jonathan Walley quite rightly noted the paradoxical dual trend toward both expansion and contraction that characterized expanded cinema in the 1970s. The apparent abandonment of cinema's traditional tools, as in *Line Describing a Cone by Anthony McCall* (1973) and *Yellow*

Movies by Tony Conrad (1973), comes from a questioning of the medium's ontological status.[2] Artworks, in their quest to identify the intrinsic nature of cinema, have become sculptural and on occasion purely conceptual, in singular and unforeseen ways. This reflects the views of Pavle Levi who, in his book *Cinema by Other Means,* regards visual work, poetic scenarios, and performances as films in their own right, albeit disassociated from the parameters of the medium.[3] It is interesting to examine the situation of contemporary cinema in light of this twin movement toward expansion and contraction. Cinema of exhibition has migrated from cinema theater to museum, offering its viewers perambulatory tropism, with frequent use of loops and multiple screens and interplay between cinema and art historical references. Is this the dialectical progression of the medium or its negation in pure and simple terms?[4]

In French there are many meanings of the term *"exposition"* (as in *cinéma d'exposition*/"cinema of exhibition"), ranging from geographical orientation (a site can be well or poorly exposed), to human sacrifice (the body is exposed), radiation (exposure to rays). The term is also used rhetorically to refer to the first part of a work where the author presents his or her argument, known in French as *exposition* or sometimes *proposition*. All these meanings can be used to describe the situation of cinema today, marked as it is by a sense of crisis and the loss of aura that came with digital projection.[5] Let us return to the rhetorical sense. The fragmentation of the parameters of the film medium has given rise nowadays to imaginary or conceptual artworks: linguistic utterances replace films, film directors comment on films as they are screened, attention is focused more on the making of the film than on the object itself through the use of background documentation. Cinema of exhibition is currently experiencing its own expansion through new film presentation modes that are more fragile, more restrained, and lower key, and taking forms such as performances, discussions, and the presentation of film fragments or work in progress.[6] Does exhibiting film as if it were an artwork or an utterance constitute a performative act? Is "to exhibit" a performative verb? Film has moved from picture house to museum, become detached from its original cinematographic apparatus and is now subjected to new technical

configurations—is performance its only way forward? It should be noted that the term "performative" has two meanings: one strictly linguistic, following Austin, whereby performative verbs perform their function through the fact of their very utterance,[7] and a second relating more generally to the field of artistic performance. Nowadays, certain artists and film directors can be seen to espouse performative practice, one that lies at the interface between these two meanings. I would like to develop the idea that there can be performative cinema by examining the works of Lettrist artists, and Roland Sabatier in particular, all of whom have no doubt offered their own concise and precise definition of this particular state of affairs. The cinema of Roland Sabatier combines the dematerialization of the artwork and a certain conceptualism through propositions and projects that are not necessarily concerned with completion, but rather make their statement through their means of expression, one that is midway between destruction, negation, and withdrawal.

1. The Situation of Lettrist Cinema

Roland Sabatier belongs to the Lettrist movement. His early works date back to 1963. Along with Maurice Lemaître, he was one of the first artists of this group to develop a consistent oeuvre of film. It is difficult to describe his work without evoking the context of the Lettrist avant-garde, which emerged at the end of World War II under the leadership of Isidore Isou, and looked beyond the aesthetic field toward a general revolution of knowledge. It is worth noting that most analysis and commentary regarding Lettrist cinema was by Lettrist artists themselves, in keeping with the movement's characteristic tendency to develop its own historiography, couched in a distinctive critical language, with copious use of neologisms, and the publication of manifestos and articles in Lettrist books and journals. Following his film *Traité de bave et d'éternité* (*Treatise on Venom and Eternity*) of 1951, Isou published his *Esthétique du cinéma*. Here, he applied a number of original concepts, including the decisive notions of the amplic (*amplique*) and chiseling (*ciselant*)[8] phases. According to Isou, the arts go through two alternating phases: the amplic, characterized by a wealth of stylistic devices and artistic resources, and the chiseling

phase, in which the medium is destroyed and negated by dissociating its elements atom by atom. Cinema, he says, has entered its chiseling phase, hence the Lettrist strategies of destroying it as a medium, by scraping surfaces and creating *discrepancy*, precisely through dissociating image and sound. Isou seeks to develop the powers of the medium after its disappearance, and the feeling of closure that he expresses is striking. "I announce the *destruction of cinema*, the first apocalyptic sign of disjunction, of rupture, of that *swollen and potbellied* organism that is called film," he states in his film. But Lettrist cinema cannot be reduced simply to the chiseling phase and discrepancy. In 1952 Isou published *Amos ou Introduction à la métagraphologie* (*Amos, or Introduction to Metagraphology*), a book described as a "hypergraphic film" comprising photographs with additional signs in gouache. Hypergraphia consists of an amalgam of visual and linguistic signs, which find filmic expression in book form through a combination of writing, photography, and drawings. Film becomes detached from its cinematographic apparatus to take the form of a book or a sequence of photographs.

In his book *Le film est déjà commencé?* (*Has the Film Begun?*), published in 1952, Lemaître describes the actions to be performed by actors during a particular session, establishing a structural link between book, performance and film.[9] Also worth mentioning are two decisive concepts which find productive expression in the work of Sabatier: "imaginary" or "infinitesimal" art, exhibited in 1956 by Isou, who rarefies sense data in pursuit of intangible or mental expression, akin to conceptual art and super-temporal art. Here the artist proposes a simple creative framework that viewers, who have become users, can exploit to extend or even contradict a particular work, one that is not limited in time.[10] It is interesting to note the way in which Lettrist films try to push at the boundaries of their medium, striving to be a "cinema by other means," in the form of books, photo collage, visual arts, sculpture, not to mention performance and debate. "Cinema is dead, and debate must now become the work," Isou wrote in *Esthétique du cinéma* in 1952.[11] "Debate, an adjunct to spectacle, must become the real drama. This is how to overturn the law of precedence."

2. On Subtraction and Negation

Roland Sabatier explored these different lines of critical
thought regarding "aesthetic polythanasia," which, in Isou's
manifesto, refers to systematic, varied, and complex ways
of destroying and negating the artwork.

> In culture especially, and in art more specifically,
> an *assassination* phase, if it is to be valid, significant,
> and ever-lasting, must mark the closing down of a
> *particular* formal system, if not a *specific* formal sector,
> namely an extremely well-known structure with
> familiar elements.[12]

The act of liquidation presupposes a logical method,
otherwise it is simply a gratuitous act.

> We must replace arbitrary, chaotic, artistic annihila-
> tion by *necessary*, *specified*, *multiple* annihilation. Our
> problem with Malevich's "white page" is that it failed
> to define the cultural or empirical sectors for which
> these destructive data are considered to be *ends*.[13]

Roland Sabatier fleshes out his personal research into the
"necessary, specified, and multiple annihilation that can
account in its negation for the different aesthetic dimensions
of the material, its mechanics, rhythm, and themes" in his
text *Situation de mes apports dans la polythanasie esthétique*
(1967–1974) (*My Current Contribution to Aesthetic Polythanasia*).[14]
The artist, adopting an attitude poised between ironic
detachment and withdrawal, diligently completed this
program with a series of works and deeds designed to "get
rid of the work." The work is abstracted from all visibility,
destroyed or covered over, evoked but not put into practice,
interrupted on the pretext that it is badly painted, quickly
painted, a botched job, a rough draft, a fragment, painted
without concentration or in disgust, messily painted,
a sketch, barely started, half finished, a rough sketch,
a memory. And, at the same time, the artist explores anti-
aesthetic performance with weariness, rejection, and disdain.
His program operates filmically through films
unrealized and forgotten, sketched, described, unfinished,

even destroyed. His cinematographic work effectively strives to suppress or deny the very characteristics of the medium. We can get an idea of what he was attempting to do with cinema if we look at *Œuvres de cinéma (1963–1983)*, a 128-page A4 book, probably photocopied or duplicated, and comprising nothing other than data sheets.[15] Each artwork adopts a standard form, familiar to traditional cinema: original title, date of filming, production, presented in various categories—film format (16 mm, super-8, film/action, video), running time, length (meters), number of reels, silent/sound, black-and-white/color, performers, public certification, and publications. A short description (a script) presents the project. Two items of technical information are not to be found in traditional cinema: "film/action," presented as a possible format, and certification, which reflects the Lettrist insistence on editorial and administrative registration, with a view to establishing the work's historical primacy. The first edition, *Œuvres de cinéma (1964–1978)*, was published in 1978 (with a second edition in 1984). The circumstances of its publication are enlightening. The author, like Maurice Lemaître and Isidore Isou, who obtained their doctorates "for practice-based work" in 1974 and 1976 respectively, was preparing a thesis on "The Internal and External Destruction of art" at the Centre Universitaire de Vincennes under the supervision of André Veinstein.[16] To strengthen his submission, he prepared a first edition of this book in what, he said, was a fairly expeditious manner. *Œuvres de cinéma* was published by Éditions Psi, founded by Sabatier himself in 1963, in order to provide an "independent, flexible editorial framework capable of certifying and disseminating his own works and those of other artists in the Lettrist movement, unbound by any external constraints."[17] This feature is typical of the editorial logic of the Lettrists, who were working to compile archives, and viewed art history as an aesthetic form.[18] Sabatier wanted to use a "cinematographic standard" for this book by choosing a data sheet that would allow him to "separate cinema from visual art." The point was to emphasize the profoundly cinematographic nature of his films, in spite of all appearances to the contrary. Most of his films have no film stock. Sound is made in the theater and running times are indeterminate. Sabatier, writing about Lettrist cinema in general, notes that,

In fact, these films, with their deluge of things from
the past, were, in most cases, unlike what we com-
monly think of as films, for the cinema that emerges
pushes the limits and stands outside cinema. It does
that in its quest to be an *alternative cinema*, constantly
leading the viewer more toward intellectual adventure
than to contemplation.[19]

While it is easy to grasp the idea behind a radical body
of work, pushing at the boundaries of the medium through
screenings of expanded cinema and performances, the
publication of *Œuvres de cinéma* never ceases to surprise.
Most of the sheets describe films that were never made,
performances that did not take place, projects that were
never carried through, set out by way of simple hypotheses,
fulfilling the wish expressed by Édouard Levé: "A book
describes works conceived by the author, but ones that he
did not make."[20] The film's data sheet (the script) has become
the film. So are we looking at what might be termed *paper
film?*[21] This homemade, self-published book, which above all
describes films, the existence of which relies primarily on
their linguistic articulation, falls clearly into the performative
domain. What status do these data sheets enjoy? Roland
Sabatier tends to speak in terms of a project, even if the
status of these documents may call to mind other terms:
score, instruction, or injunction, for example.

> What people choose to call them is a matter of
> indifference to me. I never raised this particular
> problem. Score could also serve as a generic term for
> project, a synonym for project. What should it be
> called? A sheet. It brings together all the different
> components. A kind of guide.[22]

It would seem, however, that the virtual dimension of his
films was not entirely premeditated or intended.

> I wished to position myself truly within cinema, and
> therefore created these films as intellectual concepts.
> There would be some practical issues to make them,
> but no one has ever suggested that I show them.
> Should I have had to show them, I would have

concentrated more on how to present them without losing their anti-cinema nature.[23]

And as he did not show them, he published them. But was this absence of production fortuitous? Could we not interpret publication as a performative act?

3. Performativity

It is striking that Sabatier's cinema often presupposes a script (an utterance, a text, a series of dialogues) as part of its activation. While some films just contain a simple outline of the project, published as a description in book form, others also invoke a second script to be activated at a cinema screening. Can the technical sheet be interpreted as a performative document?

> In this context, a performative document is a document that does not merely fulfill the act of documenting; instead it transforms the way of being—the ontological status—of the subject documented. It turns an ordinary or extraordinary action into an *artistic* action.[24]

The data sheets published by the artist would appear to have this effect. We can distinguish three types of performativity: a data sheet describes a performance based on a second script, following a simple procedure (*Hommage à Buñuel*, 1970); a data sheet describes a performance based on a performative script in accordance with modes of presentation that are complex, labile, diversified, and capable of existing in multiple versions (*Regarde ma parole qui parle le (du) cinéma*, 1982 [*Look at my Words that Speak (of) Cinema*]); a data sheet is a simple performative utterance accompanied by an editorial strategy (*Le film n'est plus qu'un souvenir*, 1975).

A. "The author tells the audience about the film by briefly describing its sound and image. He then ends by saying: 'I am therefore not going to make this film, but try to imagine what it might have been on the basis of the few clues that I have just given you.'"[25] *Hommage à Buñuel*, "a polythanazed hypergraphic film," was presented by

the author at the Cinémathèque Française on April 23, 1970.
This simple description presupposes a second script, read
by the author to the public, describing the imaginary work
that should have been projected. This was a "hypergraphic
film" that combined different kinds of writing and visual
signs forming a rebus.

> As a further example, another image shows a portrait
> of the maker of this film looking viewers in the eye
> *(je)* [I] … / Against a black ground, the syllables
> "PEN" and "SE" *(pense* [think]) … immediately
> completed by an / Image in line with the tail of a cow
> *(Je pense que/Je pense queue* [I think that/I think tail]) …
> / As we saw earlier, this is simply an example to give
> you an idea of the idea behind the film.[26]

The text read by the artist ends with the following words:

> By now, you know as much about the film as its
> maker, and since the latter is not inclined to transfer
> it to film, he asks you to accompany him and enter
> into the further originality of non-realization and
> imagine, as he himself does at certain moments in his
> life, what this film might have been, based on the
> clues that he has just given you. This film will there-
> fore remain as it is, hanging from the lips of Roland
> Sabatier, its producer, forever!

The technical data sheet describes a performance that is
itself performative, which activates the film through its
linguistic utterance in accordance with the principles of
imaginary or infinitesimal art.

 B. Let us now consider a more complex work, *Regarde
ma parole qui parle le (du) cinéma*, from 1982. The film script
comprises a sound section comprising a recital of technical
terms ("close-up, middle shot, close-medium shot … "),
and a visual section that relates a narrative using free
indirect speech.

> A man, no doubt sitting at a café terrace, who later
> turns out to be a filmmaker, perhaps even the author
> himself, speaks, as if giving his personal thoughts

about the general and specific problems besetting
innovative cinema.[27]

There will be references to classic films from the history of
cinema in this reflection on the power of the medium.
The film plays on the inverse relationship between saying
and showing.

> Behold my words that speak of cinema, and you shall
> see my film. While the images that comprise the
> cinema element will be available in spoken form, the
> words talking about cinema will be shown as film.[28]

The sound track, according to the instructions given for
visual effects, is to be recorded and played in the theater at
the same time as the text is read by the viewer. It can be
reproduced on film or on slides, or printed in a booklet and
handed out to the audience. "Originally, I wanted parts of
the text to appear on the screen and for a voice to speak
technical terms such as close-up, etc. I had to abandon that
approach," the artist admitted.[29] As a result, the work has
been through many different versions: graphite drawings,
text printed on cards, photographs on slides and film.
While the author was preparing a version for the Interna-
tional Avant-Garde festival in November 1983, the laboratory
lost the roll of photographs. A replacement version shows
fragments of filmed text, but technical problems render
the text illegible. A final DVD version in 1996 includes
printed inserts and photographs excerpted from films cited
in the film, and the text on the sound track is read by the
author. The lability of the different versions underscores
the performative nature of the script, as if any difficulties
encountered in presenting the film itself, leaving aside
unfortunate circumstances and technical accidents, were
an intrinsic part of the work. "He believed that all he had
to do was say 'cinema' for it to be a film, or nearly a film.
'CINÉMA', and above all 'almost' are the words that best
encapsulate the originality of the film."[30] The work evokes
the register of the almost by developing the notion of "not,"
of virtuality, tenuousness and unobservability, thereby
recalling the figure of Bartleby.[31] *Quasi-cinema*, in the words
of Helio Oiticica.[32] How far can cinema remain itself while

destroying its own constituents? Can its definition proceed via negation and subtraction? "There is no doubt that a film can be fully defined by the words used to describe it" according to Sabatier.[33]

 C. A final example: *Le film n'est plus qu'un souvenir*, from 1975, a "polythanazed film" of variable duration, with no film stock and with various documents and accessories. I quote from the data sheet:

> The author steps toward the public and, sheepishly, announces that he has made a chiseling film, but that this film has just been destroyed and therefore cannot be screened. He ends up offering to replace it with a number of documents bearing witness to its past existence. The new film, which is never named as such, can be found in allusions to the films it is replacing and is reflected in the confused and awkward manner in which various elements (tools, studio photographs, bits of leftover film stock, etc., not to mention counterfeit press cuttings of comments and reviews) are shown. According to the artist, these are all elements related to the absent film or ones that have served to make it.[34]

The performance described was never activated. It exists only as an illocution in *Œuvres de cinéma*. And yet documents exist for this film, notably a photograph which is often reproduced in catalogues, and is captioned "The film is no more than a memory," showing movie accessories (film reel, projector, director's chair, camera, tripod).[35] It could almost be a photograph of a public exhibition, and yet it is actually a photo taken by the artist in his studio in Aubervilliers. For Sabatier, there is virtually no difference. The only thing that matters is the artwork and its date of certification. But can this be seen as a performative photograph that brings a work into existence by laying a trail of false clues that act as fictional triggers? In this respect, the technical data sheet is a paradoxical performative utterance because the film is forever withheld from any kind of visibility. No doubt the data sheet itself raises an element of doubt over the nature of these artworks, poised as they are between the linguistic utterance and its potential activation.

4. On Performativity and Failure

Let us consider another facet of the artist's activity that
clarifies what he understands as performativity. This is his
use of propositions, more frequently referred to as "injunc-
tions," comprising short utterances describing attitudes and
actions designed to "elicit from the interlocutor appropriate
mental representations, deeds, and behaviours."[36] Take,
for example, "Respirez. Tous les composants de cette œuvre
sont contenus dans votre respiration (œuvre infinitésimale
et supertemporelle)" (Breathe. All the components of this
work are contained in your breathing (infinitesimal and
super-temporal work), (1968), and "Soyez discret. Œuvre
d'humilité esthétique" (Be discreet. Work of aesthetic
humility), (1969). These injunctions are written on the pages
of a book of graph paper, a facsimile of which is reproduced
in chronological order in his book *Œuvres infinitésimales
et supertemporelles, injonctions, faits, comportements*, published
in 1984.

> In this natural state, these works, with these acces-
> sible data showing how they operate and are notated,
> are "scores" that contain within themselves the
> countless potential of internalized beauties, which
> will flower in multiple future "performances."[37]

They are, he wrote,

> open to the future, stretching beyond time to grow,
> contradict themselves, change, and yet never reach
> completion, continually absorbing the values of the
> times, gaining in profile through the actions of all
> sectors of the public, through the contribution that
> this very time offers them.[38]

Some of these instructions can also be found in *Œuvres
de cinéma*, such as *Respirez*: "The film consists of handing
out pieces of paper with the words 'Breathe. The film is your
breathing' written on them."[39] Is this a performative? No
doubt it is insofar as Austin draws a distinction between
explicit performatives, for instance the performative verbs to
"bet," "promise," or "bequeath," and implicit performatives.

But, of course, it is both obvious and important that
we can on occasion use the utterance "go" to achieve
practically the same as we achieve by the utterance
"I order you to go" … It may, however, be uncertain
in fact, and, so far as the mere utterance is concerned,
is always left uncertain when we use so inexplicit
a formula as the mere imperative "go," whether the
utterer is ordering (or is purporting to order) me
to go or merely advising, entreating, or what not me
to go.[40]

It is precisely this interplay between the explicit and the
implicit that lies at the heart of Roland Sabatier's films.
Furthermore, a number of these injunctions use the impera-
tive form, while others take the form of signatures. "From
this day on, I SIGN all *voluntary* (demolition, sabotage, etc.)
and *involuntary forms of destruction* (fires, collapse, etc.) of
houses and buildings throughout the world as works of
architectural polythanasia, or works of anti-architecture"
(July 1969), or in a more scriptural register, "From this day
on, I SIGN, beyond their usual meanings, practices, all
(voluntary or involuntary) traces inscribed on all snows in
the world, as symbols in relief of various supra-temporal
chapters of an ephemeral sculpted prose or a work of
ephemeral architecture or a work of fleeting architecture,
entitled: white traces (19 July 1969)." We are aware of the
ambiguous, complex role played by the signature in per-
formativity, as noted by Jacques Derrida.[41]

We might legitimately wonder about the relationship
between propositions such as these and Conceptual art.
Take, for example, *Instruction Paintings* by Yoko Ono, exhib-
ited in 1961 in AG Gallery in New York, or *Water Yam*, a book
by George Brecht, published in 1963, containing 73 event-
scores. These offer a range of linguistic definitions of a
forthcoming action or event, presupposing an ideal meaning
of the work, an infinite number of potential performances,
and public participation. We could certainly mention
Sabatier's use of administrative procedures (the data sheet[42]),
of language to negate the visual nature of the artwork (the
performative utterance replacing the projection of the film),
his critique of reification (destruction of the film), his
legal contract binding the work to its reception (Lettrist

certification), and the importance that reception and even participation by the viewer (the imaginary or infinitesimal dimension) holds for him. And yet it is hard to see anything other than mere similarities. Roland Sabatier's artistic logic is underpinned by a close reading of the writings of Isidore Isou, and he develops their axiomatic propositions with great originality. His art is careful to distance itself from any return to Dadaism and the historical avant-garde through a renewed, methodical and systematic revisiting of their concepts, and from a particular creativity reluctant to embrace chance, or indeterminacy. And herein lies the twin challenge to Lettrism, which is isolated and entrenched in the writing of its own history and which suffers from the silence and lack of understanding with which its works are often, and occasionally unjustly, met. In this respect, the performative dimension, in my view, is likely to offer a fresh insight into a number of Lettrist artistic activities, particularly in the domain of film, but also in publishing: the administrative use of archives, a predilection for manifestoes and the use of invective and insults.

The artist does not lay claim to the performative, and yet it affords insight into the internal logic of his films. His cinema frequently presupposes the activation of a script. However, its relationship with failure is not entirely clear. This tricky question is central to Austin's ideas and is the subject of at least three lectures in his book. A performative can fail if certain conditions are not met: relevant context, appropriate interlocutors, felicity conditions.

> There must exist an accepted conventional procedure having a certain conventional effect, that procedure to include the uttering of certain words by certain persons in certain circumstances.[43]

If these conditions are not met, the performative utterance is deemed infelicitous, in terms of Austin's detailed account. If we look at his earlier works, we can see that they too must obey a certain number of conditions if they are to be felicitous. A context, such as an invitation to an event or a festival, is always presupposed. Referring to *Hommage à Buñuel*, Sabatier said:

We dedicated this session to Langlois, director of the
Cinémathèque française. If you are sitting in front of
a big screen and you do not show a film, and you
show something other than a film, it then has to be
an anti-film. That was kind of the idea I started with.
But things are not quite so simple when you show
it in a gallery. That is why I stuck with cinema.[44]

The cinema theater seems to be a necessary pre-condition
for the performative to succeed. "What I did was based on
this text," he said about a second script read during the
performance.

I kept it short because I felt that people were getting
restless. I gave a quick summary because I knew that
it did not need go on for too long.[45]

The felicity conditions for performativity are clearly not
always met. According to Austin, seriousness is also a
precondition for successful performatives. If a performative
utterance is to succeed in this instance, it requires a context
that issues an invitation, a cinema theater, and spectators
who are alert to what the experience requires of them.
Conditions such as these are apparently rarely fulfilled.
Likewise, quite apart from their incidental nature, the
technical accidents that occurred during the event (roll of
film lost by a laboratory, text illegible due to clumsy filming)
offer an insight into further impediments to the success of
the performative. So should the work actually be executed?
Strictly speaking, is not the data sheet the performative film
itself? Sabatier's cinema is located at the interface of two
tendencies. On the one hand, it presents itself as a purely
linguistic, virtually conceptual utterance, and yet leaves
open its potential activation. The fact that few performances
have actually taken place could, of course, be attributed to a
number of factors. The work was carried out on a shoestring.
Technical accidents are a symptom of extreme poverty.
The fact that these works were not performed can also be
attributed to institutional and, dare I say, sociological
constraints. The conditions for a performative utterance
presuppose, according to Pierre Bourdieu, the "effects of
symbolic domination."[46] The place of Lettrism in the history

of art can be analyzed through this prism. And yet I believe that the possibility of failure creates a promising experimental and participatory opening for the project, allowing it to fulfill its vocation of being a "film of the future." The very possibility of failure means that the script can remain an open, labile utterance, on the threshold of film and reality, offering "white surfaces, brief injunctions, concealed spaces, and, ultimately, everything or nothing" promoting, in the artist's own words, "the power of a space beyond reality where reality is not possible, will never exist and cannot even be imagined—*unimaginable*, in a sense, rather than imaginary."[47]

The proposition, rhetorically speaking, lies at the heart of Roland Sabatier's cinema. Some of his projects, described in the data sheets for his *Œuvres de cinema* as fully-fledged films, are only linked to cinema by the slenderest of imperceptible threads and, as a veritable performative tour de force, exemplify the medium's twin movement toward expansion and contraction. Pavle Levi has noted the extent to which Lettrist film works frequently presuppose an idealistic approach to cinema taking no account of its dialectical relationship with its cinematographic apparatus, and has described in detail the technical affinities between them.[48] To what extent can cinema be exhibited, and participate in its self-abolition? How effective is an injunction? These are the questions currently raised by the exhibition of cinema, in the rhetorical sense of the word, questions which are reflected in the film practice of Roland Sabatier, a long-neglected figure in the history of cinema, due to his discreet/discrete (words favored by the artist) nature, both in the sense of circumspect and distinctive.

[1] We could mention, among others: Matthias Michalka (ed.), *X-Screen. Film Installations and Actions in the 1960s and 1970s*, Museum Moderner Kunst Stiftung Ludwig, Vienna 2004; Steven Ball, David Curtis, A. L. Rees, Duncan White (eds.), *Expanded Cinema*, Tate Publishing, London 2011; Gertrud Koch, Volker Pantenburg, Simon Rothöhler (eds.), *Screen Dynamics. Mapping the Borders of Cinema*, Österreichisches Filmmuseum, Vienna 2012; *Décadrages*, no. 21–22, special issue "Cinéma élargi," Lausanne 2012.

[2] Jonathan Walley, "The Material of Film and the Idea of Cinema: Contrasting Practices in Sixties and Seventies Avant-Garde Film," *October*, no.103, 2003, p. 15–30. Cf. also, by the same author, "Identity Crisis: Experimental Film and Artistic Expansion," *October*, no. 137, 2011, p. 23–50.

[3] Pavle Levi, *Cinema by Other Means*, Oxford University Press, New York 2012.

[4] Jean-Christophe Royoux was undoubtedly one of the first critics to use the expression "cinéma d'exposition". Cf. "Pour un cinéma d'exposition. Retour sur quelques jalons historiques," *Omnibus*, no. 20, April 1997, p. 11–12; "Cinéma d'exposition: l'espacement de la durée", *artpress*, no. 262, November 2000, p. 36–41.

[5] Cf. Guillaume Basquin, *Fondu au noir*, Paris Expérimental, Paris 2013.

[6] See my own article "De la conférence comme film," *Décadrages*, no. 21–22, p. 28–37. See also Jean Bresch and Christian Merlhiot (eds.), *La Fabrique des films*, Poli Éditions, Paris 2012.

[7] John Langshaw Austin, *How to Do Things With Words*, Clarendon, Oxford 1962.

[8] Isidore Isou, "Esthétique du cinema" [1952], *Ion*, Paris, reed. J.-P. Rocher, Paris 1999. Cf. Frédérique Devaux, *Le Cinéma lettriste*, Paris Expérimental, Paris 1992. See also Andrew V. Uroskie, "Beyond the Black Box: The Lettrist Cinema of Disjunction", *October*, no. 135, 2011, p. 21–48.

[9] Maurice Lemaître, *Le film est déjà commencé?*, Éditions André Bonne, Paris 1952.

[10] Cf. Isidore Isou, *Introduction à l'esthétique imaginaire et autres écrits*, Cahiers de l'Externité, Paris 1999.

[11] Isidore Isou, "Esthétique du cinema," p. 152.

[12] Isidore Isou, "Manifeste de la polythanasie esthétique," preface to *La Loi des purs*, Pantin, published by the author, 1963, p. 8.

[13] Ibid., p. 7.

[14] Roland Sabatier, *Situation de mes apports dans la polythanasie esthétique*, Publications Psi, Paris 1974, p. 2.

[15] Roland Sabatier, *Œuvres de cinéma (1963-1983)*, Publications Psi, Paris 1984. Preface by Frédérique Devaux, "Roland Sabatier: De la reproduction à la représentation ou le cinéma en limite du cinéma." A copy is available for consultation at the Bibliothèque Kandinsky at the Centre Georges Pompidou, Paris.

[16] After being enrolled as a doctoral student for ten years, Roland Sabatier chose not to submit his thesis, despite having qualified to do so.

[17] On-line introduction to Éditions Psi: www.lecointredrouet.com/lettrisme/psi.html.

[18] Cf. Fabrice Flahutez, *Le Lettrisme historique était une avant-garde*, Les presses du réel, Dijon 2011.

[19] Roland Sabatier, "L'anti-cinéma lettriste: le cinéma sans le cinéma", in *L'anti-cinéma lettriste 1952–2009*, catalogue, Zero Gravità, Sordevolo 2009, p. 54.

[20] Édouard Levé, *Œuvres*, P.O.L., Paris 2002, p. 7.

[21] Cf. Érik Bullot, "Film papier," *Cahiers du post-diplôme* Document et art contemporain, no. 3, École européenne supérieure de l'image, Poitiers-Angoulême 2013, p. 24–27; Pavle Levi, *Cinema by Other Means*, p. 46–76.

[22] Conversation with the author, Paris, April 16, 2013.

[23] Ibid.

[24] Stephen Wright, "Visibilités spécifiques," *Cahiers du post-diplôme*, no. 3, p. 30.

[25] *Œuvres de cinéma (1963-1983)*, p. 29.

[26] Document provided by the artist.

[27] Roland Sabatier, *Trois films sur le thème du cinéma. "Regarde ma parole qui parle le (du) cinéma. 1982," "Quelque part dans le cinéma. 1982," "Une (certaine) image du cinéma. 1983,"* Paris, Psi, 1983, p. 13.

[28] Ibid., p. 25.

[29] Conversation with the author, Paris, April 16, 2013.

[30] Roland Sabatier, *Trois films sur le thème du cinéma*, p. 27.

[31] Cf. Gérard Bermond, "Le cinéma sur le mode de ne l'être pas de Roland Sabatier," in Christian Lebrat and Nicole Brenez (eds.), *Jeune, dure et pure! Une histoire du cinéma d'avant-garde et expérimental en France*, Cinémathèque Française/Mazzotta, Paris/Milan 2001, p. 204–206.

[32] Cf. Helio Oiticica, *Quasi-Cinemas*, Kölnisher Kunstverein, New Museum of Contemporary Art, Wexner Center for the Arts, 2001.

[33] Roland Sabatier, *Trois films sur le thème du cinéma*, p. 33.

[34] Roland Sabatier, *Œuvres de cinéma (1963-1983)*, p. 60.

[35] Take, for example, the cover of *Zebar*, no. 56, May 2006, or *L'Anti-cinéma lettriste*, p. 96–97. Other elements from this set of objects were exhibited in a display case when he had a solo show at the Galerie Artcade, Nice, from September 17 to October 20, 1992.

[36] Roland Sabatier, *Œuvres infinitésimales et supertemporelles, injonctions, faits, comportements*, Éditions Psi, Paris 1984. Unpaginated introduction. Copy available at the Bibliothèque Kandinsky at the Centre Georges Pompidou, Paris.

[37] Ibid.

[38] Ibid.

[39] Roland Sabatier, *Œuvres de cinéma*, p. 24.

[40] John L. Austin, *How to Do Things With Words*, p. 62–63.

[41] Jacques Derrida, "Signature Événement Contexte" [1971], in *Limited Inc.*, Galilée, Paris 1990, p. 17–51.

[42] Take, for example, Roland Sabatier's injunction: "Filling in an administrative form is an infinitesimally bureaucratic piece of work" (1969).

[43] John L. Austin, *How to Do Things With Words*, p. 49.

[44] Conversation with the author, Paris, April 16, 2013.

[45] Ibid.

[46] Pierre Bourdieu, *Ce que parler veut dire*, Fayard, Paris 1982.

[47] Roland Sabatier, "L'anti-cinéma lettriste: le cinéma sans le cinema," p. 58.

[48] Pavle Levi, *Cinema by Other Means*, p. 93.

EXPRMNTL 4
(Knokke-Le-Zoute, 1967)
The Film Festival as an Intermedia
Exhibition
Xavier García Bardón

Translated by Miranda Stewart

Stugy drawing by the Eventstructure Research Group for *MovieMovie*, 1967

The fourth Knokke-le-Zoute
international experimental film
festival took place from December
25, 1967 to January 1, 1968, in the
casino of a small, bourgeois town
on the Belgian coast. The reason
why this event, better known as
EXPRMNTL 4, enjoys iconic status
today is simply due to the historic
role it played not only in dissemi-
nating but, indeed, defining the
very nature of avant-garde cinema,
and also this particular festival's
singular focus—it was a cinema
festival that sought to reinvent the
context in which film was shown
and introduce experimental ways
of exhibiting moving images, ways
underpinned by theory and radical
politics, which would align cinema
with other artistic practices. The
festival embraced all the arts,
demonstrated an impressive ability
to capture the multifaceted zeit-
geist of the era, and a remarkable
openness to the unforeseen. These
were the pillars of its reputation.
As hindsight now shows, this is

what created a festival that was a forerunner of future developments in the field. EXPRMNTL 4, the fourth of its series, pushed at the boundaries of the field with unusual drive and generosity.[1]

EXPRMNTL had been organized by the Royal Belgian Film Archive (Cinémathèque Royale de Belgique) and embodied the vision of Jacques Ledoux (who was curator at this institution from 1948 until his death in 1988). There had only been three previous festivals in this series prior to this occasion, all held at irregular intervals. The first, in June 1949, had sought to offer the first comprehensive retrospective of avant-garde films made throughout the world since the invention of cinema, including works by filmmakers such as Oskar Fischinger, Norman McLaren, Charles Dekeukeleire, Maya Deren, Joris Ivens, and Kenneth Anger.[2] The second, held in April 1958 as part of the Brussels World's Fair (Expo 58), offered the opportunity to view the first films by Agnès Varda, Jean-Daniel Pollet, Walerian Borowczyk and Peter Kubelka and by American filmmakers who were soon to be labeled as "underground," such as Stan Brakhage, Shirley Clarke, and Robert Breer. The third festival, in 1963, introduced the format that was to make the festival legendary (adopted by the following two festivals): a slot in the calendar between Christmas and New Year, the venue at Knokke-le-Zoute casino, and the bringing together of filmmakers, artists, and researchers from a variety of different disciplines around a program which, even today, is impressive in terms of its scope and the vision that Ledoux sought to inject into it. From Ledoux' perspective, experimental cinema could no longer be viewed independently from what was happening simultaneously in the other arts; it had to be interpreted in relation to music, literature, and the fine arts and be placed within a network of these different disciplines.

Along with screenings of films as disparate as those by Gregory Markopoulos, Peter Weiss, Takahiko Iimura, Edmond Bernhard, William Burroughs, and many more, EXPRMNTL 3 organized an entire day dedicated to electronic music, with the participation of the ORTF Groupe de Recherches Musicales (in the presence of Luc Ferrari, Bernard Parmegiani, and François Bayle) and the Studio für elektronische Musik des Westdeutschen Rundfunks in

Cologne (Studio for Electronic Music of the West German Radio), a concert of works by [Bruno] Maderna, [Pierre] Boulez, and [Karlheinz] Stockhausen, an exhibition of kinetic artworks by the Paris Groupe de Recherches d'Art Visuel (Group for Research in the Visual Arts)[3] and several talks on experimentation in the arts by authors such as Marguerite Duras, Robert Pinget, Jean-Louis Baudry, and Lucien Goldmann. Discussions between film critics, readings of fragments of plays by Witold Gombrowicz, Pierre Klossowski, Nathalie Sarraute, and Günther Grass, and a performance of *The Tragedy of King Christophe* by Aimé Césaire, produced by Roger Blin, completed this already jam-packed program. There had been clandestine screenings of *Flaming Creatures* (USA, 1963) by Jack Smith the same year—a doomed film from EXPRMNTL 3, which had been selected by the jury before being rejected by the Film Archive's management, who were horrified by its graphic depiction of sexuality. Nevertheless, it had been screened on many occasions by Jonas Mekas, P. Adams Sitney, and Barbara Rubin in their hotel rooms. For most of the Europeans who attended Knokke, this represented their first taste of underground cinema: its aesthetics, modes of production, and alternative distribution practices.

EXPRMNTL 4 was to pursue this initiative and, in a way few other events had succeeded, was able to create a melting pot for all the energy and the (aesthetic, cultural, political) issues of the day. In a document from 1974, Ledoux offered a glimpse of the thinking behind his programming: "There are three aspects to the festival," he explained at the time: "1. film competition; 2. non-cinematographic activities; and 3. the unforeseen. 1 plus 2 makes 3."[4] The strength of EXPRMNTL lies in the interrelationship between these three parts—the secret behind its planning can be traced back to these fundamental ideas.

The first programming decision involved the selection of the place and time of the festivities. The festival was organized in a temporal and geographical no-man's land: the last week of the year (as if to break with the social conventions traditionally governing this time of the year), in a location overlooking the sea, far from the capital city. It was possible to hold the festival in Knokke casino precisely because the president of the Film Archive, Pierre Vermeylen

(an influential politician[5]) was friends with the casino director, Gustave Nellens. Nellens, an art collector (with a penchant for Surrealist Belgian painting as can be seen by the murals by Magritte and Delvaux on the casino walls) loaned his premises to EXPRMNTL.

In the Christmas period Knokke-le-Zoute is a deserted seaside resort, a ghost town wreathed in fog: the perfect setting for the unlikely event that Ledoux was seeking to create. In this time warp, cut off from the outside world, the first concern was to blur all points of reference by suggesting to potential festival goers (between 2,000 and 3,000 people in 1967) that they should experience total immersion, for an entire week, with no opportunities for escape or distraction. This was the kind of intensity that EXPRMNTL sought to promote, sorely testing the endurance of even the most hardened cinema lover.[6] "It was like being on an island with its own life," said exhibition curator Harald Szeemann, and we now know that his visit to EXPRMNTL 4 was an experience that would influence the way he curated a number of exhibitions over subsequent years.[7]

EXPRMNTL 4's program combined (and pitted against each other) a wide variety of disparate works, experimental both in form and content. According to the film competition regulations, "The term experimental film will be interpreted as embracing all works created for cinema or television, which give evidence of an effort to regenerate or extend the film as a medium of cinematographic expression."[8] Underground films jostled for place with structural films, Surrealist essays, lyrical documentaries, funny cartoons, collage animation, and dance films.

With very few exceptions, the competition was strictly reserved to films that had not been screened previously. EXPRMNTL 4 was the first in its series to adopt this restrictive policy, and did so in a radical and original manner. "Never before had the policy of discovering new talent been so explicitly stated or tested," noted P. Adams Sitney.[9] Under an agreement with Agfa-Gevaert, the Film Archive received large quantities of 16 mm film (black-and-white and color, including developing), which it distributed to around 100 filmmakers, upon application.[10] This was a stroke of genius, a magnificent incentive to creativity, and

remains a unique initiative in the history of cinema, encapsulating "a mixture of calculation and generosity."[11] "Generosity": Ledoux thereby offered simple, practical help to impecunious filmmakers. "Calculation": it ensured, by the same token, that works presented in Knokke would be original. Among the 59 films shot from the film stock provided by the festival and submitted to the selection panel, were works by Marcel Broodthaers, Martin Scorsese, Jean-Jacques Lebel, Roland Lethem, Piero Heliczer, Jud Yalkut, and Werner Nekes. Twenty-four of these were selected and added to a further 66, making a total of 90 films in competition, divided into 11 programs. Each program pitted a variety of different approaches and provenances against each other, breaking any illusion of coherence by pairing totally dissimilar films and by promoting discordance.

After the screening, a jury comprising Shirley Clarke, Vera Chytilová, Walerian Borowczyk, and Edgar Reitz[12] — four filmmakers who had attended at least one of the previous EXPRMNTL festivals — awarded the festival Grand Prix to *Wavelength* (USA, 1967) by Michael Snow. Other prize winners included films by Lutz Mommartz (*Selbstschusse*, Germany, 1967), Robert Nelson (*Grateful Dead*, USA, 1967), Stephen Dwoskin (*Chinese Checkers, Naissant, Soliloquy*, Great Britain, 1965–1967), Ake Ärenhill (*Besöket*, Sweden, 1965), Hellmuth Costard (*Warum hast Du mich wach geküsst?*, Germany, 1967), Charles A. Csuri and James P. Schaffer (*Hummingbird*, USA, 1967), Gunvor Nelson and Dorothy Wiley (*Fog Pumas*, USA, 1967), Michel Thirionet (*Entretien*, Belgium, 1967), Jud Yalkut (*Self-Obliteration*, USA, 1967), Mordi Gerstein (*The Room*, USA, 1967), Karl-Birger Blomdahl (*Altisonans*, Sweden, 1966) and Martin Scorsese (*The Big Shave*, USA, 1967). The program also included non-award-winning films by Marcel Hanoun, Birgit and Wilhelm Hein, Werner Nekes, Martial Raysse, Patrick Hella, Paul Sharits, Alfredo Leonardi, Pedro Portabella …

Despite the great diversity of film styles present, there was remarkable consistency when it came to projection devices. Admittedly, only two films entered into the competition had been expressly designed for twin projection,[13] and yet this type of presentation appeared to be more widely adopted than the organizers had been prepared to

accommodate within the competition. We know, in effect, that Ledoux was keen for all films entered into competition to be projected under the same conditions. We understand that he wanted to be able to compare like with like with all projects being suitable to operate under traditional projection conditions.

The most radical configurations of projection devices were to be found in the non-competition section, among the 70 films divided into five programs. Of these, the work shown by the Eventstructure Research Group (Jeffrey Shaw, Theo Botschuijver, Sean Wellesley-Miller), based in Amsterdam, has to be the highlight of the event. The organizers had invited the group to show *MovieMovie*, a mixed-media event, coordinated by Sigma-Amsterdam (Tjebbe van Tijen) and designed especially for EXPRMNTL 4, which reflected the thinking pursued by the group at the time through a series of expanded cinema projects in which inflatable structures, integrated into the urban landscape, had film projected onto them.[14]

The action of *MovieMovie*—shown twice in Knokke, on December 29 and 31, 1967—takes place in the casino foyer, right at the very heart of the festival, although not, it should be noted, inside the screening room. The spectators sat on stairs or stood on the balcony and looked down on the events from above.

> Three performers ... dressed in white overalls first brought in the inflatable structure and unrolled it on the floor. Then it was gradually inflated while film, slides, and liquid-light show effects were projected onto its surface. The architectural form of this inflatable structure was a cone with an outer transparent membrane and an inner white surface ... In the intermediate space between the transparent and white membranes various material actions were performed to materialize the projected images. This included the inflation of white balloons and tubes, and the injection of smoke.[15]

Four projectors projected a cascade of images (some abstract and brightly colored, others taken from advertising films and yet others from American anti-Communism

propaganda films) onto its huge pneumatic structure
(approximately 7 m in diameter and 10 m high).[16] Its volume
shifted as the action developed in response to the move-
ments of spectators, who would hurl themselves onto this
experimental bouncy castle.

> The *Moviemovie* show … was basically a cinematic
> proposition—to do with the environmental setup of
> cinema using stock films. The purpose behind it was
> to get away from the set relationship of film image
> and audience … The idea of this event was to set up a
> fresh cinema situation in environmental terms—not
> in image terms, not in terms of the film itself, but in
> terms of the presentation of the film materials and in
> terms of a more vitalized dialogue between audience
> and film.[17]

Musica Elettronica Viva, a group from Rome which had been
invited to Knokke to give a concert, provided the
soundtrack to the event—a wild and dense electronic
improvisation using an amplification system placed inside
and outside the inflatable structure—and the London
group, The Overheads, took care of the light effects and
fluid projections.

Part expanded cinema performance, part light show
(which was in full development in all its various forms at that
time, along with the boom in psychedelic music), and part
sophisticated fairground attraction, *MovieMovie* undoubt-
edly offered the most spectacular reconfiguration of the
cinematographic apparatus shown during EXPRMNTL 4,
and consequently provided one of the most iconic examples
of what the notion of intermedia could offer cinema.
MovieMovie was created several months after *The Exploding
Plastic Inevitable*, the multimedia show orchestrated by Andy
Warhol with the participation of The Velvet Underground, in
the United States. Its reputation had already taken on
mythical proportions.[18] As noted by Birgit Hein, by including
MovieMovie, among other events in its program, EXPRM-
NTL 4 played a crucial role in disseminating the practices of
expanded cinema and the light show throughout Europe.[19]

This extremely playful and innovative program, which
enthusiastically pushed the boundaries of artistic practice,

also included *Hawaiian Lullaby* (Wim van der Linden, Netherlands, 1967), in which a bare-breasted dancer (Phil Bloom, who at that time was extremely popular for being the first woman to appear naked, six months earlier, on the Dutch national television airwaves) shimmied onto the stage in front of a projection of a sunset; *The New Electric Cinema* (Piet Verdonk, Netherlands, 1967), projected onto an aluminum foil screen to the throb of a vacuum cleaner; *Geography of Persia* (USA, 1967), a film for two screens produced by cinema critic and theoretician P. Adams Sitney; and *Juliet & Romeo*, "an event proposal designed by John Latham," shown as "an interlude in an unending film" (the projection of a film by Latham introduced and concluded the action), in which a man (Sean Wellesley-Miller) and a woman (Phil Bloom, again), painted red and blue respectively, and covered in sheets of newspaper, undressed each other.[20]

It should, however, be said—and this is not the least of the EXPRMNTL's paradoxes—that these works had most probably been excluded from competition, precisely on account of their *expanded* nature. This can be seen in the setback encountered by Marcel Broodthaers' film, *Le corbeau et le renard* (Belgium, 1967), which had been produced especially for EXPRMNTL 4, but then rejected and sent to the out-of-competition section because its projection required a specially prepared screen bearing a variety of inscriptions (fragments of a text based by Broodthaers on Jean de La Fontaine's fable). In this work, the artist saw the screen as a nexus, allowing him to combine the different practices (cinema, writing, painting, and even sculpture) and concerns (text, object, image) that recur in his work. Both film and screen, furthermore, were the elements of an art edition—which gave the project another existence, and allowed it to circulate in another way.

The fact that this exciting project—which in retrospect is now considered a key work in Broodthaers' oeuvre (we should remember that he had only decided to become an artist three years previously)—had been excluded from the competition obviously raises the question of how open the festival actually was, and how much pushing of the boundaries of form it was in fact prepared to countenance. It might also give some insight into the organizers' opinion

of a film that had been produced within the fine arts and not
cinema. "I am not a filmmaker," Broodthaers insisted in
an interview given during EXPRMNTL 4.[21] For Harald
Szeemann, then director of the Kunsthalle Bern, who was
visiting the festival, the rejection of Broodthaers' work is
indicative of the degree of discomfort felt by Ledoux toward
works by artists, which he treated with distrust. For
Szeemann, the absence of works of this nature, or at best,
their rejection out of the competition, was the festival's only
mistake.[22] In Knokke, *Le corbeau et le renard* was projected
onto a standard screen within the casino premises, and was
also projected as a fringe event on the special screen
prepared by Broodthaers.

 Avant-garde cinema was a fragmented field at that
time, with filmmakers working in relative isolation and
unaware of what other people were working on. EXPRMNTL
offered the opportunity to view experimental films at a time
when such opportunities were rare indeed. Other events
showcasing avant-garde cinema had only recently come onto
the scene—the festivals of Geff in Zagreb in Yugoslavia and
Ann Arbor in the United States were both founded in
1963—and yet there was no other event in 1967 that offered
such a vast and ambitious overview of experimental cinema.
"Knokke-le-Zoute ..." wrote Sitney at the end of the
festival, "stands as the sole gathering of international
avant-garde filmmakers."[23] At Knokke, filmmakers, cinema
lovers, and artists had the opportunity to discover what was
happening in their field throughout the world. In these
circumstances, Ledoux' first concern was to enable these
films to be seen and allow people to meet each other. That is
why the festival catalogue provides the contact details for all
the filmmakers.[24] That is also why, during EXPRMNTL 4,
Ledoux organized an international meeting of filmmakers'
cooperatives, which had been set up to distribute indepen-
dent cinema in a number of countries following the found-
ing of the New York Film-Makers' Cooperative in 1961. In
Knokke, for the first time, representatives of various
American and European cooperatives discussed the issue of
distributing experimental films internationally. Shirley
Clarke (New York Film-Makers' Cooperative), Robert Nelson
(Canyon Cinema, San Francisco), Stephen Dwoskin (London
Film-Makers' Co-operative), Alfredo Leonardi and Gabriele

Oriani (Cooperativa Cinema Indipendente, founded in
Naples and quickly transferred to Rome), Werner Nekes
(Filmmacher-Cooperative Hamburg), Köby Siber (Zurich)
and Andi Engel (Frankfurt) took part in these debates,
chaired by P. Adams Sitney. Some of these organizations
had just come into existence—such as the Hamburg
cooperative, founded one month earlier; others were set up
on the spot, following these discussions.[25]
 At a time when the arts were expanding, Ledoux's
vision would not have been complete if the program only
included cinema. The project was more ambitious than
that—it sought to render the links between experimental
cinema and other practices more explicit and show, in line
with Ledoux's thinking, that the medium of film occupied a
central place in this constellation. "Ledoux believes that
cinema is the creative language that will put a bomb under
everything," said Jean-Pierre Van Tieghem, a future art
critic, then a philosophy student, who helped organize
EXPRMNTL 4's non-cinematographic events.[26] It was the
organizers' intention to create an event to reflect recent
upheavals in culture and the arts. EXPRMNTL opened up,
through words and deeds, a space for reflection and the
exchange of ideas. Exhibitions, concerts, readings, theater
performances, happenings, and discussions flowed freely in
Knokke and meshed into a complex fabric of projects and
ideas. Organized by a film archive and using cinema as its
line of attack, EXPRMNTL was a festival that placed the issue
of intermedia and modalities of presentation at its heart.[27]
 The American filmmaker Robert Breer exhibited
Floats, a collection of tiny motorized sculptures made with
expanded polystyrene, which moved slowly yet constantly,
their paths regularly altered by the obstacles they encoun-
tered. Edmond Couchot, a French pioneer of interactive art,
exhibited the musical mobile *Semaphora III*, "a cybernetic
system capable of reacting to any source of noise, sound,
voice, or music, and to interpret it visually using lumines-
cent and mobile devices."[28] Michelangelo Pistoletto exhib-
ited 10 paintings on mirrors and reflective surfaces. These
groundbreaking works were activated by the spectator's gaze
and embedded in the exhibition's space/time. The spectator
becomes, at one and the same time, actor and image, and
this opens up the possibility for interaction between the

work and life, with one projected onto the other. Finally, the Denise René Gallery in Paris—which had hosted, in 1955, *Le mouvement*, an exhibition curated by Pontus Hultén and Denise René, and which laid the foundations for kinetic art and the idea of creating art with movement—exhibited a series of multiples by Vasarely, Demarco, Soto, Sobrino, Le Parc, Schöffer, Morellet, Yvaral, and Kowalski entitled *SIGMA III*. Movement, light, reflection, reproduction— on the basis of these key ideas, which were explored by the art works exhibited at Knokke, all the EXPRMNTL 4 exhibitions could, broadly, be related on a conceptual level to cinema.

Composer Mauricio Kagel, reputed for his interest in concert staging, performance, and theatricality, conducted several of his pieces, played in Knokke by the Cologne Ensemble for New Music, three of which seemed particularly apt for this festival: *Variaktionen über Tremens*, "acoustic and scenic montage on drug testing" for one player, instrumental sounds and projections[29]; *Montage für verschiedene Schallquellen/Montage for various sound sources*; *Musik aus Diaphonie*, for twin projection of slides and instrumentalists. Musica Elettronica Viva gave an epic, four-hour-long improvisation at the Salle du Lustre, at the foot of *Le Domaine Enchanté*, the wall painting by René Magritte. It should be noted that these musicians were, to some extent, political activists.

Belgian composer Célestin Deliège offered the opportunity to listen to a selection of tapes significantly presented as a "music exhibition,"[30] which traced the history of 10 years of work in the field of experimental music (1957–1967). Among these there were works by Lucien Goethals, Karlheinz Stockhausen, Henri Pousseur, Konrad Boehmer, John Cage, Luciano Berio, and Jean-Claude Éloy. Similarly, the festival offered the opportunity to listen to radio recordings of literary works and plays by—among others—Monique Wittig, Alex La Guma, Edoardo Sanguineti, Samuel Beckett, Maurice-Jean Lefebve, and Severo Sarduy. English poet Bob Cobbing and Austrian Ernst Jandl were also present.

The program also included four theatrical events. Two readings: *La mort du personnage*, by Claude Ollier; and *La Naissance*, Armand Gatti's last work, read by the author and dedicated to South American guerrilleros. And two

plays: *America Hurrah* by Jean-Claude van Itallie, produced by Tom Bissinger; and most particularly *Masscheroen* by Hugo Claus, which caused a scandal. This series of exercises for two actors was inspired by the mediaeval tale of Mariken van Nieumeghen. In the original tale, a classical conversion story, a young prostitute decides to take holy orders. Claus rewrites it so that Mariken no longer follows the path of sanctity, but rather one of debauchery. The blasphemous nature of the work and the onstage nudity of several of the actors (including Bob Cobbing) caused the author serious and lasting problems with the law.

Five discussions were designed to help participants get to grips with the ideas behind the works included in the festival program. Moderated by critic René Micha,[31] one of Jacques Ledoux's most valued contributors when it came to creating each EXPRMNTL festival, these meetings focused on the general theme of *Art in Society Today*. The colloquia drew on the participation of artists, writers, and composers, including Martial Raysse, Yaacov Agam, Piotr Kowalski, Peter Handke, Claude Roy, Jean-Pierre Attal, Alfred Kern, Armand Gatti, Jérôme Savary, Frederik Rzewski, André Souris, Konrad Boehmer.

EXPRMNTL 4's programming extended far beyond the cinema screen, and indeed Ledoux saw the event as occupying the entire building, with a constant traffic of people and ideas through the space. The casino came to life with perpetual motion, visitors made it their own, including many people referred to in the press as "hippies," to the consternation of its normal denizens.[32] In this febrile atmosphere, it is hardly surprising that a whole host of new projects quickly found their place alongside the official program. That was the unforeseen side of the festival, and Ledoux almost certainly could not have predicted that it would acquire such monumental proportions.[33]

In the purest of underground traditions, screenings took place on the fringes of the official program. The story behind the ban on *Flaming Creatures* and its secret screenings during EXPRMNTL 3 was common knowledge, and the aura of legend that had grown up around these events undoubtedly played a huge role in determining visitors' expectations of EXPRMNTL 4. Some filmmakers came with a film to show that had not been selected by the festival, others

arrived with their latest production. It was hardly surprising that people very quickly started to improvise parallel screenings, especially outside the casino. French artist Jean-Jacques Lebel, a pioneer of the happening in Europe, who had been invited to Knokke to take part in the discussions, and Belgian activist Isi Fiszman, friend and staunch supporter of Marcel Broodthaers, helped to organize these. Fiszman was the one who discovered Oud Knokke, a bistro a 15-minute walk from the casino, where *Le corbeau et le renard* could be shown on the screen specially designed by Broodthaers.[34] Most of such screenings took place here, but as they were largely improvised, we have very little detail about what actually happened. Apart from Broodthaers' film, what we do know is that a film by Lebel, some reels by Pierre Clémenti and a pornographic poem in 8mm by Henry Howard (member of the Living Theater) were also screened.[35] These projections, which attracted an enthusiastic public until late at night,[36] offered screenings that were different in nature from the official sessions, and this simplicity brought into question the authority of the festival and its very selection criteria.

In an atmosphere of burgeoning contestation, that had escaped all control, a number of unforeseen events took place in the casino itself. Yoko Ono, who had come to support the out-of-competition screening of her *Film Number Four* (1967), spent several hours hidden under a black bag, recumbent in the middle of the casino hallway as part of the interpretation of her *Black Bag Piece*. Actor Pierre Clémenti, who turned up with some musician friends, took part in improvisations with them all over the casino. Mouna Aguigui, a colorful character from the streets of Paris and Nice, came all the way to Knokke to harangue the crowd and deliver his humorous, pacifist message.[37]

A number of festival events, whether actually included in the program or improvised, highlighted real-life and constructed situations: happenings, performances, and a variety of events captured the importance of the moment and tried to eliminate the boundary between art and life. EXPRMNTL 4, insofar as it provided the time and place for these events to occur, appears to be not so much the result of this combination of events, but rather the trigger that caused their proliferation. In this climate of constant

exchange of ideas, it is true to speak of a "total expanded
cinema experience."[38]

"Everybody has full freedom of expression," Ledoux
had announced several weeks before the festival. "This
year's festival will continue that tradition."[39] In what was
starting to look like improvisation writ large, a happening of
monumental proportions, other surprise guests were about
to drop in. "Cannes and Venice have starlets; Knokke had
its Maoists,"[40] noted English critic Elliott Stein. Maoists,
Marxists, anarchists, Amsterdam Provos—all strands
of radical left-wing thought were represented in Knokke.[41]
Some months before May 1968, at the height of the protests
against the Vietnam War and in the excitement of the
demonstrations that were already shaking Germany, a group
of around 30 students from the Deutschen Film- und
Fernsehakademie Berlin and the Institut für Filmgestaltung
Ulm turned up.[42] Among these students were Harun Farocki
and Holger Meins, both studying in Berlin.

In 2009, when he summed up what 1968 had meant
to him in a few words and with 40 years hindsight, Farocki
observed: "For once in my life I was ahead of Godard: at the
beginning of the year we disrupted a festival of experimental
film in Knokke, Belgium, fortunately not the films by
Shirley Clarke and Michael Snow."[43] The students had been
attracted to Knokke by the opportunity to discover new
forms of cinema. However, they were soon to make a stand
against most of the films shown during EXPRMNTL,
and indeed against the festival itself. This they did through
a variety of actions, some of which, curiously, in the way
they were orchestrated and staged and in their provocative
nature, were reminiscent of many of the performances held
during the festival.[44] Fuelled by a feeling that the revolution
was around the corner, revolted both by the political aphasia
of most of the films and the passivity of the spectators,
and the fact that the festival was being held in a casino,
a location emblematic of the bourgeoisie, the students felt
moved to speak out.[45]

Their first action was targeted at the projection of
Wolfgang Ramsbott's film *Der weisse Hopfengarten* (Germany,
1966). The students saw its presence in a festival dedicated
to experimental cinema as an aberration. Parading in front
of the screen like soldiers, they seized hold of some

Christmas trees that were on the stage and aimed them at
the public, like guns. Their second action interrupted the
projection of *The Embryo* (Koji Wakamatsu, Japan, 1966),
a film in which a shoe shop salesgirl, abducted and drugged,
is subjected to atrocious torture by her boss. During this
projection, the protesters created a human pyramid in front
of the screen and are then said to have tried to set fire to
the auditorium.[46]

The students were joined by several Belgians, and
set about creating a huge poster with a manifesto against
American imperialism, as much in politics as in the cinema.
The text started with the following phrase, written in
capital letters: "FIGHT AGAINST THE OPEN AND THE
UNDERGROUND AMERICAN IMPERIALIST AND CINE-
IMPERIALIST AGGRESSION ALL OVER THE WORLD!"[47]
This manifesto, exhibited for a very short space of time
in the casino foyer, drew a bold parallel between the military
operations carried out by the United States in Vietnam
and the activity of the experimental filmmakers (in Knokke
most of the films screened were effectively American),[48] and
was instantly destroyed by the casino director, intent on
preventing any political demonstration in his establishment.

On December 31, 1967, the last day of the festival,
the EXPRMNTL 4 program had scheduled a discussion
about the films in competition, giving the spectators the
opportunity to question the selection panel on the principles
underlying their decisions, and particularly to question the
relevance of the very idea of selection—a criticism made
time and again during the festival. Jean-Jacques Lebel quickly
intervened. After congratulating the organizers on their
transdisciplinary approach, he announced the immediate
election of *Miss Experimentation 1967.* On stage, two boys
and two girls (one of whom was Yoko Ono) stepped forward,
naked, to take part in the competition. A boy was elected.
Taking advantage of the disorder that ensued, and as agreed
with Lebel, the demonstrators then climbed onto the stage
and brandished a flag on which they had stuck fragments
torn from their poster, and cards carrying slogans such
as "No reality without the death of spectacle!" "Make art
dissolve into life," and "Long live Dziga Vertov." With the
winner of the competition dancing around naked on the
selection panel's table, the demonstrators hurled tracts

to the ground to the cries of "Reality" and "Raise conscious-
ness!" It is worth seeing these remarkable images of a larger-
than-life scene, which exploded soon afterwards into the
hall—demonstrators, casino guards, and police all coming
to blows. The program then hit absolutely the right note
with a showing of *MovieMovie* immediately after the rumpus,
with several spectators—including Lebel—jumping up
and down naked on the pneumatic structure of the Event-
structure Research Group. That was a fitting conclusion
to this turbulent week, followed by a gargantuan traditional
New Year's Eve feast.

"There were happening many sideshows," said Werner
Nekes, "and the political event was also in a way like a
sideshow."[49] "It was really the main thing at the festival ...
the most valid thing of the whole festival" Peter Kubelka
told Jonas Mekas, who quoted him in *The Village Voice*.

> I wanted to give them a prize for the lively action.
> But the strange thing is that they are so much against
> what they call a formalist cinema that they have a real
> Stalinist notion of cinema [...] They go by the
> political message only.[50]

What the demonstrators' actions had in common with
many of the artistic works shown in EXPRMNTL 4 was the
urgency with which they questioned the passivity of the
spectator's position and their burning need to break down
the boundaries between art and life, to "make art dissolve
into life," to cite one of their slogans. "In retrospect,"
said Harun Farocki,

> [EXPRMNTL 4] is nearly the last moment in which
> politics and the avant-garde, aesthetics and politics,
> are still in a copresence. From then on they separated.
> In 1968 they started to separate strongly.[51]

This provisional, practical alliance, articulated through
performance, was midway between a radical militantism
born of political reflection, and a libertarian protest
combining mockery with eroticism, two forms of protest
that might at first glance seem contradictory, and yet their
improbable union, in this particular context, seemed utterly

natural. All this underlay a questioning of the organizers' power (notably through their selection of the films), and also the organization's links with power and money (Pierre Vermeylen, president of the Film Archive, had been a government minister; EXPRMNTL was sponsored by private companies), and the films themselves. This is a fair criticism insofar as it foregrounds the event's unquestionably institutional status, its financial support (without which it could not exist) and the relatively small number of explicitly political films included in the programming (although some of the most formal abstract films could of course be considered politically significant).

In response to this criticism, and at the opposite end of the spectrum from the repressive attitudes of both the casino director and the president of the Archive, Ledoux's more conciliatory approach is particularly interesting. "Far from considering all this excess … as an attempt to sabotage his work," wrote Jean-Marie Buchet, "he saw it as an extension thereof, even if, on occasion, it left him puzzled."[52] It is tempting to think that, in the heart of EXPRMNTL, Ledoux was working to create an open structure, one of which he was aware that he might lose control. In this confined environment, the way he went about programming could be viewed as akin to the procedures for a laboratory experiment—setting up the experimental conditions and subjects, bringing them together, and accepting that the result might prove surprising, or indeed exceed all expectations. Meetings, openness, even excess, are at the very core of EXPRMNTL. EXPRMNTL aimed to reinvent the very idea of what a festival should be, underlining how unusual its mode of presentation was. The festival, by offering a construction of a temporary situation shared collectively, is an experience in itself. Knokke offers the example of a cinema festival that has become a space for experimentation, a place for an interdisciplinary exchange of ideas and political debate, at the forefront of contemporary upheavals in art and society. An event that is so at one with its purpose that it is an experience in itself, capable even of absorbing the questioning of its very essence.

Some months after Knokke, Harun Farocki, Holger Meins, and a dozen other students were excluded from the

Deutschen Film- und Fernsehakademie Berlin for their political activities.[53] Meins decided to go "underground" in the other sense of the word and join the Red Army Faction in 1970. He was arrested two years later and died in prison in November 1974 as the result of a hunger strike.

In December 1974, the fifth and last EXPRMNTL festival was held, seven years after the festival that is the focus of this text. EXPRMNTL 5, by including the emerging medium of video in the festival programming, faced other critical issues relating to the exhibition of moving images. In the meantime, the model that brought cinema and other arts together in exhibition circumstances, as EXPRMNTL 4 had sought to do in its visionary way, proved to be extremely fertile for the future. The 1967 Knokke project offered a foretaste of the opening up of art spaces to cinema practices, a movement that would gather momentum in the 1970s. Indeed, Harald Szeemann—curator of the exhibition *Live in Your Head. When Attitudes Become Form* at the Kunsthalle Bern in 1969 and responsible for documenta 5 in Kassel in 1972—would become one of the main architects of this movement toward opening up the arts. Significantly, he was also a member of the jury of EXPRMNTL 5.

[1] Extracts from this text have appeared in the following publications: Xavier García Bardón, "EXPRMNTL. Festival hors normes. Knokke 1963, 1967, 1974," *Revue Belge du Cinéma*, no. 43, December 2002 (entire issue); Xavier García Bardón, "EXPRMNTL, festival expandido. Programación y polémica en EXPRMNTL 4, Knokke-le-Zoute, 1967," *Cinema Comparat/ive Cinema*, no. 2, 2013, p. 54–66.

[2] When speaking of this festival 25 years later, Annette Michelson called it "the most important international event in the world of the avant-garde cinema." Annette Michelson, P. Adams Sitney, "A Conversation about Knokke and the Independent Filmmaker," *Artforum*, vol. 13, no. 9, May 1975, p. 63.

[3] Julio Le Parc, Francisco Sobrino, and François Morellet, about whom filmmaker John Withney enthusiastically observed, thereby confirming that the program had indeed achieved its aims: "They have literally created cinema in an art gallery." John Withney, "An abstract filmmaker's view of the Belgian Experimental Film competition (1963) and all," *Film Culture*, no. 37, Summer 1965, p. 26.

[4] "Comité Consultatif X5. Réunion du 11 février 1974," document retained in the archives of the Royal Belgian Film Archive: "X5 / Manifestations non cinématographiques programmées," under "Rapports Comité Consultatif." This program also offers historical evidence, as it was drawn up after the turbulent festivals of 1963 and 1967.

[5] Vermeylen, a member of the Belgian Socialist Party, was a Senator from 1945 to 1974; Minister of the Interior from 1947 to 1949, and from 1954 to 1958; Minister of Justice from 1961 to 1964; and Minister of Education from 1968 to 1972. He also, in collaboration with Denis Marion and André Thirifays, ran the *Club de l'Écran* in Brussels in the 1930s. In 1938, together with Henri Storck and André Thirifays, Vermeylen created the Belgian Film Archive.

[6] "Sanity and critical standards cannot survive ten hours of avant-garde films a day, eight days running," said critic Elliott Stein in 1963 (Elliott Stein, "Fog at Knokke," *Sight & Sound*, vol. 33, no. 2, Spring 1964, p. 89).

[7] Harald Szeemann, interview with the author, Brussels, April 22, 1998. As director of the Kunsthalle Bern from 1961 to 1969, Szeemann had invited many filmmakers to present their films at his institution (including Gregory Markopoulos, Taylor Mead, and Robert Nelson). In 1968, while still at the Kunsthalle, he introduced cinema into the *12 Environments* exhibition (July 20–September 29, 1968), presenting the work of filmmaker Lutz Mommartz and a double-screen cinema work by Editions Claude Givaudan, alongside works by Christo, Piotr Kowalski, and Martial Raysse among others. Szeemann was curator of documenta 5, held in Kassel, June 30–October 8, 1972, in which he included films by Larry Gottheim, Andrew Noren, Paul Sharits, Joyce Wieland, Stan Brakhage, Michael Snow, David Rimmer, George Landow, Ken Jacobs, Tony Conrad, Hollis Frampton, Werner Nekes & Dore O., Klaus Wyborny, Birgit & Wilhelm Hein, Steven Dwoskin, and Russ Meyer (the films were screened in the municipal cinema). Nevertheless, over and above a shared interest in cinema, and going by the regular recurrence of the names of several artists whose work was presented both by Szeemann and Ledoux, Szeemann's real interest must undoubtedly have resided in the idea of creating, in autonomous space/time, an event crossing all disciplines, conceived of as an experimental meeting place, one that was open to the unforeseen and which could be seen as a total work of art. Similar concerns can also be detected in the preparations for documenta 5 and in the way the Kunsthalle was run in the 1960s. In 2005, Szeemann paid tribute to EXPRMNTL by including several documents

relating to its history in the final exhibition that he curated: *La Belgique Visionnaire. C'est arrivé près de chez nous*, March 4–May 15, 2005, Palais des Beaux Arts, Brussels. I assisted Szeemann on that occasion.

[8] *EXPRMNTL 4. Fourth International Experimental Film Competition*, festival catalogue, Royal Film Archive of Belgium, Brussels, 1967, unpaginated, Regulations, art. 3.

[9] P. Adams Sitney, "Report on the Fourth International Experimental Film Exposition at Knokke-le-Zoute," in *Film Culture*, no. 46, Autumn 1967, published—belatedly—in October 1968, p. 7.

[10] "Aide à la production de films expérimentaux destinés à la Quatrième Compétition Internationale du Film Expérimental," press release by the festival organizers. The application must include a film script, "along with, where possible, a film already directed by the applicant, and a recommendation from a recognized authority in the film world, or a non-commercial entity involved in film." The Film Archive received more than 200 applications.

[11] According to Danielle Nicolas, who was Ledoux's assistant (Anne Head, *A True Love for Cinema. Jacques Ledoux, 1921–1988*, Universitaire Pers, Rotterdam 1988, p. 54–55).

[12] Pontus Hultén should have been part of their number as fifth jury member. Illness prevented him from attending Knokke.

[13] *Il mostro verde* (Tonino De Bernardi & Paolo Menzio, Italy, 1967) and *A Dam Rib Bed* (Stan VanDerBeek, USA, 1967).

[14] In the case of *Corpocinema*, for example, which had been shown several months earlier in Rotterdam and Amsterdam, slides and films had been projected onto a transparent dome. "These projections were made visible by physical events and performed actions that created temporary conditions that materialized the projected imagery within and on the surface of the dome" (see http://www.jeffrey-shaw.net/html_main/show_work.php?record_id=9, last accessed July 2015).

[15] Anne-Marie Duguet, Heinrich Klotz, Peter Weibel (ed.), *Jeffrey Shaw—A User's Manual. From Expanded Cinema to Virtual Reality*, ZKM/Neue Galerie am Landesmuseum Joanneum/Hatje Cantz, Karlsruhe/Graz/Ostfildern 1997, p. 70–72.

[16] See http://www.jeffrey-shaw.net/html_main/show_work.php?record_id=11. Last accessed July 2015.

[17] Quoted from the mimeoed program for the third and last performance of *MovieMovie*, on March 21, 1969, at the St. George's Arts Centre in Liverpool. The Event-structure Research Group, with this performance entitled *MovieMovie (The Pneu-Written)*, was able to pursue its collaboration with John Latham, and include elements from the original *MovieMovie* in a performative scenography created by the English artist.

[18] For a study of the *Exploding Plastic Inevitable*, see Branden W. Joseph, "My Mind Split Open: Andy Warhol's Exploding Plastic Inevitable," in Stan Douglas & Christopher Eaman (eds.), *Art of Projection*, Hatje Cantz, Ostfildern 2009, p. 71–92.

[19] "Interview. Gabriele Jutz with Birgit Hein," in Matthias Michalka (ed.), *X-Screen. Film Installations and Actions in the 1960s and 1970s*, Museum Moderner Kunst Stiftung Ludwig/Walther König, Vienna/Cologne 2004, p. 125.

[20] *Juliet & Romeo* had been performed on several previous occasions, in particular during the Destruction in Art Symposium held in London in 1966. The performance in Knokke was different, mainly due to the participation of Sean Wellesley-Miller from the Eventstructure Research Group: balloons were inflated and smoke escaped from the costumes.

[21] *Trépied (Tribune mensuelle de ciné-jeune)*, no. 2, February
1968, p. 4–5. Translated into English in *Marcel Broodthaers.
Cinéma*, catalogue to the exhibition curated by Manuel
J. Borja-Villel and Michael Compton in collaboration
with Maria Gilissen, Fundació Antoni Tàpies, Barcelona
1997, p. 319.

[22] Harald Szeemann, interview with the author.

[23] P. Adams Sitney, "Report on the Fourth International
Experimental Film Exposition at Knokke-le-Zoute," p. 6.

[24] "We did this in order to encourage communication
between filmmakers about their work and between the
filmmakers and their audience. This seemed to us most
necessary in the field of experimental films where there
is a great risk of misunderstanding and incomprehension.
We hope to elicit and provoke these communications
on every level, be it economic, aesthetic, or critical"
(sic) (Foreword to the notices of *EXPRMNTL 4. Fourth
International Experimental Film Competition*, festival
catalogue, Royal Filmarchive of Belgium, Brussels 1967,
unpaginated).

[25] This historic encounter in Knokke was followed by a
second meeting in Munich, in November 1968, on the
initiative of Birgit and Wilhelm Hein and Klaus Schönherr.

[26] Jean-Pierre Van Tieghem, interview with the author,
Brussels, January 11, 1999.

[27] In 1966, Fluxus artist Dick Higgins theorized the concept
of intermedia, a particularly fertile notion given the
upheaval taking place in the arts at the time (*Something
Else Press Newsletter*, vol. 1, no. 1, February 1966). For an
exploration of this notion, and its relevance to the
understanding of the practices of expanded cinema, see
the article by François Bovier, "Du cinéma à l'intermedia:
autour de Fluxus," *Décadrages*, no. 21–22, Winter 2012,
p. 11–26. This is the opening article of a fascinating
special issue of the Swiss journal entirely devoted to
expanded cinema.

[28] "Cinémathèque Royale de Belgique, Exprmntl 4/
drukwerken/imprimés", print no. 25.

[29] Drugs: when the psychedelic explosion was at its peak
and in a festival where most of the entries sought to
heighten perception, drugs would clearly have been pres-
ent in Knokke. An account by an anonymous spectator,
recounting the way he had seen *Wavelength* under the
effects of psilocybin, is a typical example. Interview with
the author, Brussels, October 20, 2014.

[30] "B.R.T.-N.C.R.V.-O.R.T.F.-R.T.B. / Ecoute permanente
de bandes / Musique. Dix années d'activités musicales
1957/1967," text by Célestin Deliège copied as a handout
and distributed by the organizers during EXPRMNTL 4,
held by the Royal Belgian Film Archive.

[31] A group helped Ledoux to formulate his ideas and
produce the event. This programming team comprised
long-standing associates René Micha, Paul Davay,
Yannick Bruynoghe, and Dimitri Balachoff (all critics,
lovers of film and culture, and/or artists themselves)
and it helped Ledoux in a variety of ways, from seeking
funding to organizing non-cinematographic events,
not to mention selecting films.

[32] "They had come from all over. France, Germany, Italy,
England, the United States. In large numbers. Very large
numbers. Wearing animal furs and enormous houppelan-
des, the inevitable profusion of trinkets and necklaces
tumbling down their chests, hair unkempt, military
jackets and Lennon-style dark glasses ... and, on top of
that, the look of people seeking to startle others but who
themselves are fazed by nothing. 'They' were 'hippies' ...
Some, the more malevolent, advocated Political Revolu-
tion and called for direct action. All, without exception,
were in favor of the Cultural Revolution. They seized

hold of this poor Casino, normally a meeting place for
the Belgian bourgeoisie and a palace of wealth and luxury.
They made it their own. It had become a madhouse.
They were everywhere—camping out on the steps,
lounging about on the carpet, enjoying themselves
at the bar. Whether they were actually artists, or simply
pretending to be, mattered little at the end of the day.
What really mattered was that this 4th Experimental
Competition was theirs." (Christine Gobron, "Les carnets
d'une festivalienne. Une aventure psychédélique chez
les hippies," *Beaux-Arts*, no. 1189, January 13, 1968, p. 15).

[33] Jud Yalkut, "Freaking the Festival Factions. Report from
the Belgium Film Festival," *New York Free Press*, February
8, 1968, p. 14.

[34] Manuel J. Borja-Villel and Michael Compton (eds.), *Marcel
Broodthaers. Cinéma*, p. 52

[35] P. Adams Sitney, "Report on the Fourth International
Experimental Film Exposition at Knokke-le-Zoute," p. 9;
Jud Yalkut, "Freaking the Festival Factions. Report from
the Belgium Film Festival," p. 9.

[36] Some sessions are said to have lasted until 7 am. Marcel
Leiser, "Knokke le Zoute [sic]. 4e compétition interna-
tionale du film expérimental," *Travelling J*, no. 21,
May–July 1968, p. 31–34.

[37] Libertarian tramp and philosopher, pacifist, ecologist,
street speaker, Mouna Aguigui (1911–1999) was at the
height of his fame during May 1968.

[38] "Total expanded cinema experience" or "expanded arts
festival," in the words of Maximiliane Zoller speaking
of EXPRMNTL 4. Maximiliane Zoller, *Places of Projection.
Re-contextualizing the European Experimental Film Canon*,
Birkbeck College London, School of History of Art, Film
and Visual Media, London 2007, p. 129 and 124. (Doctoral
dissertation, Supervisor: Professor Ian Christie.)

[39] Raoul Maelstaf, "Knokke 1967–1968," *Cinema TV Digest*,
no. 18 (vol. 5, no. 2), Autumn 1967, p. 3.

[40] Elliott Stein, "Dr. Ledoux's Torture Garden," *Sight &
Sound*, vol. 37, no. 2, Spring 1968, p. 72.

[41] René Micha, "Cinéma expérimental," *La Nouvelle Revue
Française*, no. 184, April 1968, p. 717; Stéphane Bouquet,
Emmanuel Burdeau, "Rhizome universel. Entretien avec
Jean-Jacques Lebel," in *Cahiers du Cinéma*, special issue:
Cinéma 68, 1998, p. 65; Jean-Marie Buchet, interview
with the author, Brussels, November 12, 1998.

[42] Some were sympathizers of the Sozialistischer Deutscher
Studentenbund (SDS), the Federation of German socialist
students.

[43] Harun Farocki, "Written Trailers," in Antje Ehmann &
Kodwo Eshun (ed.), *Harun Farocki. Against What? Against
Whom?*, Koenig Books/Raven Row, London 2009, p. 222.
Farocki recalls the events of Knokke in the second of
the two films that his former classmate at the Berlin
Academy, Gerd Conradt (also present in Knokke in 1967),
made in honor of Holger Meins: *Starbuck - Holger Meins*,
Germany, 2001, 90'.

[44] The images shot during the festival by Claudia Aleman
& Reinold E. Thiel for Westdeutscher Rundfunk serve
to chronicle the events: *Experimental 4 — Knokke. Vierter
Wettbewerb des experimentellen Films*, televised report,
WDR, Cologne, 1968, 46'. In it, Aleman and Thiel would
implicitly appear to share the students' point of view.
In 1969, Thiel produced Harun Farocki's film *Nicht
Löschbares Feuer* (for which Gerd Conradt was cameraman).

[45] Harun Farocki commenting retrospectively on the events
of Knokke in Gerd Conradt's film, *Starbuck - Holger Meins*,
Germany, 2001, 90'. According to Farocki, Holger Meins
and Oimel Mai (who studied in Ulm) were to be the main
protagonists of these actions.

[46] Roland Lethem, "Koji Wakamatsu à Knokke, Noël-Nouvel
An 1967-68," published in Japanese in *Bun Gei*, special
issue Wakamatsu [*Koji Wakamatsu, The Genius Who Kept
Fighting*], Kawade, Tokyo January 2013, p. 135. Original
French text supplied by Roland Lethem. It was ironic
that the action of the demonstrators had hit the film of a
filmmaker so highly reputed for his political commitment
(in Japan at least) that students called him "Che."

[47] This text is reproduced in its entirety in P. Adams Sitney,
"Report on the Fourth International Experimental Film
Exposition at Knokke-le-Zoute," *Film Culture*, no. 46,
Autumn 1967, published—belatedly—October 1968, p. 6.

[48] While more than a third of the 90 films presented in
competition in Knokke had been produced in the United
States, Jonas Mekas, an indefatigable promoter of the
North American avant-garde, wrote, at the time of the
festival, the following, undeniably triumphalist, lines:
"Internationally, this year has been very busy for the
American avant-garde film. The Museum of Modern Art
sent extensive expositions to Japan and Asia. A letter
which just came from Calcutta says, 'The American avant-
garde shook India.' The Film-Makers' Cinematheque
shipped another huge Exposition to Europe (15 hours of
film), where it is being shown with tremendous success
(always sold out) in Italy, Switzerland, Germany, Austria,
Belgium, Yugoslavia ... The Film Museum of Vienna
devoted an entire month to the American avant-garde
film" (*The Village Voice*, vol. 13, no. 12, January 4, 1968,
p. 34).

[49] Werner Nekes, interview with the author, Brussels,
July 11, 1998.

[50] *The Village Voice*, vol. 13, no. 13, January, 11 1968, p. 43.
Kubelka's support for the students' action can be seen
in his opinion of the film selection: "the festival started
very sterile, and very dull—so many bad films. And then
THEY came ... the demonstrators ... " The following
extract, taken from a conversation between Mekas and
Kubelka, is no less revealing:
Jonas: "What about the prizes? Were they fair?"
Kubelka: "The Grand Prize to *Wavelength* was really
fair."
Jonas: "Did you see any promise in films from other
countries?"
Kubelka: "Most of them are completely insignificant.
But there was one interesting filmmaker from
Hamburg, very young, Werner Nekes. Then there
were two Swiss filmmakers, Klaus Schonherr [sic]
and Siber. Also, Alfredo Leonardi, from Rome.
I think they will make beautiful films some day."
In the same article, Mekas includes Kubelka (who lived in
New York at the time) among the filmmakers representing
the American avant-garde in Knokke.

[51] Harun Farocki, interview with the author, Brussels, April
20, 2013.

[52] Jean-Marie Buchet, "Ledoux exprmntl film," *Revue Belge
du Cinéma*, no. 40, November 1995, p. 33.

[53] Harun Farocki, p. 222. Among those students were
Hartmut Bitomsky and Wolfgang Petersen.

Socio-Ecologico-Critico Intruders in the History of Early French Video
Stéphanie Jeanjean

Fred Forest, *Les gestes du photographe* (Gestures of the Photographer), 1974 [1972]
Black and white video, 20 min.

On March 2, 2014 (Hollywood, LA), British video artist Steve McQueen received the Academy Award for Best Picture for his movie *12 Years a Slave* (2013). On that night, he not only became the first black director to obtain this distinction, but also the first visual artist honored by cinema professionals for his achievement in the film industry.[1] Beyond acknowledgment from cinema specialists and inscription in the history of cinema, his movie on slavery, described as his most traditional narrative work, has been guaranteed screenings in movie theaters and access to various dark rooms worldwide.[2] *12 Years a Slave* has been exposed to a large audience of cinema-goers and movie watchers, often not familiar with the visual artist, many of whom will access his movie from home, on DVD, as Play on Demand, or perhaps even pirated from the Internet. McQueen's exposure is enviable and his success admirable! However, acknowledging this path

reserved for the "best," underscores countless restrictions, most often set by the institution and industry themselves, which have affected visual artists in a diversity of ways; McQueen included. As a matter of fact, today, only few months after its "oscarization," *12 Years a Slave* is already no longer scheduled in New York's movie theaters, nor in LA, not even in London. It is effectively already out of sight of spectators, who have already moved on to the next "best thing."

In retrospect then, one might want to ask: What were the conditions of exposure and visibility for visual artists creating early video works, who did not benefit from this level of visibility? What was the conjuncture before—was it better or worse? What was it like to work with video in France, for example, where the camera and other media devices were commonly demonized as tools forged by industrial capitalism against a background of anti-American-ism prevalent in the 1970s? What happened especially to those who positioned themselves with non-narrative formats (specifically to challenge commercial exploitation practiced in cinema)? Furthermore, what were the factors for inclusion or exclusion, and the arguments justifying that these works be presented or not to an audience, when visual arts, independent video, video art, expanded and experimental cinema, cinema, and television were fields growing apart rather than together? Ultimately, how did these factors translate into spaces of visibility for artists? How did they cope with the customarily antithetical rapport between the darkened room of the movie theater and the white cube of the exhibition space, and how did they contribute to concepts of exhibited cinema?

In France, the most thought-provoking artists—whose works were already concerned with the consider-ations above in the early 1970s—were practicing forms of Conceptual art, performance, feminism, and socially and politically engaged art. They represented collectives and trends then identified as sociological art, ecological art, and socio-critical art, as well as collectives of women producing feminist video, who did not explicitly identify themselves as artists. Today, they are under-recognized and hardly remem-bered even in France. They were forgotten—or denied—during the institutionalization of video as a new medium of

the visual arts and seem almost to be intruders in their own culture. To explain their path, I will undertake an analysis of some of the pivotal events in this largely unexamined history, considering independent artistic endeavors, exhibition history, market opportunities, and cultural politics.

Artist Engineers and French Television

Despite the French government's well-established support for the arts, including visual arts—which has tended to be more developed in France than in many other countries— state funding has not reached the vast population of artists, and certainly not in any equal way. This was also true for artists who initiated video explorations. In fact, beginning in the late 1960s and early 1970s, due to problems of format compatibility and complaints about the amateur quality of production, independent video was banned in France from movie theaters to public television before it was even considered by artistic institutions (around the mid-1970s) as a medium for visual practice. In some respects, this con- trasted with the relatively larger exposure of independent production in the United Kingdom and in the United States, where artists were eventually able to buy segments on private and commercial television to broadcast their work. This was an option that was not available in France during the same period within the context of state-funded and controlled public television. Eventually, works were created even if they were rarely able to reach a considerable audience. Even today, the earliest videos, video installations, media art, and films by visual artists created in France are difficult to locate and are almost impossible to view. They are located in an alternative network of independent associations, known by word of mouth among the cognoscenti.[3]

 In France, starting in the late 1950s, an early phase of experimentation with film, video, and audio-visual technology took place within the framework of French television. In his dissertation *Reconsidération de l'histoire de l'art vidéo à partir de ses débuts méconnus en France entre 1957 et 1974* (Reconsideration of the History of Video Art from its Unknown Beginnings in France between 1957 and 1974), Grégoire Quenault compiles a little known fragment of the French history of video.[4] As early as 1957, he explains,

pioneering works were created at the RTF (French Radio-
diffusion and Television), later known as ORTF (Office for
French Radio and Television), especially at the Service de
la Recherche (Research Service), which was opened in 1960.[5]
From its inception and until its cessation in 1974, musicolo-
gist and acoustician Pierre Schaeffer—known since the late
1940s for his contribution to Musique concrète—directed
the Service de la Recherche.[6] The Service was composed
of four distinctive research groups: music, technology,
critical studies, and image. The last of these, the Groupe de
Recherche sur l'Image (GRI, Image Research Group) opened
in 1968. It employed visual artists, musicians, filmmakers,
scientists, philosophers, engineers, and audiovisual techni-
cians, who tested and tinkered with images in the form
of visual effects, graphic animations, abstraction, video clips
(associating music and image), as well as with the use of
electronic technology and colored images. From 1960 to
1974, some of the major names working for Groupe de
Recherche sur l'Image or at the Service de la Recherche
included Jean-François Lyotard, Robert Cahen, Dominique
Belloir, Martial Raysse, Raymond Hains, Jean-Luc Godard,
Chris Marker, Jean-Christophe Averty, Peter Foldès, Pierre
Henry, and Nicolas Schöffer. A couple of them (Cahen and
Belloir), who had been trained there, went on to develop
an independent video production in the late 1970s and 1980s,
after the Service de la Recherche had closed.[7] The Service
de la Recherche at ORTF is today acknowledged as a major
research institution in the fields of image and sound pro-
duction and television. It trained "artist-engineers" experi-
menting with video as well as with other technologies
associated with image in motion, not only using the latest
and most advanced video technology, but also contributing
to its development.[8] Paradoxically, the Service de la Recher-
che offered very limited creative freedom to its employees.
It was a closed institution, not known to be particularly
welcoming to independent visual artists (Martial Raysse and
a few others, who started going there as early as the 1960s
were exceptions) and their productions were hardly shown
on television, even if created within the framework of ORTF.[9]

In the early 1960s, Raysse was a promising young
artist. In 1965, at the age of 29, he was offered a solo retro-
spective at the Stedelijk Museum (Amsterdam). He had

started going to ORTF in 1960, when he worked with 16mm
film. There, in this format, he produced *Portrait électro-
machinchose* (1967) and *Camembert Martial extra-doux* (1969).
Both were recordings of provocative and parodic theatrical
performances, surprisingly critical and anti-Pop in charac-
ter, if one considers the conventional reading of Raysse's
work as a derivative of American Pop art. Also while at
the ORTF, in 1964, Raysse began experimenting with video,
which ultimately resulted in one of his greatest works,
Identité, maintenant vous êtes un Martial Raysse ("Identity.
Now you are a [work by] Martial Raysse," hereafter referred
to as *Identité*). *Identité* is the first video installation created
in France. It is also one of the first closed-circuit videos
ever produced internationally—according to Chrissie Iles,
the first closed-circuit installations in the United States
were created later, around 1968–1969, by Dan Graham,
Peter Campus, and Bruce Nauman.[10] *Identité* was first shown
in the exhibition *Cinq tableaux, une sculpture* (Five Paintings,
One Sculpture) at the Alexandre Iolas Gallery in Paris
(April–May 1967), but preparatory sketches by Raysse attest
that he had already conceived of his project as early as 1965.
Identité is comprised of a large wooden surface painted black,
about two-meters high, that leans on a wall of the gallery,
in the middle of which a generous oval shape—a simplified
contour of an oval face—has been cut out. A television
monitor is hung in the lower part of this hole and shows a
live recording from a video surveillance camera installed on
one of the walls adjacent to the wooden form and pointed
toward it. When the viewer approaches the piece, his or her
image is captured by the camera and transmitted, with a
time delay of a few seconds, onto the monitor at the center
of the black surface. Viewers face the monitor, but see
themselves from above and behind, making them aware of
being observed. This contradicts their expectation of seeing,
in the monitor, something like a reflection of themselves
or something wholly unrelated to themselves altogether.
However, as Raysse stated in his title, participating in the
installation resulted in the viewer becoming (part of) a work
of art by him. Captivated by the work, the viewer is absorbed
into it, hence the sense of loss of identity and loss of
connection with the self (as one usually constructs or
engages with it), comparable to an out of body experience.

Nauman later achieved similar effects in works such as
Live-Taped Video Corridor (1970). Having worked primarily as a
painter and sculptor, *Identité* is one of the few video installa-
tions Raysse ever created.[11] He was nonetheless already
somewhat identified as contributing to video when he
was invited to *Art/Vidéo Confrontation 74*, the first exhibition
dedicated to video art organized in France, in 1974, for
which he proposed his videotape *Lotel des Folles Fatmas* (1974).

The Exhibition History of Early Video in France

Art/Vidéo Confrontation 74 took place at the Musée d'Art
moderne de la Ville de Paris from November 8 to December
8, 1974, within the framework of the *Festival d'Automne*.[12]
It was organized by ARC 2 and CNAAV (Centre National
d'Animation Audio-Visuelle) and was curated by its respec-
tive directors, Suzanne Pagé and Michel Fansten. Dany Bloch
and Don Foresta were also associated with the exhibition's
organization. Bloch assisted Pagé on this occasion and later,
in the early 1980s, became known for curating and writing
extensively on video. In 1974, Foresta was director of the
American Cultural Center in Paris, then known as the
American Center (a position he occupied from 1971 to 1976)
where he pioneered the exhibition of video art in France.[13]
Foresta's involvement in the exhibition *Art/Vidéo Confrontation*
allowed the list of participants to be expanded to include
a significant number of American artists, most of whom
had previously worked with Foresta at the American Center.
This list of artists included: Vito Acconci, John Baldessari,
Lynda Benglis, Peter Campus, John Chamberlain, Douglas
Davis, Frank Gillette, Dan Graham, Nancy Holt, Allan
Kaprow, Paul Kos, Les Levine, Robert Morris, Bruce
Nauman, Denis Oppenheim, Nam June Paik, Richard Serra,
Keith Sonnier, Bill Viola, Steina and Woody Vasulka, and
William Wegman to name but the most renowned. As
Jean-Paul Fargier recalls: "It was in 1974 at the MAMVP that
the museum enthroned video as an art form."[14] *Art/Vidéo
Confrontation* was the first exhibition of this scale dedicated
to video to take place in a French institution.
 1974 was a respectable date for showing video in
a museum setting; although earlier examples of video
exhibitions had taken place in the United States, Germany,

the United Kingdom, and Canada, these were primarily in commercial galleries.[15] However, the closest comparison, with respect to the curatorial goal consisting in presenting video as a new artistic medium for the visual arts and defining it within a wide diversity of international practices, was the noteworthy exhibition *Impact Art Video Art 74*.[16] It was an eight-day video event that had opened just a month earlier (October 8–15) that same year, organized by the Groupe Impact (Henri Barbier, Serge Marendaz, Jean Otth, and Jean-Claude Schauenberg), at the Musée des Arts Décoratifs de la Ville de Lausanne.[17] The exhibition included 120 artists from 15 countries, representing video art along with sociological, political, and educative video.[18] The Parisian exhibition *Art/Vidéo Confrontation* assembled an enormous variety of video practices, with 125 artists representing a large range of countries (Belgium, Canada, Cuba, France, Israel, Italy, Japan, Germany, Greece, Norway, Quebec, Spain, Switzerland, Turkey, UK, USA, etc.) and aligning video with Body art, performance, installation, environment, theater, sociological art, socio-critical art, along with more formalist and medium-based videos, were exhibited as video art. Many of the same artists participated in both exhibitions (*Impact Art Video Art* and *Art/Vidéo Confrontation*), often even presenting the same pieces, despite the fact that the exhibitions remained independently organized.

The international dimension of *Art/Vidéo Confrontation* was one of the curators' primary goals. Eventually, the show attempted to inscribe French production within an international framework, even though US artists were twice as numerous as the French were. There were no French artists as committed to video in the early 1970s as American artists such as Vito Acconci, Dan Graham, and Nam June Paik. The French most genuinely interested in video were probably Roland Baladi, Robert Cahen, and Fred Forest. However, video was just one of many media Forest used at that time, the same being true of Baladi (who presented in the exhibition a series of videotapes made with students from the École des Beaux-Arts in Nancy). Moreover, Robert Cahen's independent video work only developed later in the 1980s; in 1974 he showed works created at the ORTF Service de la Recherche. Other French artists participating in the *Art/*

Vidéo Confrontation used video only very occasionally in their careers, along with other media that they clearly favored (photography, installation, performance, film, and so on ...). Artists such as Gérard Fromanger, Paul-Armand Gette, Martial Raysse, and Christian Boltanski, for example, ultimately used 16mm film rather than video, even when the final quality sought did not visibly require professional film format. It is significant that the majority of French artists invited to participate in the exhibition were using video for the first time, with video equipment lent to them specifically for the purpose of making works for the show, and then went on to never or rarely work in video again (Bernard Borgeaud, Gérard Calisti, Patrick Hugues, Michel Kanter, Bertrand Lavier, and Christian Tobas).

 Art/Vidéo Confrontation was organized around three independent sections: "Art Vidéo" (Video Art), "La Vidéo et les Artistes" (Artists and Video), and "Environements" (Environments). The majority of French artists were included in "Artists and Video" (in comparison to "Video Art," which presented formal and self-referential use of the medium and was mostly represented by American artists). "Artists and Video" gathered together works using the video camera principally as a tool to record performances; this type of relationship to video specifically concerned Body art and primarily involved self-recording. In this section Gina Pane presented her videos *Self-Portrait* (1973) and *Psyche* (1974), both of which were based on recordings of her performances. Significantly, as we shall see later, this is only to the credit of Carole Roussopoulos. Regrettably the exhibition ignored her important contribution to militant and feminist video documentation and exploration while she was living and working in Paris.[19] Conversely, Christian Boltanski was included in this section of the exhibition with videos based on his autobiographical performances. *La vie c'est gai, la vie c'est triste* (Life is Happy, Life is Sad, 1974) showed the artist simultaneously crying and laughing; and *Quelques souvenirs* (Some Memories, 1974) was a series of sketches played by the artist based on his own memories of a tormented childhood (both videos were previously shown in the exhibition in Lausanne). Nil Yalter (born in Cairo, educated in Turkey, and then living in France since 1965) was also included in the section "Artists and Video." Not yet

a video artist at the time she was invited, she presented her first video, *La Femme sans tête ou la danse du ventre* (The Headless Woman or Belly Dancing), created in 1974 for the exhibition with video equipment lent to her by the organizers of the show.[20] The work features a dance performance focusing on the naked hips and bellybutton of a dancer (played by Yalter) writing on herself in capital letters, along her hips and in circle from inside/out around her bellybutton: "LA FEMME VÉRITABLE EST À LA FOIS 'CONVEXE' ET 'CONCAVE'" (The True Woman is Both "Convex" and "Concave"). The image is accompanied by the sound of oriental music and of the authoritative voice of the artist reading quotes from *Erotic and Civilizations* (1972) by René Nelli (Occitan writer and historian of civilization, specialized in courtly love). Consequently, Yalter continued working with video throughout the 1970s, which she often associates with photography in installations, and that was eventually referred to as socio-critical art. She focused her investigations on minorities, primarily documenting the challenging conditions of seclusion and exclusion faced by those most representative of the then latest waves of immigration in France: Turkish, Algerian, and Portuguese. Particularly concerned for women, for instance, she worked together with Judy Blum and Nicole Croiset, on *La Roquette, prison de femmes* in 1974; a video that was recorded at and about women prisons.[21] Distinctly, in the section "Artists and Video," the above-mentioned works on display used TV monitors arranged in the show's rooms, making the exhibition look more like an electronic store than an art museum.[22]

By contrast, the last section, "Environment," compiled video installations and artistic actions. "Action" was a term preferred by some artists in the 1970s (Fred Forest used it, for example). Rather than performance, it refers to the unstaged quality of their work, which was principally built from interactions with an audience. "Environment" was, therefore, the place where most sociological works conducted by visual artists were located. There was Fred Forest (born in 1933 in what was then French Algeria, moved to Paris in 1967), who by 1974 was definitely already keen to use video in his artistic work. In the exhibition, he presented a new installation part of his socio-analytical project series using video surveillance. *Socio-analyse de la circulation parisienne*

(Socio-Analysis of Parisian Traffic, 1974) was a closed-circuit video apparatus using video surveillance to record urban traffic in Paris, with a camera placed just outside of the museum (on Avenue du Président Wilson), recording live from the street and transmitting it back in real-time in the exhibition rooms. A year earlier, Forest had conceived similar installations where he started using image technology as a tool for sociological investigation of given sites and situations, which allowed him to expose human organizations as well as media ability to manipulate behaviors and perception. Forest focused on these notions in a series of closed-circuit installations, first created for galleries, where he dimmed the white cube to allow the projected image. Key examples of this body of work were *Archéologie du présent: Autopsie de la rue Guénegaud* (Archeology of the Present: Autopsy of Guénegaud Street), held at Germain Gallery, Paris, in May 1973, and *Autopsie et analyse électro-sociologique de la rue Augusta: Petit musée de la consommation* (Autopsy and Electro-Sociologic Analysis of Augusta Street: Small Museum of Consumption) at Portal Gallery, São Paulo, in December 1973.

 Autopsie de la rue Guénegaud was an investigation of a quiet, narrow street in the 6th arrondissement in Paris, where the gallery was located. For this project, the entire length of the street was placed under video-surveillance with three closed-circuit cameras broadcasting, in the gallery and in real-time, the activities taking place in the street. The street was then shown in the exhibition as a life-size video projection on one of the gallery walls. The wall text accompanying the projected image stated: "CE DOCUMENT QUI VOUS EST PRÉSENTÉ ICI DATE DES ANNÉES 1973, DE MAI 1973 TRÈS EXACTEMENT, À CETTE ÉPOQUE LA RUE GUÉNEGAUD ÉTAIT … " (This document, which is presented to you, was created in the years 1973, May 1973 to be precise, at this time the Rue Guénegaud was …). Broadcasts from the three-cameras in the street were also available on ten television monitors arranged as a video wall inside the gallery, very much like a surveillance room. At the same time, more cameras recorded the interior; this recording was shown on a monitor visible through the gallery's vitrine, for passersby in the street. Put simply: whether by means of their virtual presence as video images,

or watching what was in the gallery on a TV screen, viewers in the street found themselves "in" the gallery space before, or independently of, actually entering it. Forest also insinuated that images mediated on screens result in a perception of the present as something experienced in the past, and other similar distortions particularly involving time and space. In addition to this relatively complex camera and screen setup, the gallery space also displayed an installation of trash and objects found in the street. A further element in the show was a punch clock with which visitors at the exhibition were encouraged to punch their invitation card and record the exact day and time of their visit and awareness of Guénegaud Street. The punched card was a gift, a personalized multiple, from the artist to potential collectors visiting the show. Its explicit reference was to that of the gesture of starting a day's work for countless factory workers throughout industrial France. Expanding the documentation of the project, Vilém Flusser (existentialist and phenomenologist philosopher) as well as art critic Pierre Restany (known in relation to Nouveau Réalisme) were invited to provide comments about the street through sound recordings of their observations, which were available in the exhibition. Lastly, seven months later in São Paulo, Forest conceived a very similar project mixing installation and video surveillance in *Autopsie de la rue Augusta*, at Portal Gallery, São Paulo, 1973. In each manifestation the artist's project tested in real-time the socioeconomic and geopolitical conditions of living.

When the exhibition *Art/Vidéo Confrontation* opened, Forest participated in discussions that defended a sociological approach to art. As a matter of fact, less than a month before the exhibition opened, he cofounded the Collectif d'art sociologique (Sociological Art Collective) with Hervé Fischer (b. 1941, visual artist and philosopher) and Jean-Paul Thenot (b. 1943, a trained and practicing psychologist, who studied with Jean-Francois Lyotard). As a collective, Art sociologique was active from 1974 to 1981.[23] It promoted an approach akin to that of the social sciences and was also concerned with society, the relationships among individuals, as well as the relationship between art and people. Fischer, Forest, and Thenot publicly defined their positions in a co-signed the "First Manifesto" written on October 7 and

published on October 10, 1974, in the national newspaper, *Le Monde*. It is where they explain that

> (*Art sociologique*) fundamentally makes use of the theories and methodologies of the social sciences. In practice, it also wants to create a field of investigation and experimentation for the theory of sociology. The *Collectif d'art sociologique* … uses the methods of animation, survey, and pedagogy.[24]

For *Art/Vidéo Confrontation* each of the three members presented independent work in the form of videotapes, as they often did during their periods of activity within the collective, and perhaps also due to the young organization's lack of time to coordinate a collective action.[25] Therefore, in addition to his video-surveillance project, Forest showed *Les gestes du coiffeur* (The Hairdresser's Gestures, 1974)— isolating, recording, and decoding gestures associated with different professions and/or socio-professional activities. From 1972 to 1974, Forest developed a body of works involving videotapes used as a mean to record human behaviors. He focused on the observation of gestures in everyday life and, more specifically, on the theme of professional gestures involved in social relationships. Forest recorded a photographer (as an illustration of this text), a hairdresser (shown in Paris in 1974), and a professor (featuring Vilém Flusser).[26] As for Hervé Fisher, at the exhibition *Art/Vidéo Confrontation*, he proposed his video *Hygiène des chefs-d'œuvre* (Hygiene of the Masterpieces, 1974) from his series *Hygiène du musée* (Museum Hygiene), an anti-museum project that discussed the symbolic destruction of works of art. Jean-Paul Thenot presented *Constat d'enquête* (Survey Results, 1974), a sociological and perceptual study of colors, recorded with video. Notably, the works listed above had been created with the art institutions, museums, and galleries in mind and were intended to be shown in those associated exhibition settings.

 Other artists were invited to participate in *Art/Vidéo Confrontation* who, even if they had not enlisted with the *Collectif d'art sociologique*, had expressed similar interests, adopted related methodologies, and themselves broadly interrogated the relationship between art and society

(thus the terms sociocritical art or ecological art sometimes used to characterize their work). Equal to the collective, their pieces were envisioned for museums and galleries, and generally developed in the form of installations encompassing written documents, diagrams, photographs, and/or videos. For instance, Argentine-French Léa Lublin (1929–1999, in Paris since the early 1970s, and notably one of the few women included in the exhibition) had developed projects entitled *Dedans/Dehors Le Musée* (Inside/Outside the Museum, first made for the Museo Nacional de Bellas Artes, Santiago de Chile, in 1971), which conflated the inside and the outside of the museum, and reflected on the level to which the reception of art had been mediated by the institutional cultural machinery. From there, and for the exhibition *Art/Vidéo Confrontation* in Paris, Lublin proposed *Polylogue extérieur: Dedans/Dehors Le Musée* (Exterior Polylogue: Inside/Outside the Museum, first shown at Yvon Lambert Gallery earlier in 1974), which included video interviews using elaborate artistic discourses by French art critic Marcelin Pleynet, and philosopher Philippe Sollers talking about art, which contrasted with a modest installation using slide projections with reproductions of works from the history of modern art. Furthermore, Lublin expanded this work in a series called *Interrogations sur l'art* (Interrogations on Art, 1974–1991) for which she employed a set of questions formulated as such: "Is Art Desire?" "Is Art a System of Signs?" "Is Art a Concept?" "Is Art Ideological?" "Is Art a Mystification?" "Is Art a Sublimation?" "Is Art a Neurosis?" etc. Using video to harvest responses from society at large (artists, critics, writers, philosophers, economists, scientists, as well as anonymous passersby, women and men in the street), she articulated a popular version of institutional critique that presented a diversity of opinions, as well as indifferently formulated good and bad reactions to art. She continued and repeated the experiment (in France, Germany, Italy, etc.) with the inhabitants of the cities and diverse audiences of the exhibitions to which she had been invited. It must be recalled that, early on, Lublin had already radically moved the discourse of art to address life. In 1968 she had attracted public attention with *Mon fils* (My Son), during the *Salon de Mai* (May Salon) at the Musée d'Art moderne de la Ville de Paris when, during administrative

hours for the month-long show, she exhibited herself taking care of her seven-month old son, Nicolas. Performing her daily routine before museum-goers, in the form of a doubled working shift allowed Lublin to not only demonstrate aspects of her condition as a woman artist responding to the museum invitation for a solo show, but more generally giving testimony and creating documentation of the situation of any working woman becoming a new mother. Still too early for portable video (which arrived in France later that year, in 1968), this performance work was documented with photography exclusively.

Roland Baladi (b. Cairo, 1942, lived in France in the 1970s) was also included in the section "Environment." He presented *Ecrire Paris avec les rues de cette ville* (Writing Paris With the Streets of this City, 1973), a project based on the artist riding his motorcycle through the city and writing the letters of the word "Paris" by tracking his motion in the streets. The action was documented with a map and a video recording, which together formed an installation that even included a motorcycle on which the visitor was invited to sit while viewing the video presented on a small camera-controlled screen. The artist insisted that promoting writing in the city, rather than indicating what to write, was ultimately the purpose of his work. Similarly, both Forest and Lublin rarely expressed their personal opinions in their work, preferring to use them to create spaces and/or situations of communication for viewers to appropriate, and in essence shape with their own perceptions and experiences. However, beyond giving access to speech, if there was a political dimension to these projects, it was fed particularly by the specific contexts in which the critical engagement occurred, as well as by the nature of the viewers' contributions. For example, Forest noted that the audience's responses he collected in Brazil had a highly political dimension—that did not exist in those he collected in France—reflecting the situation of the then ruling political dictatorship.[27] Between 1964 and 1985, Brazil was under the control of successive military regimes, which heavily constrained the freedom of speech and democratic principles. In contrast, the French responses were far less politically revealing and more disillusioned with economy, politics, and governing institutions. As a matter of fact,

France in the 1970s was marked by a climate of political disenchantment and economic struggle, due to the instability on the European and US stock markets. The resulting cynicism was exacerbated with the oil crisis of 1973 and massive layoffs. Nevertheless—and despite the conditional political dimension of some of their works—the artists associated with sociological art and socio-critical art most often asserted a non-demagogic approach to the relationship between art and audience, directly opposing manipulations and pressure exercised by institutional power.

Art/Vidéo Confrontation remains one of the first international surveys of video art (history). With regards to French video, it marked an attempt to institutionalize the medium as new, almost before it was even really practiced by visual artists in the country. And despite meager critical feedback in the press, it looms as a pivotal event in the history of video. Even so, *Art/Vidéo Confrontation* was not a single curatorial initiative welcoming a sociological approach to art; it was followed a year later, in November and December 1975, by the less known exhibition *Une expérience socio-écologique: photo, film, et vidéo: Neuenkirchen 75* (A Socio-Ecological Experience: Photo, Film, and Video, Neuenkirchen 75, hereafter referred to as *Neuenkirchen*). It was also organized by ARC 2 and took place at the Musée d'Art moderne de la Ville de Paris, during November and December 1975. Suzanne Pagé (of ARC) curated it in collaboration with Pierre Gril of the Office Franco-Allemand pour la Jeunesse (or OFAJ, Franco-German Youth Office), a binational governmental agency for the promotion of French and German friendship and cultural exchanges. The exhibition presented 15 French and 13 German artists, side-by-side, and aimed to have them promote an interrogative and critical approach to art, working together on studying the sociological context of Neuenkirchen, a tourist town near Hamburg in Lower Saxony.[28] The artists were invited to stay in Neuenkirchen for a three-week period (in June 1975), during which time they were expected to mingle with the city's inhabitants and conceive works. Ultimately, the pieces exhibited undeniably resulted from the artists' experiences in the town and often involved direct interactions with the locals.

The Collectif d'art sociologique was invited to participate in *Neuenkirchen* and again proposed a collective project in addition to the inclusion of individual works by each of the three members. For the latter, Forest showed *Vidéo-gazette action de dynamisation sociale* (Video-Gazette Action of Social Dynamization) in which he recorded informal conversations with the local population in Café Müller. Fisher reenacted an older performance piece, *Pharmacie Fischer & cie* (Fischer's Pharmacy & Co.), in which the artist dressed as a pharmacist and sold pills to passersby in the streets of Neuenkirchen (an action recorded on video by Forest). Thenot proposed *Contrat socio-thérapeutique* (Socio-Therapeutic Contract), a document signed between the artist and his viewers negotiating their collaboration toward the creation of the viewer's photographic portrait. The contract discusses the nature of the portrait, the sitter's intention, the portrait exploitation by the artist, privacy agreements, etc. With this project, Thenot intended to interact with Neuenkirchen's inhabitants and get a better understanding of their own image, which they hoped to communicate. As for the Collectif d'art sociologique's collaborative project *Conversations: Neuenkirchen est-elle un paradis?* (Conversations: Is Neuenkirchen a Paradise?), it consisted in a dialogue with the town's inhabitants developed around the question in the title. The collective interviewed random bystanders at the supermarket, in the parking lot, at the pharmacy, and in the street. The question functioned as an open call urging the locals to express their individual and collective hopes, or to formulate concerns about their daily life and/or residential situation. Most of them, rather old, avoided engaging with the questions and minimized potential hardship they encountered. The conversations, in German, were recorded with video and the tapes were then shown in Paris, as audiovisual material documenting the sociological action and interactions as both art and social practice.

Similarly working from a survey for Neuenkirchen's inhabitants, Léa Lublin presented a piece from her series *Dedans/Dehors Le Musée. Interrogations sur l'art* (see previous description), entitled *Qu'est ce que l'art?* (What is Art?). It involved asking onlookers to answer questions—written on banners hung at the entrance to the town and in front

of the supermarket—interrogating art's honesty and capacity to truly reach an audience. Inhabitants' answers were recorded with video; they represented a diversity of visions, ideas, and reactions to art, or to the questionnaire itself. As for Nil Yalter, she documented aspects of the town's social fabric and traditions with an installation composed of photographs, a short video, texts, and two series of drawings depicting portraits confronting the routines of an immigrant cleaning lady who worked for the local Gallery Falazik, and of local men shooting guns in preparation of the annual village celebration. Ultimately, the most provocative work in the exhibition was by the Paris-based Spanish artist Joan Rabascall, who took a helicopter trip around Neuenkirchen to locate the sites of former concentration camps—numerous in this region of Germany—which he documented on video and with still photography. He then produced a series of postcards of these sites that he left on a display in one of the town's tourist shops. This work tested not only the population's relationship with its past, but also more generally Franco-German friendship, still at the time a rather fragile concept.

Neuenkirchen remains as an important if isolated example in French curatorial history, since no other national institutions on ARC's scale either supported or undertook the exhibition of works associated with sociological art, ecological art, and socio-critical art. Despite this, through-out the late 1970s and 1980s the artists continued to develop sociological works alongside the institutionalization of the medium by the visual arts.[29]

The Institutionalization of Video Art

A crucial stage in the French institutionalization of video was the creation of Département Nouveaux Médias at the Centre Pompidou in Paris, which concentrated on video and screen-based practices, including video installations and interactive environments. The Centre Pompidou had begun acquiring video art in the late 1970s; today it continues to be in charge of the video collection for the entire Musée National d'Art Moderne, the French national collections. When the Centre Pompidou officially opened to the public in 1977, video was already somewhat identified as an art

medium and was regularly included in the museum's programming. It was first associated by default with the large department that grouped together photography and film. This allowed video to be first shown in the Centre's projection rooms, based on display modes inspired by film that involved specific viewing times and fixed seating. However, when Christine Van Assche started working at the Centre at the beginning of 1980, she requested that video be included within the Department of Visual Arts and consequently presented in the museum's exhibition galleries.[30] This shift in viewing parameters, from theater projection to exhibition rooms, prompted the creation of the *Département Nouveaux Médias*. It also defined a preference toward video installations occupying exhibition spaces. Today, the New Media collection at the Centre Pompidou is considered one of the best of its kind in the world. Not only is it one of the oldest, it is also one of the most diverse collections, enabling the reconstruction of an international history of video and video installation from early pioneers to the present day. This is especially true if one considers that most international museums waited much later, often until the 1990s, before beginning to make video acquisitions part of their permanent collections.[31] Contemporarily to the creation of Département Nouveaux Médias at the Centre Pompidou, in the late 1970s, a handful of other institutions in Europe also began collecting video and new media art for their collections; namely: the Stedelijk Museum in Amsterdam, the Kunsthaus in Zürich, the Kunstmuseum in Basel, and the Ludwig Museum in Cologne.[32]

It is interesting to note that the first video installation to enter the French national collections was Dan Graham's *Present Continuous Past(s)*, created in 1974 and acquired in 1976; and that the oldest piece in the collection is Nam June Paik's *Moon is the Oldest TV* (1965), acquired by the Département Nouveaux Médias in 1985. By 2006, the Video and New Media collection at the Centre Pompidou comprised 85 installations and 1,200 videotapes, out of which only few works were by French artists—in particular the ones created between the mid-1970s and 1980s, or those acquired long after they had been created (for example Yalter's 1970s video acquired in 2007 and 2013). There were a few exceptions representative of the Internationale Lettriste

(Jean Dupuy and Ben Vautier), Fluxus (Robert Filliou), Body art and performance (Gina Pane and Michel Journiac), and a few other independent figures including filmmakers (Chris Marker and Jean-Luc Godard). Considering the choices made for the national collections, it is clear that militant video from the 1970s, as well as sociological art and socio-critical art, which were also often the most radical and experimental, have been almost completely overlooked. The only exemption was *Jean Genet parle d'Angela Davis* (1970), a video by Carole Roussopoulos, acquired in 2001. Created prior to her involvement with feminist collectives, it is arguably perhaps one of her "safest" works, addressing issues far from home (across the Atlantic ocean), as it advocated in favor of the Civil Rights Movement in the United States. Roussopoulos' was in fact the only example of militant video by a female videographer in the collection until 2012, when, in response to a very recent interest in France in militant women's production, the explicitly feminist video *Maso et Miso vont en Bateau* (1976) by the collective Les Insoumises (Roussopoulos with Delphine Seyrig and Ioana Wieder) was acquired by the Département Nouveaux Médias.[33] As yet, no works by Forest, Baladi, or Lublin have been acquired for the New Media collection, even if few recent programs, exhibitions, and conferences organized by the Centre Pompidou indicate an attempt to conceal their obvious absence.[34]

Clearly, the constituted New Media collection was never intended to reflect the national production of con-temporary video; instead it focused on composing a broad international survey of screen-based artistic practices; a common model, as demonstrated also by the first video exhibition. Inevitably, a major aspect in the composition of collections also corresponded to the tapes readily available in copies on the video market during a specific period. By the late 1970s and early 1980s American video was the most accessible and well distributed. It was easy to acquire and also relatively cheap. As a result, a similar trajectory of occurrences can be traced regarding the video collection at the Kunstmuseum in Basel. It was started in 1977 with American video (especially Acconci, Nauman, and Warhol). Only in the 1990s did a larger proportion of Swiss artists enter the collection. By contrast, early on the Whitney

Museum and the Tate Gallery placed an emphasis on showing and supporting their respective national artists. For instance, the first acquisition of video at the Tate Gallery was a work by Gilbert & George (bought in 1972); the Whitney bought works by Nam June Paik (1982) and Mary Lucier (1983).[35] Back in France, however, the national collections gathered together works to produce a history of video that was gradually defined as video art, a category that originated with, and was best exemplified by American artists. In this equation, militant video by women collectives, sociological art, ecological art, and socio-critical art were by then considered too intertwined with sociology and too political to fit the restrictive concept of what constituted artistic practice.

Rediscovery and Reintroduction

Recent institutional trends toward participatory art, socio-politically engaged art, critical engagement art, and different forms of media activism, championed by younger generations of artists in the 1990s and early 2000s, have retroactively expanded the definition of what constitutes artistic inquiry and practice. Earlier forgotten and/or largely unseen works have become newly relevant within these emerging fields of interactive viewing and participatory making. Almost as intruders within their own culture, early French video creators form what Branden Joseph has called in reference to Tony Conrad a "Minor History" inhabited by under-recognized figures absent from canonical histories, who nonetheless define the artistic landscape and chart regimes of power.[36] Similar concerns are raised again: What are, or are there any, spaces for creativity and visibility left outside of the commercial sphere—particularly when social and political topics become adopted as themes by art institution as possible business models? Are "unaligned" artistic forms of political and social action still achievable? What lingers from the artist's initiative? In the early approaches to video described above, artists saw in video a more democratic means of expression and communication (relative to television and cinema), and embraced this potential to serve and reach a larger audience. They created works beyond themselves and art itself, based on interaction

and participation, taking society, social relationships and
behaviors as their principal object of analysis. The most
formulated goal of their practice is to give a voice to others,
to involve participants freely nourishing an unscripted
content informed by and informing the conditions of their
lives, their opinions on the state of the world, their relation-
ship to it or to art, as well as the aspirations and dreams
they still harbored. These early video artists created an
expanded approach to exhibited cinema by working beyond
the borders set by the art system, outside of usual institu-
tional frames and spaces of creativity and visibility. Most of
their works developed in the public sphere, in direct relation
to society, opting for decidedly new modes of presentation
and representation beyond the confinement and restrictions
of the black box, the white cube, or specific configurations of
"proper" viewership. Using video, these early experimenters
posed new and seemingly extraordinary contexts for art:
at work (at union meetings), in militant circles (in feminist
meetings), at the supermarket, parking lots, the street, etc.
allowing them to exhibit society to its inhabitants.

[1] McQueen is familiar with illustrious artistic distinctions; he had been honored before, in 1999, with a Turner Prize (the British visual art award organized by Tate) and, in 2008, with a Caméra d'Or for his movie *Hunger* (2008), at the Cannes Film Festival.

[2] Centre audiovisuel Simone de Beauvoir facilitated a projection of *12 Years a Slave* at Maison d'arrêt des femmes de Fleury-Mérogis (Fleury Mérogis Women's Prison, in the southern suburb of Paris) in April 2014, followed by a debate with Harold Manning, translator of the French version of the movie.

[3] For example at the Centre Audiovisuel Simone de Beauvoir, CJC (Collectif Jeune Cinéma), Le Peuple Qui Manque, Light Cone, and Re:voir Video, all of which are located in Paris.

[4] Grégoire Quenault, *Reconsidération de l'histoire de l'art vidéo à partir de ses débuts méconnus en France entre 1957 et 1974*, PhD dissertation, University Paris 8, Paris 2005.

[5] Service de la Recherche was a state run organization that operated under the tutelage of the French Ministry of Information. The RTF (1949–1964) and ORTF (1964–1974) were public offices in charge of producing and programing for French radio and television. For more information on the Service de la Recherche, see Denis Maréchal, "Le Service de la Recherche," in Jérôme Bourdon et al. (eds.), *La Grande Aventure du petit écran: la télévision française 1935-1975*, Musée d'Histoire Contemporaine, Paris 1997, p. 164–165.

[6] For more information on Pierre Schaeffer, see Jocelyne Tournet, *Coup d'œil sur l'œuvre de Pierre Schaeffer*, INA-Institut National de l'Audiovisuel, Paris 1990.

[7] In addition, one should consider Thierry Kuntzel, Dominique Belloir, Patrick Prado, and Catherine Ikam, who trained and worked at INA (National Audiovisual Institute), a governmental organization founded in 1975, which eventually replaced ORTF. They created formal and introspective works with video, which often developed into installations, and were exhibited and collected by French institutions when they were created in the late 1970s and throughout the 1980s.

[8] For example Marcel Dupouy invented the "Movicolor," a synthesizer for colorizing and creating special effects on video at ORTF in 1973.

[9] Quénault qualifies the work by these artists as "Intrusions in the Service de la Recherche." See Quénault, "Les intrusions au sein du Service de la Recherche," *Reconsidération de l'histoire de l'art vidéo*, p. 342–431.

[10] Chrissie Iles (ed.), *Into the Light: the Projected Image in American Art 1964-1977*, Whitney Museum of American Art, New York 2001.

[11] Raysse, *Identité, maintenant vous êtes un Martial Raysse (1974)* was acquired, in 1991, for the new media collection of the Musée National d'Art Moderne, at the Centre Pompidou, Paris.

[12] An exhibition catalogue was published: Dominique Belloir, Dany Bloch, Claudine Eizykman, Michel Fansten, Don Foresta, and Yann Pavie, *Art/Vidéo Confrontation 74*, Musée d'Art moderne de la Ville de Paris, Paris 1974.

[13] At that time, Foresta had already established long-lasting relationships and friendships with Nam June Paik and other forerunners of video art, such as Steina and Woody Vasulka. As early as 1971, Foresta started presenting their videos at the American Center, along with those of Frank Gillette, Bill Viola, and Gary Hill. These presentations were the first opportunity to see American video in France. Ramon Tio Bellido recalls that these video presentations used a modest television monitor coupled with television furniture facing 20 or 30 chairs. Ramon Tio Bellido, email correspondence with the author, July 27, 2012.

[14] Jean-Paul Fargier, "Histoire de la vidéo française.Structures et forces vives (1992)," in Nathalie Magnan (ed.), *La Vidéo entre art et communication*, École Nationale Supérieure des Beaux-Arts, Paris 1997, p. 55. My translation.

[15] The earliest exhibition history of video art developed in private commercial galleries: *Exposition of Music, Electronic Music Television* at Parnass Gallery in Wuppertal (March 1963), with Nam June Paik, and *Television Décollage* at Smolin Galery in New York (May 1963), with Wolf Vostell. In New York, Bonino Gallery organized Paik's second solo show in 1966. Castelli and Sonnabend Galleries were also active with video in the late 1960s; together they formed the *Castelli-Sonnabend Tapes and Film* (a collection of early video from the 1960s and 1970s, today reconstituted at the Whitney Museum as a special collection within the permanent collections). The Howard Wise Gallery was also committed to video, and organized the celebrated exhibition *TV as a Creative Medium* in 1969. That same year, Gerry Schum opened the first video gallery in Düsseldorf. Video exhibitions in museums were an exception; the Everson Museum in Syracuse was pioneer in showing video as early as 1967. The Vasulkas started promoting and presenting video at the Whitney Museum in 1971, and the same year founded The Kitchen as an artists' collective.

[16] As pointed out by the editors.

[17] René Berger was the Director of the Musée cantonal des Beaux-Arts de Lausanne, from 1962 to 1981.

[18] As mentioned in the "Introduction" of the exhibition catalogue *Impact Art Video Art 74*, Galerie Impact and Musée des Arts Décoratifs de la Ville de Lausanne, Lausanne 1974. Also included in the catalogue was René Berger's essay "Art vidéo: défis et paradoxes" (dated August 1974). *Impact Art Video Art 74* was itself a development from an earlier exhibition, *Action/Film/Video*, also organized by Impact, at Galerie Impact in Lausanne in May 1972.

[19] Carole Roussopoulos (b. Lausanne 1945; d. Sion 2009) moved to Paris from 1967, to 1995. She is credited for having collaborated with Gina Pane on recording her 1973 and 1974 performances (some shown in the exhibition), as well as for recording Michel Journiac's illustrious *Messe pour un corps* (Mass for a Body, 1975) at the Stadler Gallery in Paris. Roussopoulos addresses this experience with performance in comparison to her own militant practice with video in Julia Hontou, "Gina Pane: Entretien avec Carole Roussopoulos," *Turbulences Vidéo*, no. 52, July 2006, p. 46–51. Roussopoulos was the most prolific video director active in France in the 1970s and 1980s, when she signed and cosigned more than 50 video productions; working especially with the collectives *Video Out* created in 1970 and *Les Insoumuses* with Delphine Seyrig and Ioana Wieder, founded in 1975. Her first video was *Jean Genet parle d'Angela Davis*, in 1970. For more information on Roussopoulos, see Hélène Fleckinger (ed.), *Carole Roussopoulos: caméra militante, luttes de libération des années 1970*, MetisPresses, Geneva 2010 (including a DVD of Carole Roussopoulos' videotapes of the 1970s). See also my essay on militant video, including Roussopoulos: "Disobedient Video in France in the 1970s: Video Production by Women's Collectives," *Afterall: A Journal of Art, Context, and Enquiry*, no. 27, Summer 2011, p. 5–16; reprint in Hilary Robinson (ed.), *Feminism-Art-Theory*, Blackwell, Oxford 2014. It is also available, as permanent link, http://www.afterall.org/journal/issue.27/disobedient-video-in-france-in-the-1970s-video-production-by-women-s-collectives (last accessed July 2015). In addition to Roussopoulos, *Video Out*, and *Les Insoumuses*, there were many other individuals and collectives active in France

with militant video in the early 1970s that were over-looked by the curators of *Art/Vidéo Confrontation* (see for example women-led collectives Vidéo 00, 1971; Les Cents Fleurs, 1973; Vidéa, 1974).

[20] *La Femme sans tête* was recently acquired, in 2008, for FNAC (National Funds for Contemporary Art) collections. The BNF (French National Library) has also recently archived Yalter's work.

[21] *La Roquette* were women's prisons, in the 11th arrondissement in Paris; they closed in 1974. Blum, Croiset, and Yalter's project was successful to a certain extent; it was presented in 1976 at The Kitchen and at A.I.R. Gallery in New York, as well as at the Biennale of São Paolo, in 1979.

[22] There are only two exhibition views (black and white photographs) available in the archives at the Musée d'Art moderne in the Ville de Paris; they show TV monitors and other electronic devices on view on pedestals or stands. Then, most images from the catalogue are stills from videotapes and do not include views of the exhibition neither of the environment it encompassed.

[23] The most significant publications on *Art sociologique* to date were edited by the artists themselves. They are only available in French: Hervé Fischer, Fred Forest, and Jean-Paul Thenot, *Collectif d'art sociologique: théorie, pratique, critique*, Musée Galliera, Paris 1975; Hervé Fischer, *Théorie de l'Art sociologique*, Casterman, Tournai 1977; Fred Forest (ed.), *Art sociologique. Vidéo*, Union Générale d'Editions, Paris 1977; and Fred Forest (ed.), *100 actions*, Z'éditions, Nice 1995.

[24] Fred Forest, Hervé Fischer, and Jean-Paul Thenot, "Manifeste 1 de l'Art sociologique," *Le Monde* (October 10, 1974). My translation.

[25] Fischer and Forest presented similar videotapes to those they had exhibited in Lausanne a month earlier. As for Thenot, he did not participate in *Impact Art Video Art 74*. The creation of the collective occured during the same week as the exhibition in Lausanne.

[26] These videos were inspired by studies of gesture by Flusser (1920–1991). In 1977, Flusser presented his lecture series "Les Gestes" at the École d'Art d'Aix-en-Provence; they were later published with Marc Partouche as *Les Gestes* (1999).

[27] Fred Forest, interview with the author, Paris, January 15, 2011.

[28] French artists and artists based in France invited to *Neuenkirchen* were Fred Forest, Hervé Fischer, and Jean-Paul Thenot composing the Collectif d'art sociologique; in addition to Roland Baladi, Jean-Pierre Bertrand, Richard Gilles, Tomek Kawiak, Léa Lublin, Miloslav Moucha, Ernest Pignon, Fabrizio Plessi, Anne & Patrick Poirier, Joan Rabascal, Sosno, and Nil Yalter. Many of these artists had already participated in *Art/Vidéo Confrontation*.

[29] The only exception is the exhibition *Art socio-critique* that was held much later, in 1982, at a minor institution, Maison de la Culture, La Rochelle, during the multidisciplinary *Festival de la Rochelle*. It was a one off. Artists invited to this exhibition included: Bernard Borgeaud, Nicole Croiset and Nil Yalter, Hans Haacke, Suzanne Lacy, Léa Lublin, Joan Rabascall, Jean Roualdès and Wolf Vostell.

[30] Information collected from Christine Van Assche (then Curator in Chief and Curator for New Media at Centre Pompidou), interview with the author, Paris, June 21, 2011.

[31] The Musée d'art moderne de la Ville de Paris only began purchasing video art in the mid-1990s. Other museums such as the Whitney Museum of American Art, in New York, and the Tate Gallery in London, were similarly slow.

They discreetly institutionalized video in the 1980s, and acquired more in the 1990s.

[32] Two catalogues were published on the video and new media collection of the Centre Pompidou: Christine Van Assche (ed.), *Vidéo et après*, Editions Centre Georges Pompidou, Paris 1992; and *Collection Nouveaux Médias. Installations*, Editions Centre Georges Pompidou, Paris 2006. The Stedelijk Museum in Amsterdam and the Kunstmuseum in Basel have not yet published a catalogue of their video collections. For the Kunsthaus in Zürich and the Ludwig Museum in Cologne there are catalogues available: Friedemann Malsch, Ursula Perucchi-Petri, and Dagmar Streckel, *Künstler-Videos: Entwicklung und Bedeutung. Die Sammlung der Videobänder des Kunsthauses Zürich*, Kunsthaus Zürich and Cantz Verlag, 1996; and Barbara Engelbach, *Bilder in Bewegung Künstler & Video/Film 1958-2010*, Ludwig Museum/Walther König Verlag, Cologne 2010. See http://www.newmedia-art.org/ (last accessed July 2015).

[33] By contrast, François Bovier insists that Roussopoulos' videos were already broadly acquired since the late 1990s by the Centre pour l'image contemporaine, Saint-Gervais, Geneva.

[34] Recent initiatives at the Centre Pompidou to promote under-recognized early French video include: Etienne Sandrin's organization in 2011 of a projection and panel discussion on the topic of 1970s feminist militant video, which involved Anne-Marie Faure (member of the women's collective Vidéa) and Nicole Fernandez-Ferrer (director at the Centre audiovisuel Simone de Beauvoir); the touring exhibition *Video Vintage* (2012), which displayed works from 1963–1983, included Fluxus, Performance, socio-critical with Nil Yalter, and militant video by Carole Roussopoulos, Nadja Ringart, Delphine Seyrig and Ioana Wieder; Yalter's presentation of her work at the Centre Pompidou in February 2012; and Catherine Francblin's presentation on Léa Lublin at the Centre Pompidou in May 2014. See also *Séminaire de recherche: Vidéo des premiers temps* (Research Seminar: Early Video) organized by Paris Sorbonne 1, 3 and 8, and BNF, started in 2012.

[35] See Noah Horowitz, "Appendix B," *Art of the Deal: Contemporary Art in a Global Financial Market*, Princeton University Press, Princeton 2011, n.p.

[36] See Branden W. Joseph, "What is a Minor History?," *Beyond the Dream Syndicate: Tony Conrad and the Art after Cage* (A "Minor" History), Zone Books, New York 2008, p. 11–58.

* Thanks to Claire Bishop, Tracy Ann Essoglou, Fred Forest, and Maud Jacquin.

Video Art and the "Artist Channel": Interview with Don Foresta
François Bovier

Don Foresta, with Kit Galloway and Sherrie Rabinowitz, shooting in the streets of Paris in 1976

FRANÇOIS BOVIER When you arrived in Paris, in 1971, you started putting on programs of videotapes. During your involvement with the American Cultural Center, you organized different exhibitions of video art. Could you go back to your beginnings in Paris?

DON FORESTA First of all, my introduction to video art: in 1970 I knew I was coming to Paris in 1971 as director of the American Cultural Center. The American Center was connected to the American Embassy and was part of the American government cultural program. I was looking for original programming to bring to Paris and I read an article in the *Washington Post* on video art exhibited at the Corcoran Gallery, which I went to see. And I walked into the gallery with my young son who was seven years old; and Nam June Paik picked him up, put him in a chair, and colorized him. And I thought that was marvellous and I absolutely

had to take video art to France. So I met everybody at the show: Nam June Paik, Doug Davis, Global Village with John Reilly and Rudy Stern, the people from *Radical Software*, Ira Schneider, and the whole early group of video artists in those days. Around the same period I met Stan VanDerBeek who is best known as an experimental filmmaker, but is also someone who was beginning to work with video. And Stan VanDerBeek was actually the first that I showed at the American Cultural Center when I came to Paris. It was in September 1971. From that point on, I showed video art systematically. And in that period I indirectly met Woody and Steina Vasulka, who at the same period were actually creating The Kitchen in New York.

FB Which was one of the main places to show video art ...

DF It was the first place where you could see video art, along with the American Cultural Center. I never thought of that before, but we actually started in parallel in New York and in Paris. And a lot of video art I showed in Paris I got through them. In 1973 I was contacted by the Musée d'Art moderne de la Ville de Paris to organize what would be the first show of video art in a museum in France. I don't think it was the first show in Europe, but it was certainly one of the earliest video art shows in Europe. We did that at ARC2, which was run by Susanne Pagé. We organized that show for the public, and it was the first major public introduction of video art in Paris.

FB Some months before, the collective Impact organized a show in Lausanne, also called *Video Art*. It was smaller but there were different pieces of international video art that were to be shown in the ARC2 show. In the catalogue introduction there is an essay by René Berger which was also published in the catalogue of *Video Art Confrontation* by ARC2.

DF I met René Berger. I met him several times along with some Swiss video artists. I don't remember who ...

FB Jean Otth, maybe?

DF Yes, and there was another artist with him.

FB Gérald Minkoff?

DF Yes, I met some of the people who were experiment-
ing in Switzerland at that time. It was easy because there
were so few people in Europe working with video art.
We all met each other very quickly. Actually that was the
beginning of my relationship with Chris Dercon. At the
time he was a journalist in Belgium and he would come to
Paris a couple of times in a year, because it was one of the
few places were you could actually see video art. We began
to be quite friendly in those days—and of course today he
is the director of the Tate Modern. It was a friendly group
and there was no rivalry; it was before the time we became
chapels, because we were so small. And when I finished at
the American Cultural Center I decided to stay in Paris.
At the same time I was asked to open the video art depart-
ment at the École nationale supérieure des arts décoratifs
(ENSAD) which became a day-job, the meta-living for the
rest of my time in France until retirement. I was always
interested in showing video art and I began to work quite
early with the Biennale de Paris, and Georges Boudaille,
who very early was interested in video art, probably right
after the show at ARC2. I constantly worked with Georges
Boudaille, across several Biennales. Ironically, the person
who was the architect for the Paris Biennale was Jean
Nouvel. I was talking with Jean Nouvel: How do you show
these works in a museum context? And no matter what
we did I was never satisfied with it. Everything was reduced
to a small screen and a monitor. It wasn't a very effective
way of communicating these works to a public, but that
was what we did.

FB ARC2 was a huge space, but it wasn't convincing for
exhibiting video art.

DF No, it was monitors. A museum context is usually
huge, but we reduced this space to these tiny little screens
and people sitting in chairs in front of them.
 When I was doing this, I had a very early contact
with French television and the Groupe de recherche at the

ORTF. That was Pierre Schaeffer at the time. And I brought John Reilly and Rudy Stern over in November 1972 to show works from Global Village, mostly video documentaries. We did that at the offices of la Recherche, and that began a long relationship with the French television research group, which was a very mixed and strange experience. There was an interest in video, but Schaeffer himself was more interested in sound than in image. And most of the researchers at ORTF, which then became INA, were film people who didn't like video. Pierre Schaeffer was replaced by the poet Pierre Emmanuel. We met many times and actually worked together. I organized a show of French video art with INA that was sent to the United States and seen in several cities around the USA. And we also signed a contract between INA and ENSAD to bring artists to ENSAD with videotapes. We created an alternative, parallel organization in video, because we knew we couldn't make video art work inside INA, which was dominated by film people. Emmanuel organized conferences and I brought over artists—I brought over Ed Emshwiller and Juan Downey to conferences that were organized, and we had big fight with film people who said it was a dirty image and had scanned lines. It was an attempt but it was a failure, because French television did almost nothing in video art. And INA, apart from our very short-lived experiments, did nothing else with video art. Our experiments operated for about four years and then they dropped it. And almost none of the results have ever been shown up on French television.

FB They didn't broadcast these experiments on French television?

DF No. There was only a Bill Viola piece commissioned by Arte. I thought it was a very poorly done piece, based on a painting by Vasarely. The French-language Belgian television system tried to get video art going to some degree, but they didn't succeed very well. There was a tiny bit of experimentation in the UK, but it never went anywhere. And then there were the Swiss experiments. That was the situation as far as Europe goes. In America …

FB It began earlier …

DF It all started with WGBH in Boston. That was the
real beginning of the experiment with video, starting in
1966 or 1967. And they consistently programmed and broad-
casted video art for about ten years. That was followed
later by WNET, the public television station in New York.
There was a little bit of work that was done by KQED,
which was the public television station in San Francisco.
By far the most important experiment was with WGBH in
Boston. In 1967 they produced a piece that was broadcast
called *The Medium is the Medium*. There were pieces broadcast
consistently in those days, collaborations with artists and
with the Center for Advanced Visual Studies and MIT.

FB They were pieces made for broadcast. In a sense it
was a new framework in which to exhibit video art.

DF Yes, it was a collaborative production between
television and artists using television tools. I specifically
remember a piece called *Music for Prague* which was a
symphony orchestra playing a piece by the Czech composer
Karel Husa. The image was a symphony orchestra treated
with video effects, it was a very interesting piece. And there
were earlier experiments. Fred Barzyk, a producer, was
the first person I knew at WGBH. Then there was David
Loxton at WNET in New York. A lot of people were invited
there. I was actually with Nam June Paik in 1973 when he
was editing *Global Groove* at WNET. Public television at that
time was the only place in America for experimentation.
It was a television system that belonged to the public, not
to the government, and it was usually run by universities.

FB There was an educational idea.

DF In the beginning it was totally educational. Then it
moved more and more to regular broadcasting, but always
with this experimental and educational side too. WGBH
has been traditionally the most successful public television
station, the richest, and the one that collaborated with other
stations in America and in Europe.

FB In a sense it was a new conception of producing
and distributing video art for many people, instantaneously.
It was a new way of making and showing art.

DF Completely, following the idealism of the time. It was
a way of bringing art to the masses, using a system of mass
communication, with artists who were creating for that
particular medium. It was just before György Kepes created
the Center for Advanced Visual Studies at MIT, and video
artists were present there. Nam June Paik built the Paik-Abe
synthesizer that was used by WGBH. Eventually it was
rebuilt at the Center for Advanced Visual Studies by an artist
called Ron Hayes, who used it to make visual forms and
interpret music. These experiments using the Paik-Abe
synthesizer were consistent for a short period of time.
They also used the machine that was built by the Whitney
brothers. It was a scan-line processor.

FB A modified scanner?

DF Yes, it was used in the last sequence of the film *2001:
A Space Odyssey* (Stanley Kubrick, 1968). John and James
Whitney built that machine. Ron Hayes used the same
machine for some of his video works broadcasted both by
WGBH and WNET.

FB So there was a relationship between a new way of
exhibiting moving images and a new way of producing
distorted and reworked images.

DF Exactly. There was this brief period of experimenta-
tion within the public television system. Some of it was
even founded by the Corporation for public broadcasting
in Washington and PBS itself. There was another parallel
development that was interesting, but once again it was
a complete failure. It was the beginning of cable television.
At its very beginning, cable television was negotiated on a
city level in an attempt to open public channels. Every cable
operator had to offer a certain number of channels free
to the public. So the public communities could broadcast
anything they wanted. And it differed from city to city.
In New York they negotiated five public channels from the

very beginning. Other cities didn't bother and nothing happened, it was mixed. But in New York a certain number of artists jumped into these public channels and began broadcasting. Some of them were very controversial, because they were very scatological and challenging, very often terribly boring, but people were beginning to experiment. And then what happened in the 1980s when the Republican Party began to dominate in America ... they changed all the rules and the public channels disappeared. It was no longer publicly accountable, it became nothing more than a platform for commercial television. So those experiments were eliminated because laws changed. But I think what happened in public television here was a fear of public reaction and not being able to predict how the public would react to what was basically experimental television. They became more and more cautious. New York continued to show video art on a regular basis, but framed it in a documentary form with someone explaining what it was. The first program that became relatively important in doing this was called *VTR*, which was obviously the name of the machine, the Video Tape Recorder, but they changed it to mean *Video and Television Review*. It was run by Russell Connor who every so often would make program around a particular video artist. A lot of video art was shown in that format. It really was a pedagogical attempt to show the public and not to frighten them, to say: "This is very experimental, you will maybe be surprised, but here it is!" And little by little WNET became less and less interested in experimental video, and it died out. Boston held on longer than anyone, but again they became more and more cautious. The bleakest example for me is a commission that they gave to Bill Viola. They asked him to imagine interludes, short pieces that would be broadcasted between programs, of thirty seconds to a minute maximum, because public television had no commercials. So they were separating programs with these interludes, and they asked Viola, giving him a small budget, to commission a certain number of these interludes. Viola went into people's homes and filmed them watching television straight up; so people are sitting in their chairs and he filmed a whole lot of them. The idea was that people at home who are sitting in their chairs watching TV all suddenly see somebody sitting in a chair looking back at them.

FB They see themselves watching TV, interrogating their own point of view.

DF I think it was a brilliant idea. But when WGBH broadcast it, instead of broadcasting it as interludes between programs, they just took the whole piece and broadcast it as a 50-minute piece, which means the whole idea was destroyed. They were afraid to do it—to engage with the public. I think it's one of the psychological qualities of television: they think of themselves as a one-way broadcast. They expect to send things out and to be received passively. And of course art doesn't like passivity, but asks people to respond. Somehow, psychologically, it was against the whole idea of broadcast television.

FB This rather short period of time corresponds to a utopia like the Videosphere, where you could interact.

DF The idea was definitely there. I think in France the real experiment only came in 1984 with Nam June Paik, because they did a piece between Paris and New York, *Good Morning Mister Orwell*. Paik organized this direct transmission of artists in both cities, from the Whitney Museum in New York and the Centre Pompidou in Paris. Paik had this whole group of artists coming to both venues and sending their stuff to other people. Some notable things happened. Merce Cunningham made a piece where an image of himself dancing was sent to the moon and back. He received an image of himself coming back with a delay, and he danced with that image, and that went out and come back with another delay, and he would dance with those images. There were people in each city doing something for people in the other city. I was on the French side with Paik. He had designed a whole series of special effects and there was a rehearsal on the night before when all this was worked out. And when it actually happened in real time it was on the French third channel, FR3, all the technicians stopped; they didn't do any of the special effects.

FB They were afraid of it!

DF They became very cautious, and there was just
straight camera work of the artist doing his thing, with none
of Paik's interventions. It's a classic! Around the same time,
a year later, I worked with Doug Davis doing a similar
project that was totally interactive called *Double entendre*
between the Whitney and the Pompidou again, with a man
and a woman. It actually worked in both directions, with
people in New York reacting to people in Paris, back and
forth, according to a rehearsed script. Paik did another
piece during the Olympic games in Korea that again was
supposed to be broadcast, but which was only partially
broadcast. By that time, the whole experimental attempt
by television to work with video art had come to an end.
There was the musical clip business, but that came from
a very different direction. The whole idea of musical clips
really was promoted in London by cinema studios. It became
the only kind of experimentation with visual language. At
the same time, Gene Youngblood's *Expanded Cinema* pub-
lished in 1970 became an incredibly important book, and
it is still somehow a cult book. He did an incredibly beautiful
summary of what was going on in experimental film, with
a small section on video. One of the things that Gene
Youngblood said in his book was that by 1986 artists would
have their own television channels. And ironically, by 1986,
television experimentation with art was finished. Television
became what it is today, very cheap, vulgar commercial
entertainment. So video art has been confined, when it is
shown at all, to museums and to galleries.

FB What about the idea of a TV gallery, like Gerry
Schum's experiments in 1968–1969? He redefined the
television as a gallery space.

DF Yes, and the potential is still there. Given the state of
television today, it is just never going to happen on TV.

FB It was a new way of looking at TV as an exhibition
space, of incorporating television in a different logic. Today,
in the network era, we could still use this public sphere
in an artistic way, experimenting with the diffusion, the
production, and the idea of exhibition.

DF I still think it is a useful thing. My own interest over the last 35 years has been with the network. I started to use the telephone network as an artistic space in 1981, with an exchange between the American Cultural Center in Paris and the Center for Advanced Visual Studies at MIT. I should explain that in Paris there were always two centers. There was the American Cultural Center that I directed that was part of the American Embassy. I left in 1976 and I went to the other center, which was called the American Center and which was a private center for the arts. I was involved there for another eight years. That's actually where I started giving video workshops. And apart from the Arts Déco where I ran the video art section, that was the other place in Paris where people could learn video art. Between the two centers I was very much involved in the formation of an early generation of video artists in France (Hervé Nisic, Dominik Barbier, Yann Nguyen Minh, and Jérôme Lefdup among others). At the American Center we organized workshops, first of all with American artists who would come over, and then eventually French artists, and artists from other places as well. Artists who gave workshops on video art would also present their work. For a period about ten years we had a lot of video performances going on. I stopped doing this around 1983 and it was taken over by Anne Marie Stein for a couple of years before she went back to the United States. In the early days of the network I didn't think of it as being a space for video art, but we were still working with video artists. In a way the images were still images, so it wasn't quite the same thing. We really didn't turn to moving images over the network until the early 1990s. But they were still crude and it was quite impossible to think of it as a space for moving image.

FB Due to technical difficulties.

DF Yes. We tried everything that we could think of from 1987 on to get movement into the thing, and we couldn't do it until the end of the 1990s when the band got better. I did a lot of experiments with concerts, because the first people interested in the network as an artistic space were musicians. We did concerts throughout the 1990s, but they were very primitive and we had enormous technical problems. Already

in around 1987 or 1988 I was thinking of the network as an
alternative to television.

FB The network couldn't be invested in as a medium for
the moving image or as a new way of reactivating the stakes
of video art before the end of the 1990s.

DF Going back to Gene Youngblood's idea of artist
channels, when Woody Vasulka contacted me about seven
years ago, he said we have to preserve all these works,
otherwise they will disappear with us. That's why we started
working on the idea of getting videotapes online. Which we
did with the Vasulka tapes experimentally over the MARCEL
network (see http://mmmarcel.org/). We had this section
on the MARCEL website called Marcel TV and in that we
had the beginning of a video archive. I started with 60 of the
Vasulka's titles. They are free, people can screen the works.
I said to Woody at one point: "Woody, you know, we are
still living in Gene Youngblood's dream of artist channels."
And he said: "Yes we are." I really think that it can happen.
We can go back to this original idealistic idea. It is one
of the vocations behind the MARCEL network.

FB It was also close to the Movie-Drome and VanDerBeek's
idea of centers of communication with the possibility of
diffusing images and sounds instantaneously from different
places, abolishing the distance of time and space.

DF Geography, yes.

FB Abolish geography, and you have a living network.

DF This is the direction in which we are going. I've been
talking to different institutions, including Tate Modern,
about the idea of museums no longer being within four
walls, but museums being part of a network. I think this
is the future, which will again bring alive this idea of using
electronic technology to bring art to a larger group of
people, and to really create artist channels and to begin
to present works in a way in which the public interacts
with the works. It is a direction that I've been following
for 35 years! (*Laughs*) It is only becoming technologically

possible now. For me the whole idea of interactivity has been a very fundamental notion in 20th-century art: how do you bring the work to a public, and how do you get people to interact with the work. This has been experimented with throughout the 20th century, starting with Duchamp. But the technology hasn't really been there to respond to the artists' imagination. I think historically we are finally reaching a point where the technology can actually respond to the artists' imagination and we can go back to that ideal and begin to think of art in a totally interactive way.

FB Interactive and without hierarchy—that is, open and without a center.

DF Yes, a horizontal organization, not another vertical pyramid. People can actually participate while making their works happen. Throughout my teaching career I used the Duchamp quote in which he said that it is the spectators who complete the work. It is something that I've always believed in, and now we have the technology to allow that to happen. That's the kind of research that I am working on with Woody and Steina Vasulka.

FB The idea is not only to exhibit video art in museums, but to use the network as an alternative exhibition space, allowing different ways of interacting with the audience. It can give a second life not only to ideas of artist channels, but also to video art pieces.

DF I think so. A lot of young people using the network for art are not aware of that history. If they were aware of it, they would probably even go faster. For me the Vasulkas were the first artists to invent a digital vocabulary. That aspect of their work was not well known in the art world and certainly not understood by most people in the art world. But I think there is a whole generation coming up that understands that, and they recognize that they were the early definers of a digital vocabulary and what will become the symbolic language of the digital network.

FB The archaeology or genealogy of the network has still to be dug up or excavated ...

DF Exactly. What is actually called for is a whole revision of 20ᵗʰ-century art history, a lot of it with an understanding of the art and science interface. In fact in the 19ᵗʰ century artists were extremely interested in science, because science was proposing a new definition of reality. The observer was extremely important in scientific definition. Artists are doing the same thing. That to me is just another way to say interactivity. I think it is important to correct history, and to go back and reexamine a lot of what was going on in a new light. That's one of the reasons I am extremely interested in the work of Linda Henderson, because I think as an art historian she is starting a revisionist history of 20ᵗʰ-century art. *The Fourth Dimension and Non-Euclidian Geometry and Modern Art* (1983/2013) is a key book, a cult book. I think it is the beginning of a whole new look at 20ᵗʰ-century art, understanding that in a way that mixing experimental film, video art, and computer art makes it much more obvious as the place that really picks up that same avant-garde of experimentation. If you go back to the way she was looking at the early days of 20ᵗʰ-century art, then you see how what was being done in film, video, and computer, and so forth, and now the network fits in with that all notion of the fourth dimension.

Imprint

Edited by François Bovier & Adeena Mey, ECAL/University
of Art and Design Lausanne

Editorial Coordination & Copy Editing
Clare Manchester

Design Concept
Gavillet & Rust, Geneva

Design
Vera Kaspar

Typeface
Genath (www.optimo.ch)

Print and Binding
Présence Graphique, Monts (Indre-et-Loire)

Photo Credits & Copyrights
P. 14: Photographer: Shunk-Kender © J. Paul Getty Trust.
The Getty Research Institute, Los Angeles (2014.R.20).
Gift of the Roy Lichtenstein Foundation in memory of
Harry Shunk and Janos Kender; 54: Courtesy of Anthology
Film Archives; 74: Courtesy of the artist; 98: © Roland
Sabatier; 116: Courtesy of the Royal Belgian Film Archive;
138: © Fred Forest; 162: © Don Foresta

© 2015, the authors, the photographers, the editors, ECAL,
and JRP|Ringier Kunstverlag AG

PUBLISHED BY
JRP | Ringier
Limmatstrasse 270
CH–8005 Zurich
T +41 43 311 27 50
E info@jrp-ringier.com
www.jrp-ringier.com

IN CO-EDITION WITH
Les presses du réel
35, rue Colson
F–21000 Dijon
T +33 3 80 30 75 23
E info@lespressesdureel.com
www.lespressesdureel.com

ISBN 978-3-03764-433-1 (JRP | Ringier)
ISBN 978-2-84066-823-7 (Les presses du réel)

Distribution

JRP | Ringier publications are available internationally at selected bookstores and from the following distribution partners:

GERMANY AND AUSTRIA
Vice Versa Distribution GmbH
www.vice-versa-distribution.com

FRANCE
Les presses du réel
www.lespressesdureel.com

SWITZERLAND
AVA Verlagsauslieferung AG
www.ava.ch

UK AND OTHER EUROPEAN COUNTRIES
Cornerhouse Publications HOME
www.cornerhousepublications.org/books

USA, CANADA, ASIA, AND AUSTRALIA
ARTBOOK | D.A.P.
www.artbook.com

For a list of our partner bookshops or for any general questions, please contact JRP | Ringier directly at info@jrp-ringier.com, or visit our homepage www.jrp-ringier.com for further information about our program.

Documents Series 23:
Cinema in the Expanded Field

This book is the twenty-third
volume in the "Documents" series,
dedicated to critics' writings.

The series is directed by
Lionel Bovier and Xavier Douroux.

Also available by the same editors
in the same series:

Exhibiting the Moving Image, 2015

René Berger, *L'art vidéo et autres
essais,* 2014

Also available

DOCUMENTS SERIES (IN ENGLISH)

John Baldessari, *More Than You Wanted to Know About John Baldessari*
ISBN 978-3-03764-192-7 (JRP | Ringier) [*Vol. 1*]
ISBN 978-3-03764-256-6 (JRP | Ringier) [*Vol. 2*]

Raymond Bellour, *Between-the-Images*
ISBN 978-3-03764-144-6 (JRP | Ringier)
ISBN 978-2-84066-513-7 (Les presses du réel)

Joshua Decter, *Art Is a Problem*
ISBN 978-3-03764-195-8 (JRP | Ringier)
ISBN 978-2-84066-621-9 (Les presses du réel)

Gabriele Detterer & Maurizio Nannucci, *Artist-Run Spaces*
ISBN 978-3-03764-191-0 (JRP | Ringier)
ISBN 978-2-84066-512-0 (Les presses du réel)

Christian Höller, *Time Action Vision*
ISBN 978-3-03764-124-8 (JRP | Ringier)
ISBN 978-2-84066-396-6 (Les presses du réel)

Hans Ulrich Obrist, *A Brief History of Curating*
ISBN 978-3-905829-55-6 (JRP | Ringier)
ISBN 978-2-84066-287-7 (Les presses du réel)

Hans Ulrich Obrist, *A Brief History of New Music*
ISBN 978-3-03764-190-3 (JRP | Ringier)
ISBN 978-2-84066-619-6 (Les presses du réel)

Igor Zabel, *Contemporary Art Theory*
ISBN 978-3-03764-238-2 (JRP | Ringier)
ISBN 978-2-84066-573-1 (Les presses du réel)

Hans Ulrich Obrist, *The Czech Files*
ISBN 978-3-03764-387-7 (JRP | Ringier)
ISBN 978-2-84066-760-5 (Les presses du réel)